Majolica

British, American & European Wares
Revised & Expanded 2nd Edition

Jeffrey B. Snyder and Leslie Bockol

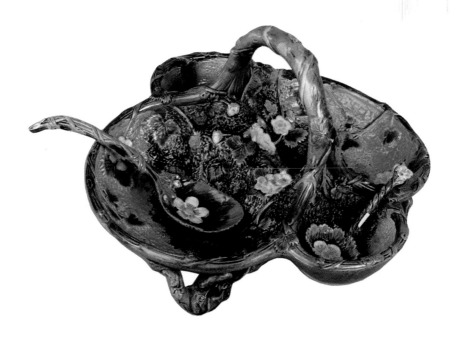

4880 Lower Valley Road, Atglen, PA 19310 USA

Dedication

To our families, for their encouragement and toleration.

Acknowledgments

We would like to express our gratitude to all the people who made this book possible, especially Michael Strawser and Majolica Auction's spring of 1993 event in King of Prussia, Pennsylvania, and other collectors who chose to remain anonymous. Without their cooperation, generosity, and never-ending store of wonderful majolica stories, our book would have been much less fun, if not impossible, to write. Our gratitude is also extended to Peggy Osborne and Peter Schifffer for their help with marathon photography sessions, to our editor Nancy Schiffer for helping us to fine-tune our words and ideas, and to Sue Taylor for making it all look as splashy as a couple of majolica-lovers could hope for.

Pricing

The prices found in the captions are in United States dollars. Prices vary immensely based on the location of the market, the venue of the sale, the rarity of the items and/or their glaze treatments, and the enthusiasms of the collecting community. Prices in the Midwest differ from those in the West or East, and those at specialty shows or auctions will differ from those in dealer's shops or through dealer's web pages.

All of these factors make it impossible to create absolutely accurate price listings, but a guide to realistic pricing may be offered. **Please note:** these values are not provided to set prices in the antiques marketplace, but rather to give the reader a reasonable idea of what one might expect to pay for mint condition majolica wares.

Revised price guide: 2001
Copyright © 1994 & 2001 by Schiffer Publishing Ltd.
Library of Congress Catalog Card Number: 00-110857

Typeset in ShelleyAllegro BT/ZapfHumnst BT

ISBN: 0-7643-1250-2
Printed in China
1 2 3 4

Published by Schiffer Publishing Ltd.
4880 Lower Valley Road
Atglen, PA 19310
Phone: (610) 593-1777; Fax: (610) 593-2002
E-mail: Schifferbk@aol.com
Please visit our web site catalog at **www.schifferbooks.com**

In Europe, Schiffer books are distributed by Bushwood Books
6 Marksbury Avenue Kew Gardens
Surrey TW9 4JF England
Phone: 44 (0) 20-8392-8585; Fax: 44 (0) 20-8392-9876
E-mail: Bushwd@aol.com
Free postage in the UK. Europe: air mail at cost.

This book may be purchased from the publisher.
Include $3.95 for shipping. Please try your bookstore first.
We are always looking for people to write books on new and related subjects.
If you have an idea for a book please contact us at the Atglen, PA address.
You may write for a free catalog.

Contents

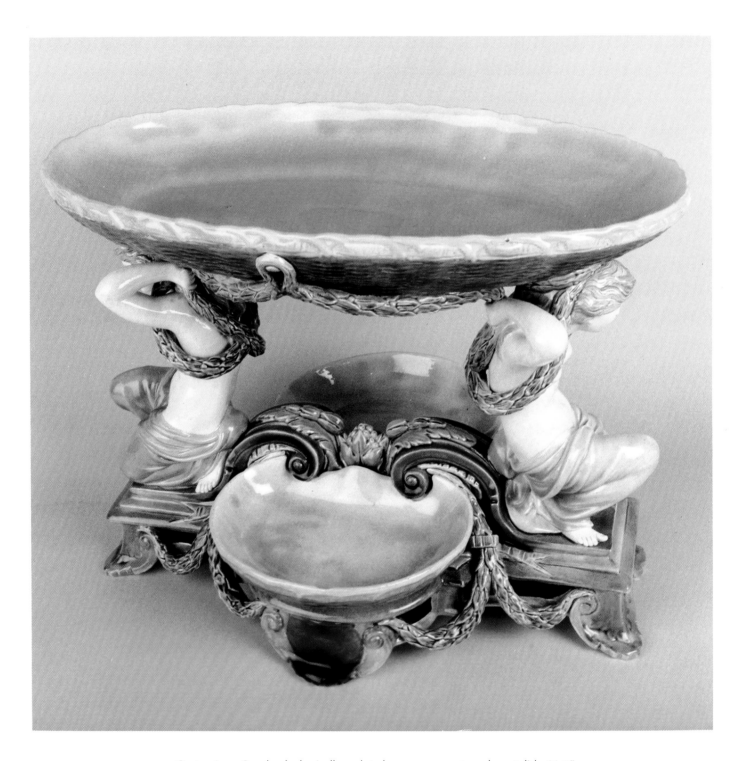

Centerpiece, Copeland; classically-sculpted women support an elegant dish. 11.5" high x 14.5" long x 9" wide. A piece like this could keep a crowd of the "right" sort buzzing for a week. *Courtesy of Michael G. Strawser, Majolica Auctions.* $9750+

Introduction

A middle aged man heads home down a narrow London street through the gathering shadows of candle-lighting in the mid-1850s. His name and profession are unimportant. Of importance is the fact that he is part of the relatively recent phenomena, a growing middle class. As he climbs the steps to his row house, he wonders if his wife has managed to gather anyone of a higher social status for their upcoming dinner party. He hopes for some impressive calling cards to leave out for all to see, at the very least.

Entering his home, he drops his cane in the umbrella stand by the door, nods to the maid-of-all-works and climbs the stairs to the second floor drawing room. His wife is there, brimming with excitement in the candlelight. Much to his amazement she has received word that the barrister and his wife will attend. Our man is delighted by the news and envisions himself ascending another rung on the social ladder.

His face clouds then. He looks around, does a quick mental inventory of the house's contents and finds them lacking. *Ye Gods, what furniture or table settings do we have that could possibly impress such lofty guests?* he wonders anxiously. Seeing his concern and sure of its source, our man's wife produces an object that takes his breath away. Amidst the dark trappings of a Victorian home with dark wood furniture and heavy closed drapes protecting the carpeting, the object she has revealed virtually glows with handsomely colored high relief designs.

"Do you think this will impress?" she asks with a sly smile. He nods, eyes bulging, unable to speak. Although he is not sure, being no antiquarian himself, before him appears to be a much sought after antiquity from the Renaissance, a centerpiece for the table no less.

"Where did you get this?" he asks, sitting down hard and not daring to ask what it cost. She names a shop.

He is puzzled: this is no dealer of antiquities. "Well, wherever it came from, we can't keep it!" he exclaims.

"Yes we can. It's new." she replies. "The price is low." Once she quotes the figure, our man is both relieved and impressed with his wife's abilities. Truly she must be the unsurpassed queen of domestic affairs, he marvels.

The dinner party is a great success and our couple rises in social standing among their friends and neighbors. Their centerpiece is a topic of conversation for days to come.

The centerpiece, far from being the Renaissance antique it seemed, was one of the new majolica wares, held in high acclaim since Herbert Minton introduced them only a few years before at the Crystal Palace Exhibition of 1851. From roughly 1851 on until the waning years of the nineteenth century, colorful, relief molded majolica would continue to grace dinner tables, parlors, conservatories and gardens of upwardly mobile middle class homes. Today it is gracing homes again, as a steadily increasing group of collectors re-discover majolica and its colorful allure.

Chapter 1
Defining Majolica's Parts

"...there is no fixed standard of the beautiful, but it varies
and changes with the individual ... Each has his own
conception of what is beautiful." - William Ware, 1852.[1]

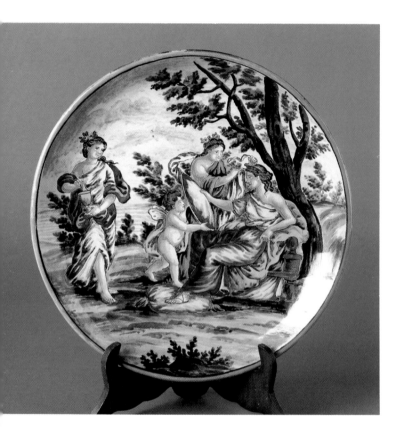

Traditional wall plaque, unattributed, early Italian, reminiscent of
actual *maiolica*; classical scene, polychrome painting. 12.5" high.
Courtesy of Michael G. Strawser, Majolica Auctions. $450+

Majolica and Its Purpose

Majolica is a soft, low fired earthenware molded
with high or low relief decorations, coated with an
opaque glaze or slip, and painted with brightly col-
ored lead glazes which generally accentuated the
molded designs. The name "majolica" is a trade-name
developed by Herbert Minton to introduce this dis-
tinctive ware in c.1850 in England.

Majolica, in its earliest incarnation, was patterned
after an Italian tin-glazed earthenware known as
maiolica, named from an Italian term for luster ware
from Valencia which had been shipped in the six-
teenth century from the island of Maiolica, now
Majorca. This Renaissance ware was being written
about by scholars in the mid-nineteenth century, ac-
quired by museums, purchased by antiquarians for
their private collections, and coveted by many more.

English potter Herbert Minton's early majolica
designs of the mid-nineteenth century imitated not
only the ancient Italian earthenware, but also the
French pottery of naturalist Bernard Palissy (1510-
1590). Palissy's ware was encrusted with very detailed
animals and plants, an attention to detail and natural
themes which resonated well with mid-century popu-
lar thought. Palissy's authentic work was purchased
by wealthy antiquarians and envied by those who only
dreamed of such luxury items.

The Industrial Revolution in England at this time
was providing an abundance of new goods and eco-
nomic opportunities. It also helped create a new so-
cial force, a relatively affluent and growing middle
class that bought the affordable, mass produced con-
sumer goods. Majolica, with its allusions to antiquity
and striking colors became popular in England. Ma-
jolica was also a welcome change in the dining room
from the well known blue and white transfer printed
wares, creamwares and ironstones that the previous
generation or two used. With a design philosophy
stressing visual impact over function, Majolica stood
out among these staid patterns.[2]

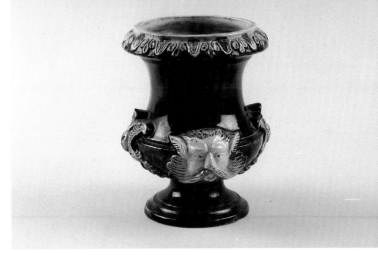

Vase, unattributed; gargoyle ornament. 5" high. $190+

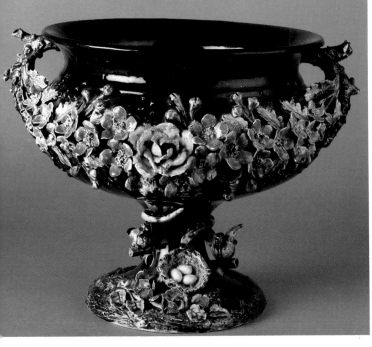

Very large urn, unattributed; cobalt with Palissy-style organic decoration, applied flowers and foliage; a snake lurks at its foot, waiting to snatch the eggs from a wary bird at its nest. 14" dia. x 11.25" high. *Courtesy of Michael G. Strawser, Majolica Auctions.* $600+

Majolica, with its allusions to antiquity and striking colors, became popular in England. Trophy cup, unattributed; classical style with relief-molded centaurs and cherubs. 4.5" high. *Courtesy of Michael G. Strawser, Majolica Auctions.* $190+

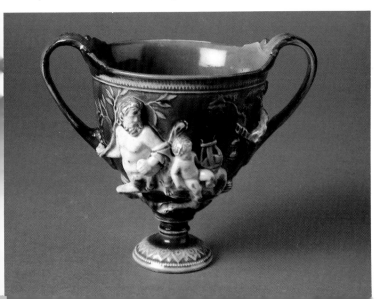

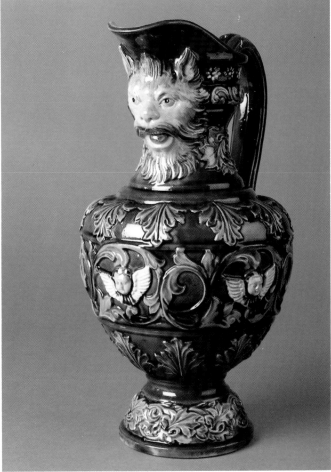

Pitcher, unattributed; mythical griffin spout and a circle of cherubs. 11.5" high. *Courtesy of Michael G. Strawser, Majolica Auctions.* $450+

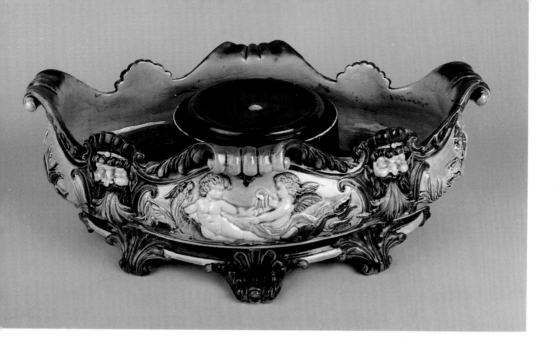

Majolica was also a welcome change in the dining room from the blue and white transfer prints, creamwares and ironstones so familiar to the previous generation or two. Centerpiece bowl, unattributed; sea nymph and cherub ornamentation, 18" x 11.5" x 6". *Courtesy of Michael G. Strawser, Majolica Auctions.* $425-470

THE NATURAL SCIENCES

Majolica wares also offer us today a glimpse into the fascinations, humors, and culinary delights of the Victorian era. Advances in the sciences of botany, horticulture, marine biology and conchology, zoology, ornithology, and even humorous intimations of the theory of natural selection make their appearance on majolica. The increasingly varied Victorian diet is well represented in majolica dish forms. The passion for oysters, for example, more readily available at the market place with improvements in transportation technology, is evident in majolica oyster plates fashioned as replicas of the food itself. For a Victorian diner eating from majolica, if the food is unidentifiable, the dish will reveal in no uncertain terms what is set upon it.[3]

With new developments in the natural sciences of botany, horticulture, marine biology, conchology, zoology and ornithology Victorian society developed a fascination with the world around them. This lively interest often expressed itself in print and in majolica decorative motifs.

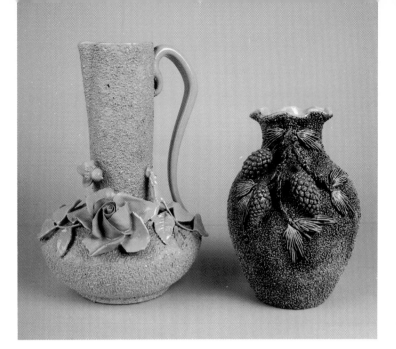

A small, unattributed salt-glazed ewer, and salt-rolled vase with applied pine cone ornament, very naturalistic. 11" high and 8" high. *Courtesy of Michael G. Strawser, Majolica Auctions.* $125+ each

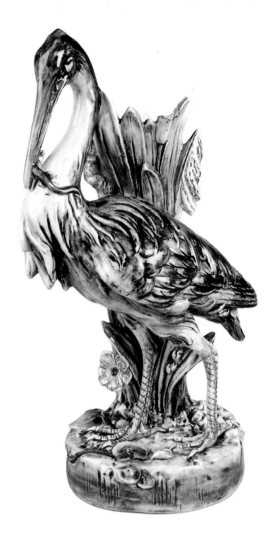

Vase, unattributed, Continental; heron with cattails and pond lily scene. 21" high. Herons and storks were a popular motif. In England, Holdcroft produced flower stands modeled after these birds; Minton produced walking stick stands and decorative figures. French maker Delphin Massier produced 5' pedestal jardinieres with heron, flamingo and peacock bases. *Courtesy of Michael G. Strawser, Majolica Auctions.* $2435+

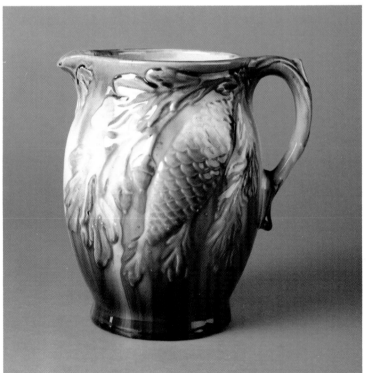

Pitcher, unattributed, mottled with oak leaf and pine cone theme. More abstract than pine cone on the salt-rolled vase, but attention to detail and respect for the beauty of natural forms are still evident. 7.5" high. *Courtesy of Michael G. Strawser, Majolica Auctions.* $125-135

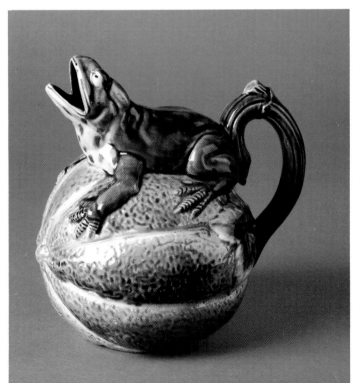

Pitcher, unattributed; beautifully modeled figural frog perched on a cantaloupe. 7" high. Attention to botanical and zoological detail was crucial for both the modeling and painting of exquisite pieces like this one. *Courtesy of Michael G. Strawser, Majolica Auctions.* $800-880

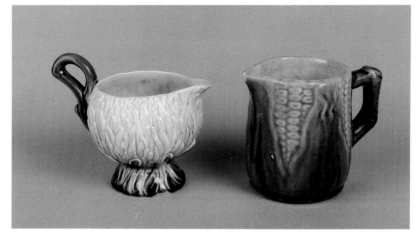

Two creamers, unattributed. Figural chrysanthemum (possibly by Julius Dressler of Biela, Bohemia: a leader among Central European potters in the manufacture of both majolica asparagus and berry servers who produced majolica wares from c. 1860s to 1910), Continental, 3.5" high and figural corn, 4" high. *Courtesy of Michael G. Strawser, Majolica Auctions.* Chrysanthemum: $125-140; Corn: $100-110

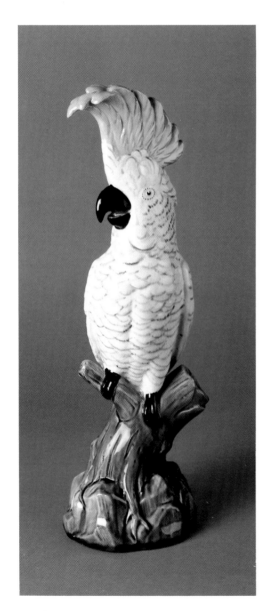

Bread tray, unattributed; oak leaf and acorn patterns. Not only a depiction of the natural world the Victorians found so engaging, the oak leaf and acorn were understood to be symbols of strength and continuity. Both 12" long. *Courtesy of Michael G. Strawser, Majolica Auctions.* $565-625

Statuette, unattributed; cockatoo on a stump. 14.5" high. Natural themes were very popular; *exotic* natural themes were even better. *Courtesy of Michael G. Strawser, Majolica Auctions.* $500-550

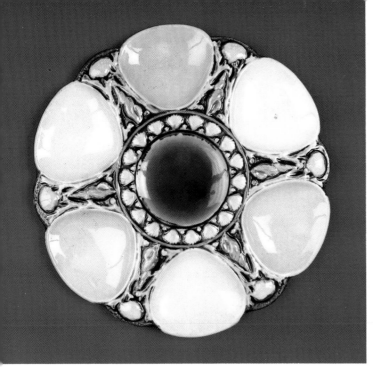

Oyster plate, unattributed. 12.75" x 2" high. *Courtesy of Michael G. Strawser, Majolica Auctions.* $550+

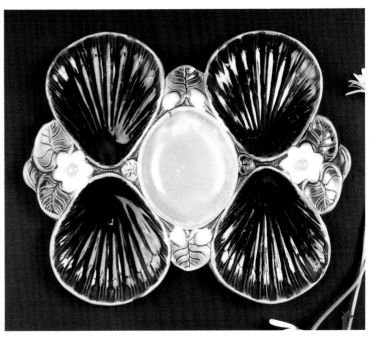

The Victorian passion for oysters is evident in the large numbers of majolica oyster plates produced during the latter half of the nineteenth century. Oyster plate, Holdcroft-type; outside wells with mottled glaze. 9.25" x 7.5". *Courtesy of Michael G. Strawser, Majolica Auctions.* $1200+

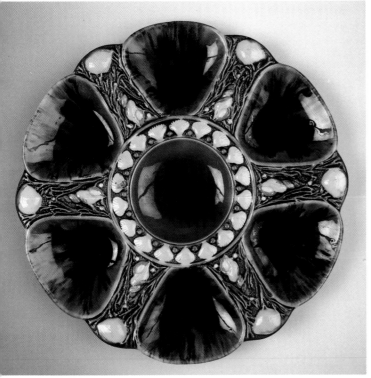

Oyster plate, Minton; mottled glaze. 9" dia. The shells and seaweed adorning this plate are better and more carefully defined and decorated than in the previous unattributed plate. *Courtesy of Michael G. Strawser, Majolica Auctions.* $660-725

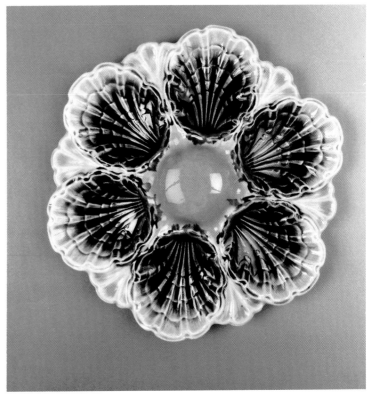

Oyster plate, unattributed. 9" dia. *Courtesy of Michael G. Strawser, Majolica Auctions.* $335+

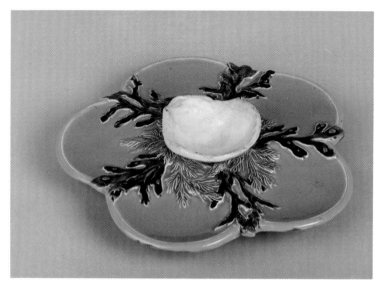

Oyster plate, George Jones, marked with "GJ" manufacturer's mark, c. 1861 to 1873, and an English Registry Mark. 7.5" dia. *Courtesy of Michael G. Strawser, Majolica Auctions.* $1560+

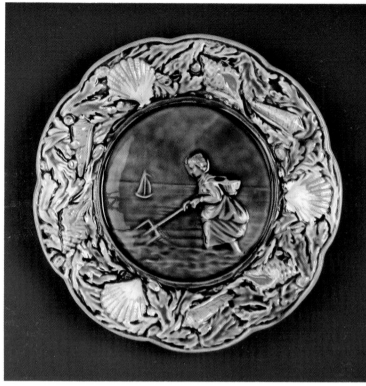

Plate, unattributed, possibly produced by George Jones; shells with claming scene in center. 8.5" dia. *Courtesy of Michael G. Strawser, Majolica Auctions.* $650+

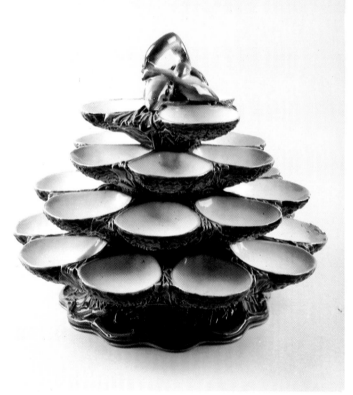

When a plate full of oysters just was not enough ... four-tiered oyster stand, Minton, c. 1856; base detaches. 10.5" high x 12" dia. $4500-4950

Oyster plate, marked Sarreguemines. 9.5" dia. *Courtesy of Michael G. Strawser, Majolica Auctions.* $250-275

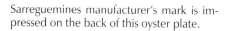

Sarreguemines manufacturer's mark is impressed on the back of this oyster plate.

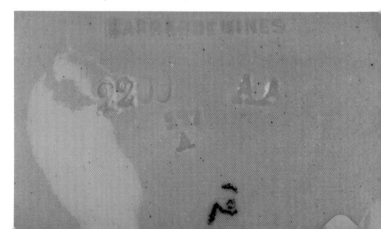

FOOD

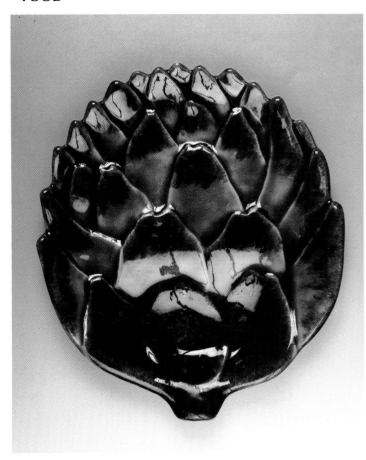

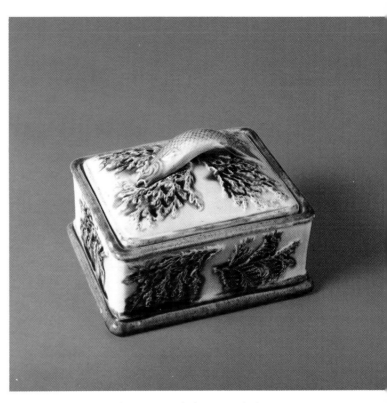

While sardines are easily recognized when served, they were considered a Victorian delicacy and this sardine box would ensure the host and hostess that their guests appreciated their presence at the table, unattributed; seaweed and fish ornamentation. 6.5" x 5.5". *Courtesy of Michael G. Strawser, Majolica Auctions.* $900-1000

If the Victorian diner was confronted with a delicacy rendered unrecognizable during preparation, he or she could identify it by the form of the majolica dish it was served on—as with this artichoke plate. Marked "Made in France for Carole Stupell" on the base. It would be interesting to know if Carole Stupell was aware that the blossoming artichoke was considered to be a symbol of fertility. 9" x 8". *Courtesy of Michael G. Strawser, Majolica Auctions.* $150-180

Back markings on artichoke plate. "Made in" began to be used in 1887 and continues today.

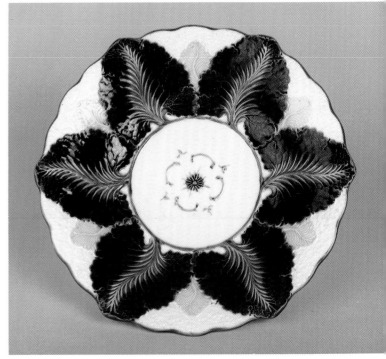

Bowl, Wedgwood; cauliflower leaf pattern. 11" dia. x 2" high. *Courtesy of Michael G. Strawser, Majolica Auctions.* $400+

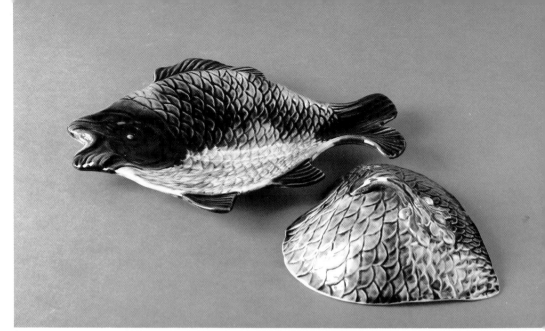

Covered dish, unattributed; fish motif with twig and oak leaf handle. 10" x 7.5". *Courtesy of Michael G. Strawser, Majolica Auctions.* $685+

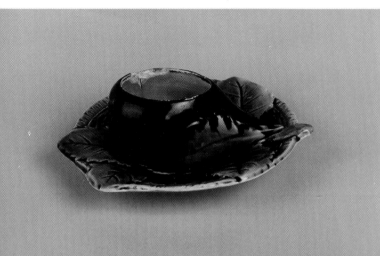

Condiment dish, unattributed; fruit and leaf motif, with underplate. 6.5" long. *Courtesy of Michael G. Strawser, Majolica Auctions.* NP (**N**o **P**rice)

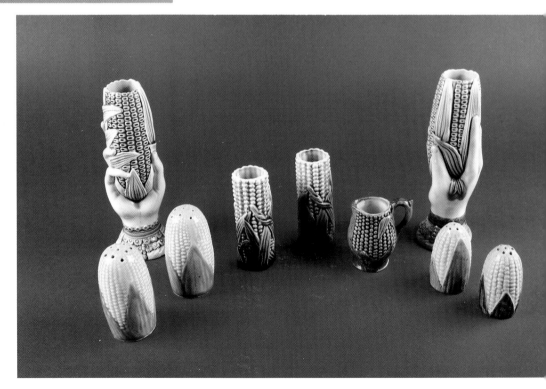

Variation on the corn theme, all unmarked. Tallest item, 7.25" high.

GARDENS

During the Victorian era, the "conspicuous consumption" of well-to-do families in industrialized cities took a turn towards Nature, leading many homeowners to indulge in hothouses and indoor conservatories. This trend necessitated a wide range of garden accessories, from pedestals and garden seats to jardinieres and small planters. Majolica was ideal for these modish pieces; if the roses, geraniums or narcissus refused to bloom, the bright ceramic pots and ornaments would nevertheless keep the room suitably cheerful.

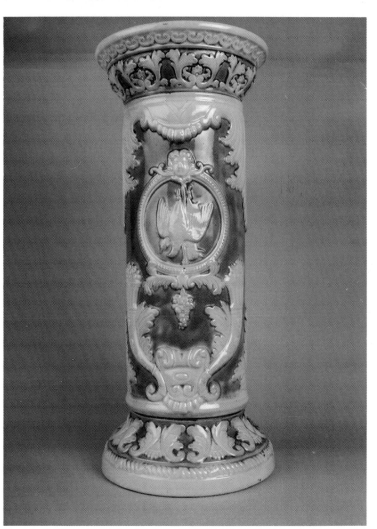

Jardiniere stand, Wardles. 19" high. *Courtesy of Michael G. Strawser, Majolica Auctions.* NP

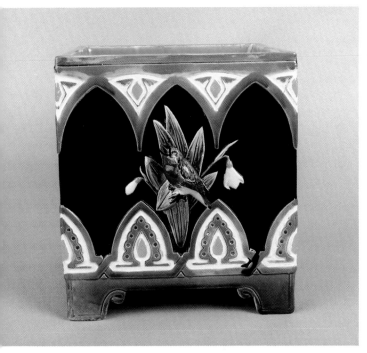

With the rising interest in the natural world, the well-to-do Victorian brought Nature home, adding hothouses and conservatories to the home. Majolica potters provided an array of garden accessories to help the curious Victorian observe the wild kingdom. Jardiniere, Holdcroft; cobalt. 7.5" sq. x 9" high. *Courtesy of Michael G. Strawser, Majolica Auctions.* $1375+

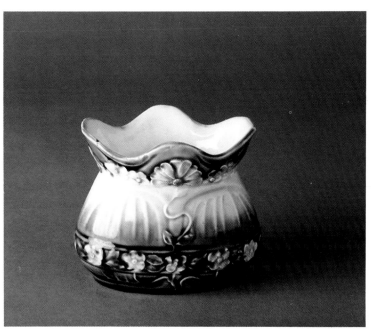

Planter, unattributed, Continental; with a floral motif. 4.5" dia. x 3.75" high. *Courtesy of Michael G. Strawser, Majolica Auctions.* $115-125

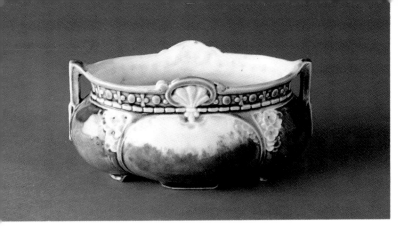

Planter, unattributed, Continental. 6" dia. x 3" high. *Courtesy of Michael G. Strawser, Majolica Auctions.* $185+

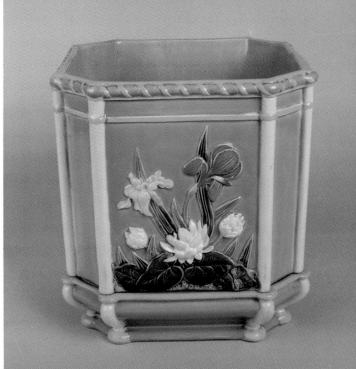

Jardiniere, George Jones; separate basket and drainer. Total 10" high. *Courtesy of Michael G. Strawser, Majolica Auctions.* $2400+

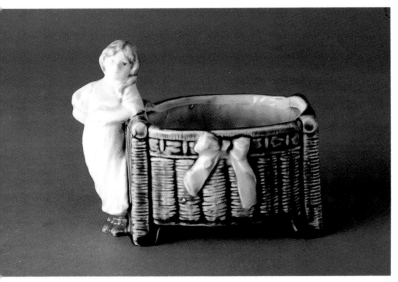

Planter, unattributed from Austria; figurine of girl with basket and bow. 5.5" x 4.5". *Courtesy of Michael G. Strawser, Majolica Auctions.* $185+

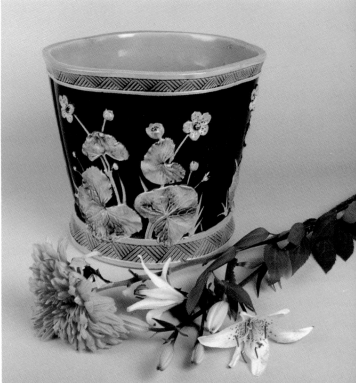

Jardiniere, George Jones; buttercup decoration with spider in base. 9" high. *Courtesy of Michael G. Strawser, Majolica Auctions.* $2400+

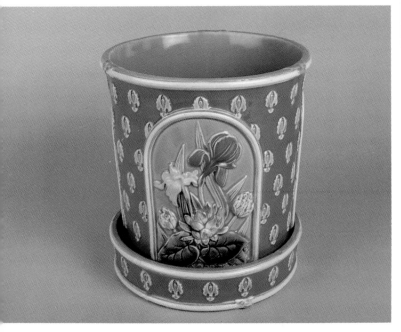

Jardiniere, George Jones; two-piece, iris pattern. 9" high. *Courtesy of Michael G. Strawser, Majolica Auctions.* $3940+

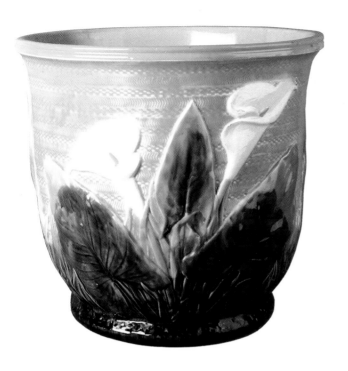

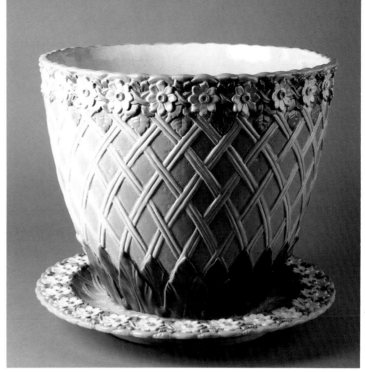

Cachepot, George Jones; Calla Lily pattern, c. 1873. 11" high x 12.5" dia. *Courtesy of Michael G. Strawser, Majolica Auctions.* $2850-3660

Cachepot with underplate, Minton; daisy and wicker pattern. This piece employs several of Léon Arnoux's distinctive shades of green. This cachepot dates from c. 1860. Total 15" high; pot alone 12" high x 14" dia. *Courtesy of Michael G. Strawser, Majolica Auctions.* 2875+

Garden seat, unattributed, English; in the Oriental style, with cobalt glaze. 19" high. *Courtesy of Michael G. Strawser, Majolica Auctions.* NP

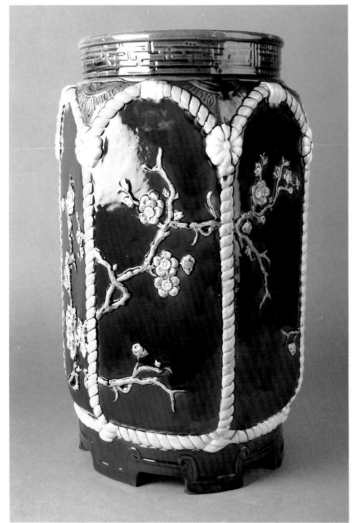

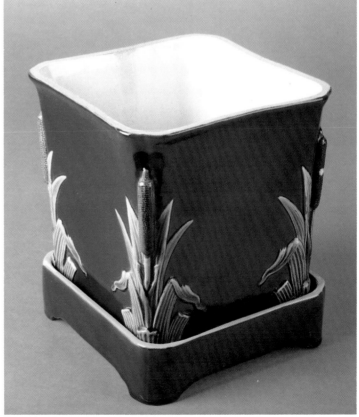

Planter with underdish, Minton; cobalt with cattail decoration. 6.5" sq. x 7.5" high. *Courtesy of Michael G. Strawser, Majolica Auctions.* $1200+

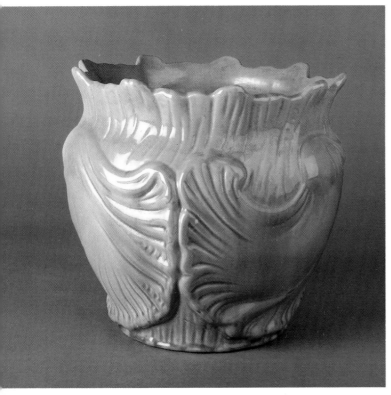

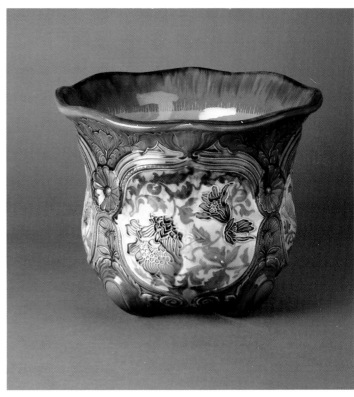

Jardiniere, Minton; Palissy-style seashells molded in relief. 9" dia. x 9" high. *Courtesy of Michael G. Strawser, Majolica Auctions.* $1000+

Large jardiniere, Minton. 13" dia. x 10" high. $2250+

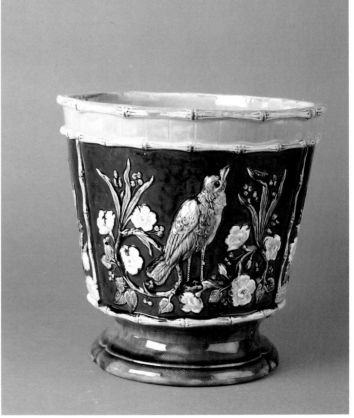

Underside of Minton jardiniere. The impressed name Palissy, referring to the style rather than the manufacturer, is present as well as a registration number. This design was registered in 1885. The BB impress stood for Best Body.

Jardiniere, unattributed; cobalt with turquoise interior. 10" x 10". *Courtesy of Michael G. Strawser, Majolica Auctions.* $750-825

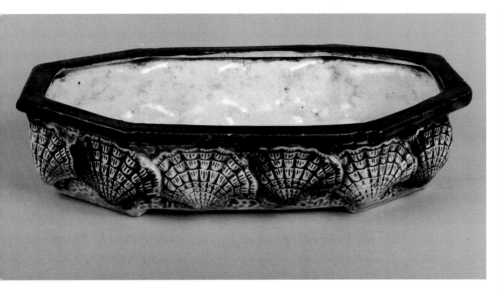

Planter, unattributed; cobalt with shell ornament. 11.25" x 7.5". *Courtesy of Michael G. Strawser, Majolica Auctions.* $150-165

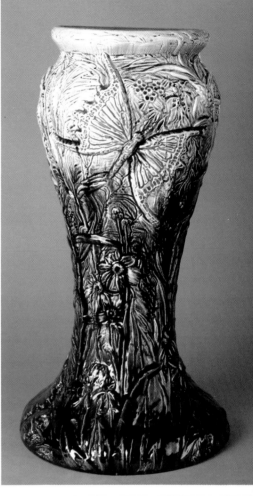

Jardiniere, unattributed; floral and butterfly decoration. 13.25" dia. x 18" high. *Courtesy of Michael G. Strawser, Majolica Auctions.* NP

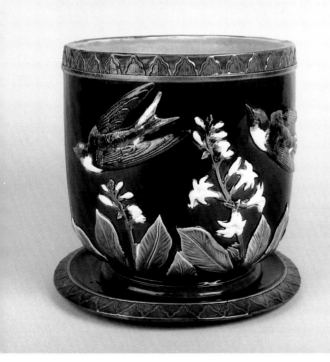

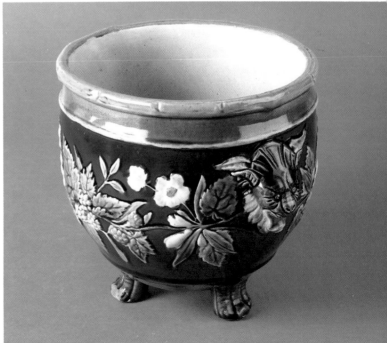

Jardiniere, Holdcroft; two-pieces with swallow and flowers. 8" dia. x 8.5" high. *Courtesy of Michael G. Strawser, Majolica Auctions.* $2225+

Jardiniere, marked "J.R.L.," possibly initials of an artist; cobalt and floral with griffin heads and feet. 8" high. *Courtesy of Michael G. Strawser, Majolica Auctions.* $695-765

STRAWBERRIES

The hothouse trend created a secondary craze for strawberries — home grown, with any luck. Tableware created specifically for serving the fruit was manufactured in many elegant styles, generally decorated with painted or molded strawberry plants. Typically, they included bowls for sugar and small creamers. Many pieces not made specifically as strawberry servers were also decorated with the motif.

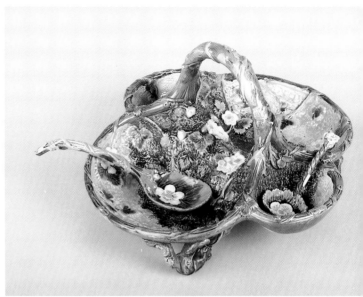

Strawberry server, George Jones; footed, with two spoons and decorated baskets, c. 1873. Server, 11.5" across; spoons, 7.5" and 4.5" long. *Courtesy of Michael G. Strawser, Majolica Auctions.* $4235-4655

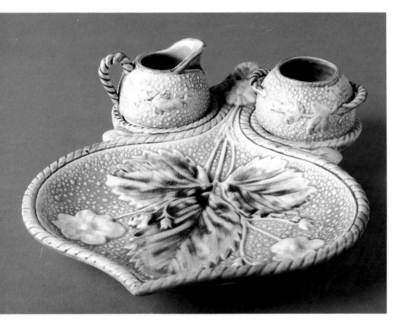

Strawberries were very popular hothouse produce grown in properly equipped Victorian homes during the 1870s and 1880s. The strawberry's popularity was reflected in the production of majolica strawberry servers. Strawberry server, Griffen, Smith and Co.; creamer and sugar bowl. 11" x 8". *Courtesy of Michael G. Strawser, Majolica Auctions.* $2250+

Strawberry platter, Wedgwood; with bows. 6.5" dia. *Courtesy of Michael G. Strawser, Majolica Auctions.* $150-165

Strawberry server, George Jones; napkin pattern, with creamer and sugar bowl. 15" x 9". *Courtesy of Michael G. Strawser, Majolica Auctions.* $2150-2500

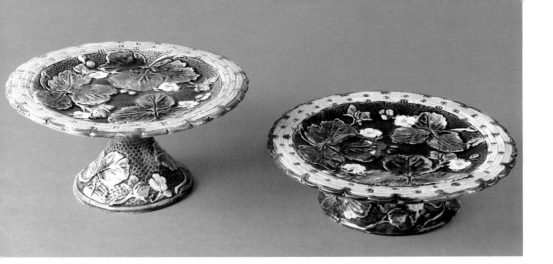

Two comports, unattributed, strawberry and basket motifs. Both 8.5" dia., 4" and 2" high. *Courtesy of Michael G. Strawser, Majolica Auctions.* Left: $525-575; right: $335-375

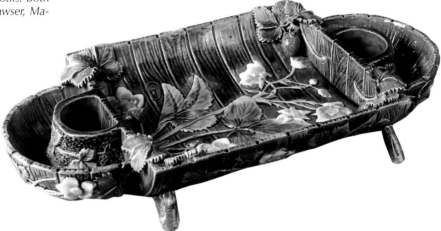

The popularity of hothouse strawberries withered after 1890 and the production of majolica strawberry servers ceased. Strawberry server (base only), George Jones; barrel motif. 15" long x 7.5" high. *Courtesy of Michael G. Strawser, Majolica Auctions.* $955-1065 complete

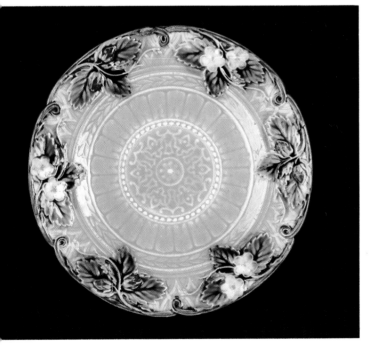

Plate, Sarreguemines with mark impressed on back; medallion center with strawberry border. 8". *Courtesy of Michael G. Strawser, Majolica Auctions.* $65-75

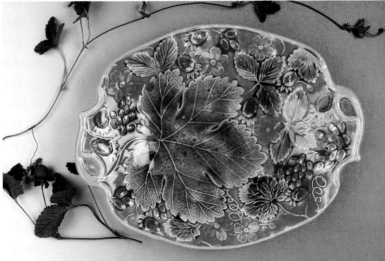

Strawberry platter, unattributed. 11" x 8.25". *Courtesy of Michael G. Strawser, Majolica Auctions.* $750+

Strawberry platter, unattributed; basketweave with bows. 13.5". *Courtesy of Michael G. Strawser, Majolica Auctions*. $500+

Plate, unattributed; black, white and gray blackberry pattern. 9.25" dia. *Courtesy of Michael G. Strawser, Majolica Auctions.* $65-75

Platter, unattributed; floral and lattice patterning. 9" x 11.25". *Courtesy of Michael G. Strawser, Majolica Auctions.* $315+

Majolica Production

Knowing how majolica was made increases our appreciation of the ware today. The body of majolica is most often a simple buff colored earthenware. The production of earthenware pottery was a time honored tradition among English potteries centuries before the introduction of majolica. In fact, the majolica body type had entered England in 1567, when Italian craftsmen arrived in the country, bringing maiolica potting techniques that had been in use in Spain and Italy since the 14th century. This majolica body type first played an influential role in England during the 17th century, long before its re-introduction in majolica.[4]

Earthenware ceramics are produced with soft, water absorbent bodies made impermeable by glazing, utilizing glazes consisting of lead sulfides with additives introduced to add color or opacity to an otherwise colorless and transparent substance. Wedgwood & Company used a fine pearlware for some of their majolica bodies, a natural development for the firm that in 1779 had developed the "Pearl White" ware while experimenting to create a whiter body than their earlier creamware. Copeland and Dudson used stoneware bodies, while some manufacturers used terra-cotta bodies which created a courser grade product.[5]

Majolica has a soft, water absorbent, buff colored earthenware body in most cases. Wheat plate, unattributed, marked "wsys 209"; unglazed. NP

The soft nature of the majolica body is attested to by the damage easily incurred in everyday use over time. In this George Jones jardiniere, one of the twig-form feet is snapped off; banana leaf pattern with twig-form feet. 7" high. *Courtesy of Michael G. Strawser, Majolica Auctions.* NP

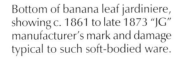

Bottom of banana leaf jardiniere, showing c. 1861 to late 1873 "JG" manufacturer's mark and damage typical to such soft-bodied ware.

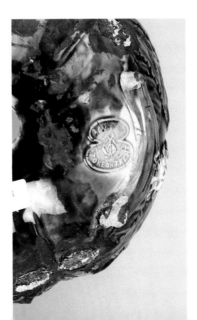

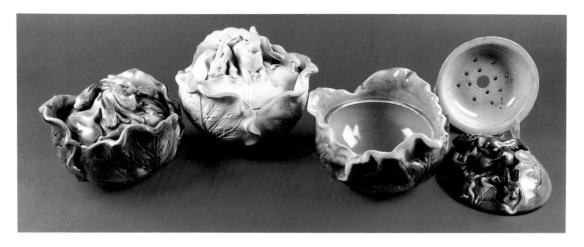

To make majolica's earthenware body impermeable to water, glazes were applied. Fine example of the fired but unglazed majolica body as it would have arrived at the painters table and examples of the end product after glazing. Well trained artisans applying glazes skillfully were essential to the creation of quality majolica. Three covered butter dishes, unattributed; rabbit in lettuce figural. Glazed, both 5" high; unglazed, 6" high. $900+ each (glazed)

The striking designs molded into the majolica earthenware bodies were integral to the success of the design. Most hollow forms in majolica were molded using a technique called slip casting, a technique still in use today. The saucers, plates and bowls were molded using a variation of the slip casting technique; these forms were cast as solids and pressed into shape.[6]

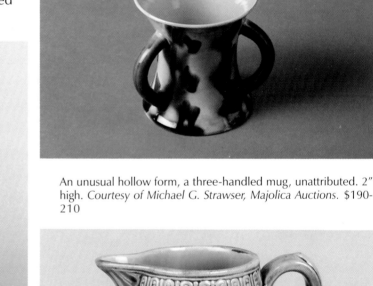

An unusual hollow form, a three-handled mug, unattributed. 2" high. *Courtesy of Michael G. Strawser, Majolica Auctions.* $190-210

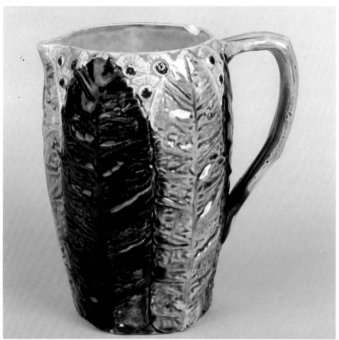

Most hollow forms in majolica were molded using a technique called slip casting. Pitcher, unattributed; banana leaf pattern. 7" high. *Courtesy of Michael G. Strawser, Majolica Auctions.* $375+

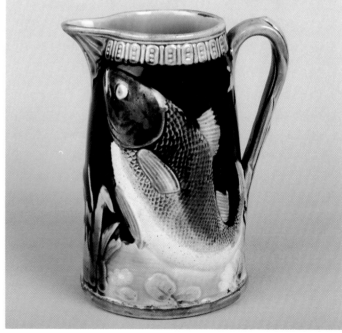

Pitcher, unattributed; cobalt with leaping fish. 7" high. *Courtesy of Michael G. Strawser, Majolica Auctions.* $225+

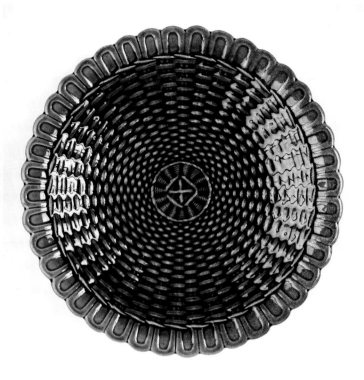

Saucers, plates and bowls were cast as solids and pressed into shape. Plate, unattributed; wicker background. 9.5" dia. *Courtesy of Michael G. Strawser, Majolica Auctions.* $90-100

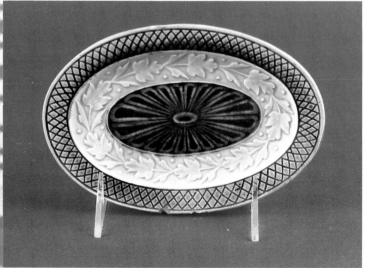

Oval dish, unattributed. 7.5" long x 4.75" wide. $50+

Humidor, unattributed; figurine of a black man perched on a conch shell. 10.5" high. *Courtesy of Michael G. Strawser, Majolica Auctions.* $545+

To mold a hollow form, a clay slip is poured into a hole in the top of a finished mold. The slip is allowed to stand and settle, then the excess clay is removed. The mold remains untouched until the clay stiffens and contracts, which enables the mold to be removed. Then the piece is assembled, sponged to remove visible seam lines left by the molding process, and the joins are smoothed over.[7]

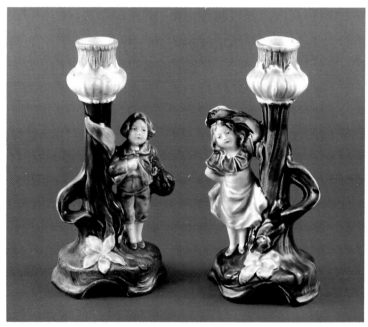

Candlesticks, unattributed; figural children. 6.75" high. $330-360

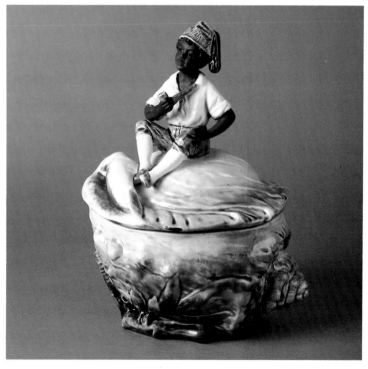

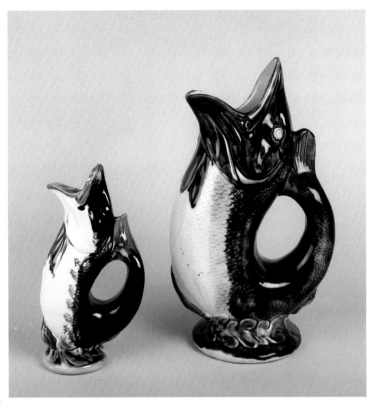

This molding process has a major drawback, however. With repeated use, molds wear out, the impressions become less crisp. Some manufacturers sold their worn molds to smaller potteries. While this practice was economical for the second user and enabled them to produce an established design, the quality of the pieces was greatly reduced. Therefore, known quality designs from better firms may appear in a poorly potted state.[8]

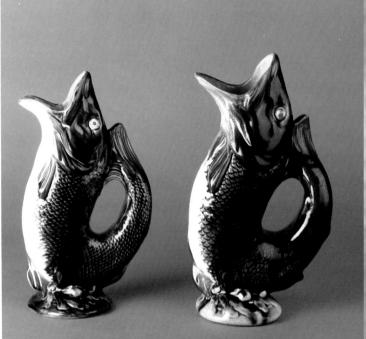

Molds wore out with repeated use, creating impressions that were less crisp than when they were new. Some manufacturers sold their worn molds to smaller firms. Differences in "crispness" are evident among these six fish pitchers. Gurgling fish pitchers such as these have been found impressed with the American potter George Morley's manufacturer's mark dating to c. 1880. Two pitchers, unattributed; figural fish. 11.5" and 10.5" high. *Courtesy of Michael G. Strawser, Majolica Auctions.* $375-425 each

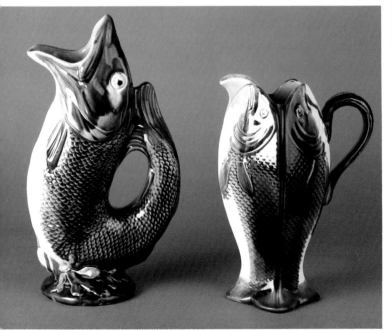

Two fish pitchers, unattributed. (Left/Right) Four-sided fish, 9.5"; (Right/Left) figural fish, 13". *Courtesy of Michael G. Strawser, Majolica Auctions.* $375-425 each

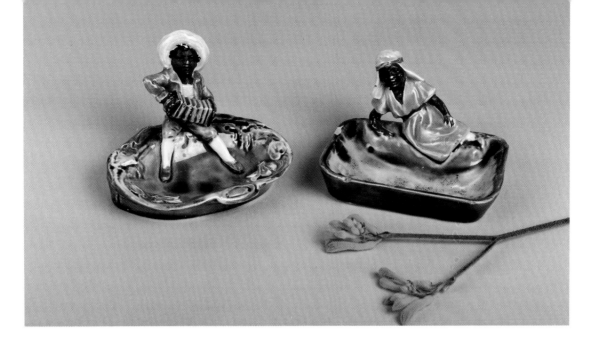

Figural dishes, unattributed; two black figurines. Figurines also provide a glimpse into the Victorian British, European and American views and stereotypes of other races and cultures. Occasionally the various majolica producing nations even poke fun at each other with a variety of satirical figurines. Both black figurines presented here measure 4.5". *Courtesy of Michael G. Strawser, Majolica Auctions.* $185-225

During the latter half of the nineteenth century, technological improvements in automation and firing techniques changed the role of the workers involved. Unhappy with the increasing automation and fearful of being displaced by the machines, workers formed labor unions by 1850 in England. Despite the advances of that technological age, the individual skills of the artisans and workers remained basic to the success of the ceramics. The importance of the modeler of ma-

jolica, for instance, was paramount. For hollow forms, modelers determined exactly how to divide the design into pieces to be molded and assembled. Jugs required a two piece mold, one each for the handle and body, teapots required three, for the body, the handle and the spout. Figures and wares with figures attached to them were even more complex with heads and limbs molded separately. The creation of the plaster of Paris mold itself required great skill.[9]

Jugs, pitchers and the like required a two piece mold, one for the handle and another for the body. Pitcher, unattributed; mottled with bird and branch design. 5.5" high. $310-340

Creamer, unattributed; narcissus and iris decoration. 4.25" high. *Courtesy of Michael G. Strawser, Majolica Auctions.* $310-340

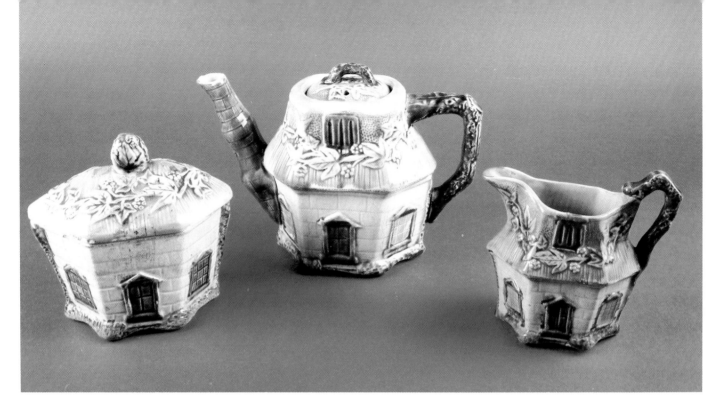

Tea set, unattributed; figural village scene. Similar in form to a set manufactured by Warrilow and Cope of Longton, England in c. 1882. Tea pot, 6" high; sugar bowl, 5.5" high; creamer, 4" high. NP

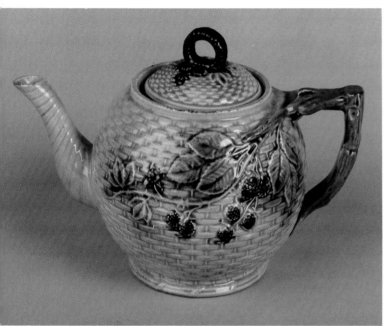

Teapots required a three piece mold for the body, the handle and the spout. Teapot, unattributed; blackberry and basket motif. 5.5" high. *Courtesy of Michael G. Strawser, Majolica Auctions.* $315+

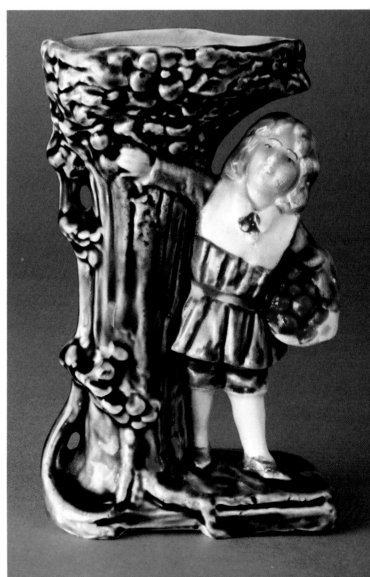

Figures and wares with figures attached to them were even more complex with heads and limbs molded separately. Figural vase, unattributed, Continental. 5.75" high. *Courtesy of Michael G. Strawser, Majolica Auctions.* $135-165

Some majolica designs were taken from earlier successful lines in different ware types. This expediency created two classes of majolica: 1) wares designed for general production and decorated in the majolica technique and 2) wares created specifically for majolica. Wedgwood reintroduced eighteenth century designs glazed in majolica colors to help keep up with the rising demands for the popular ware. Some of the smaller Staffordshire potters regularly used traditional Staffordshire designs from earlier in the century in their majolica production. This saved time and effort, requiring no new artistry prior to production. However, the most successful majolica wares were those designed and produced strictly as majolica.[10]

The brilliant colors of majolica are what first draws attention to the ware today and first drew the Victorian eye as well. Metallic oxides added to clear lead sulfides create the effect. Copper produces green, manganese a brownish-purple, cobalt generates a deep blue, and so on. As time passed and technology improved yellows, pinks and turquoise were added to the majolica palette. In most cases, the bright, colored glazes rested on an opaque white glaze, covering the natural color of the clay. The colored glazes tended to be thick, an attribute most notable on the undersides of wares where glaze tended to pool. The soft blend of majolica colors was the result of a higher than usual firing temperature.[11]

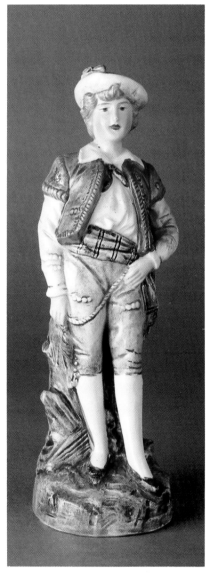

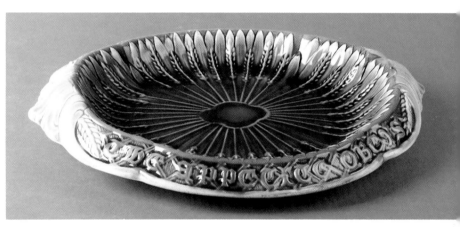

Metal oxides added to clear lead sulfides created the brilliantly colored glazes which first drew attention to majolica. Copper produced green. Bread tray, unattributed; wheat pattern with words of wisdom to reflect on during a meal: "Where reason rules, appetite obeys." 13" x 10.25". *Courtesy of Michael G. Strawser, Majolica Auctions.* $660-725

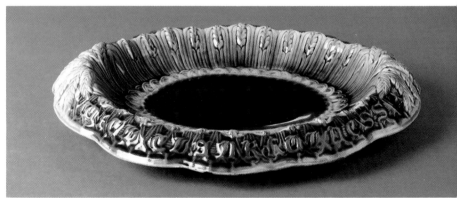

Some majolica designs were taken from earlier successful lines in different ware types. Figurine, unattributed; man at tree stump. 9.5" high. *Courtesy of Michael G. Strawser, Majolica Auctions.* $225-255

Cobalt produced the deep blue in the center of this bread tray, unattributed; "Eat Thy Bread With Thankfulness." 14" x 11". *Courtesy of Michael G. Strawser, Majolica Auctions.* $660-725

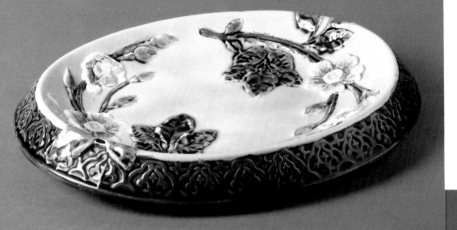

As time passed and technology improved, yellows, pinks and turquoise were added to the majolica palette. Bread tray, unattributed; 14" x 11". *Courtesy of Michael G. Strawser, Majolica Auctions.* $660-725

Proper glaze colors were essential for a successful majolica design. While a beautifully glazed piece is a delight, a poorly glazed one is wretched. Many manufacturers who were not lucky enough to hire skilled artisans with proper training turned to professional specialists to provide the proper colors and glazes. The most prominent majolica glaze manufacturer in England was A. Wenger; other firms included S. Fielding and Company, Harrison & Son of Hanley, and James Hancock & Son of Worcester. So important was the proper glaze coloration that, as late as the 1880s, American manufacturers were still importing all their colors, mostly from England and Germany.[12]

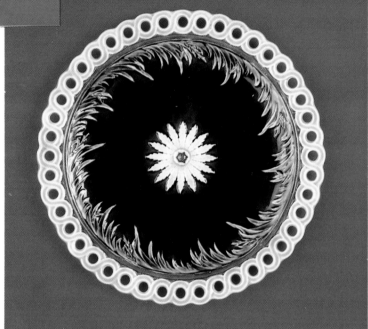

The increasing range of colors and technical expertise produced stunning results such as this Wedgwood plate; cobalt with fir needle circle and a pierced border. *Courtesy of Michael G. Strawser, Majolica Auctions.* $925

Proper glaze colors and skillful artisans applying them were absolutely necessary to create beautiful majolica; skillful work creates delightful majolica, poorly glazed examples can be wretched. Pitchers, unattributed; fence and fern motif. Both 6" high. *Courtesy of Michael G. Strawser, Majolica Auctions.* $200+ each

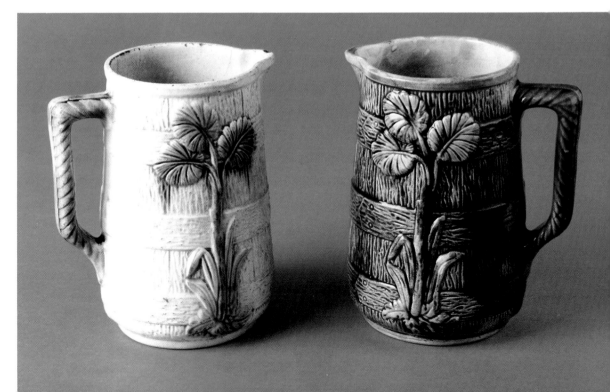

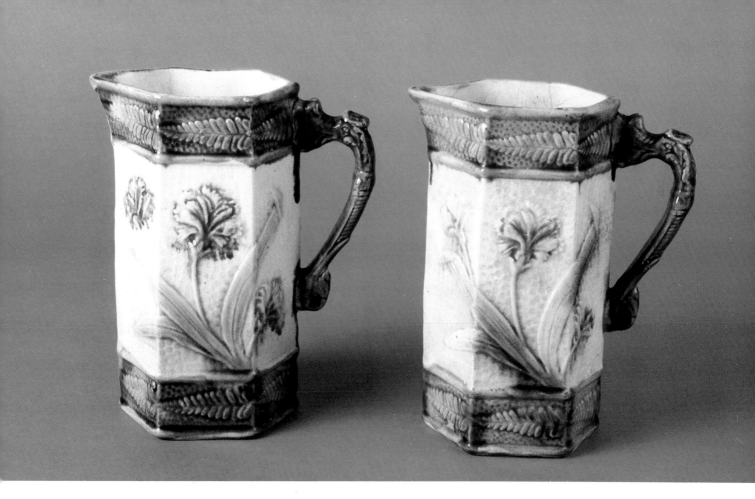

Two pitchers unattributed; these show typical differences in their glazing. *Courtesy of Michael G. Strawser, Majolica Auctions.* $200+ each

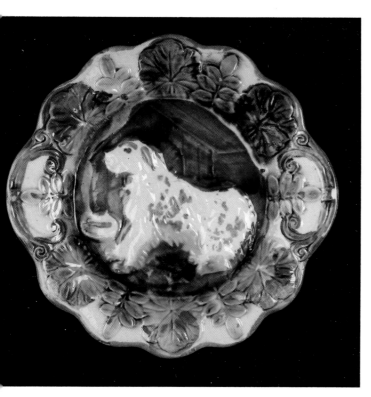

Platter with handles, unattributed; dog and doghouse vignette. 10.5" dia. *Courtesy of Michael G. Strawser, Majolica Auctions.* $375-410

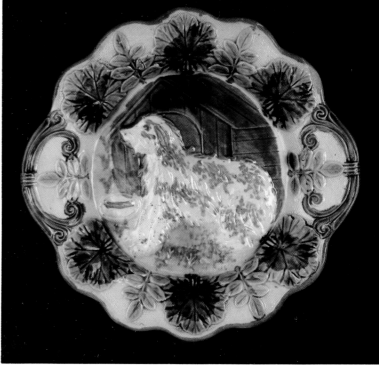

Platter with handles, unattributed; dog and doghouse design. 11" x 10". *Courtesy of Michael G. Strawser, Majolica Auctions.* $375-410

Often three raised marks are noticeable in the glaze on the underside of majolica wares. These marks are left by the three-legged stands used to stack wares in the kiln during firing and are not imperfections in the piece or some sort of damage. Crazing in the glaze is common in majolica wares found today. The soft-bodied wares were initially fired at low temperatures which did not remove all the moisture from the resultant bisque. Over time, water dries from within the body, causing it to shrink ever so slightly. The surface glaze, with its glass-like properties, can not follow suit and so tiny cracks appear. If a crazed piece is used extensively, these cracks become discolored as the spaces between the cracks fill.[13]

Frequently three raised marks are found in the glaze on the underside of majolica wares. These marks are left by the three-legged stands used to stack wares in the kiln during firing as shown here. Mug, marked "Faiance, GIEN, Medailles D'Or Diplumes D'Monneor" on bottom; basketweave texture. 3.25" high.

Note the badly crazed glazed of these pieces. It is particularly evident within the pitcher and is the result of shrinkage within the earthenware body long after firing, shrinkage which the glaze cannot duplicate, cracking as a result. Gravy boat pitcher and tray, Wannopee, marked "Trade Mark 'Lettuce Leaf'" on bottom of platter. Pitcher 3.5" high; platter, 9" long. NP

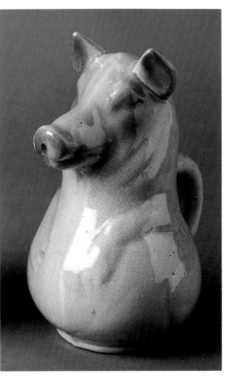

Pitcher, Sarreguemines; figural pig. Crazing is readily apparent on this piece as well. $425-470

Majolica Style

The forms of majolica pieces reflected the artistic styles in vogue during any given period of its manufacture which were frequently hybrids of many traditional styles. The earliest patterns, beginning with Minton's work, were inspired by the Renaissance, maiolica and the work of the French potter Bernard Palissy and his contemporaries. Artists working for Minton had access to collections of old maiolica and Palissy wares and examples of Henri II ware provided by the Duke of Sutherland, a Minton patron. While critics accused Minton and his artisans of relying too heavily on historical revivalism in their early work, Minton was also well aware of the publics fascination with and avarice for the original wares. Designs based on these wares were sure to sell well.[14]

Cherubs and figures inspired by the French also appeared. Many such designs would find homes in conservatories or gardens, others on tables in the form of candelabras. From time to time individual figures reappeared in groups when demand dictated that molds be reused.

Tudor forms with a Mannerist decorative ornament, of rich jewel-like decoration, were also popular. As time passed, classical mythology added designs to the majolica repertoire in England, America and on the Continent.[15]

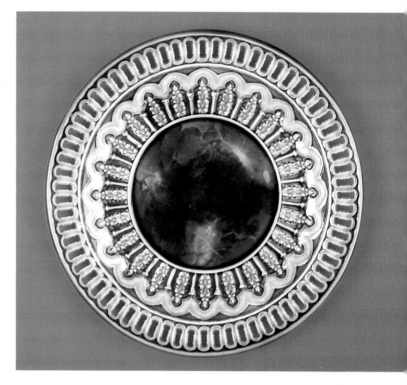

Tudor forms with a Mannerist decorative ornament, or rich jewel-like decoration, were also popular. Plate, Wedgwood, 1864; marked and date coded on back, geometric design with open border. 8.5″. *Courtesy of Michael G. Strawser, Majolica Auctions.* NP

Impressed WEDGWOOD manufacturer's mark on reverse of geometric Wedgwood plate and three-letter code system first used by the firm in 1860 is present with the letters "CMS." The third letter, S, denotes the year of potting, in this case 1864.

Cherubs and figures inspired by the French appeared in majolica designs. Sweetmeat dish, Holdcroft; Putti figurine. 17″ long x 9″ high. *Courtesy of Michael G. Strawser, Majolica Auctions.* $1000+

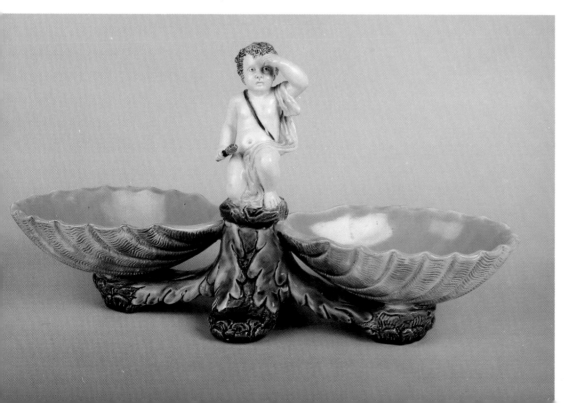

Most pervasive, though, and most often associated with majolica wherever it was made, were the designs based on nature. Eighteenth century vegetable forms were resurrected. Plants and animal forms abounded. Great attention was paid to details from the texture of the bark on the trees to insects, eggs and animals. The regular flowing forms of vines were both popular and appropriate climbing majolica drinking cups or jugs. Much of this fascination with nature evolved from the discoveries in many avenues of natural history. Animals were usually given natural portrayals; however, at times they had a comical bent such as the monkey teapot which takes a satirical stab at the theories of Josiah Wedgwood's grandson Charles Darwin over the issue of natural selection presented in his book *The Origins of the Species* in 1859. While Darwin put the monkey in the man - relating man and beast, majolica manufacturers put the monkey back in what many perceived to be its proper servile, and entirely unrelated, place.[16]

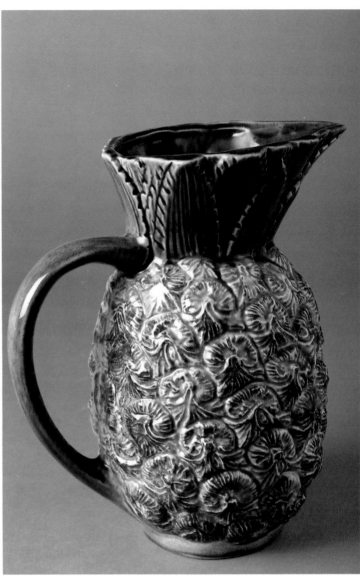

The details on this pineapple are stunning. Pitcher, unattributed; pineapple form. While unmarked, this is very reminiscent of Mintons' pineapple pitchers dating to 1881. 8.5" high. *Courtesy of Michael G. Strawser, Majolica Auctions.* $250-275

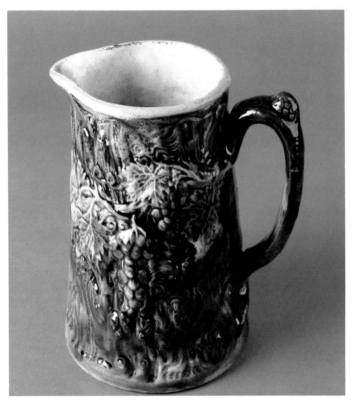

Most pervasive were the designs based on nature. Close attention was paid to details such as the texture of tree bark as seen here. Pitcher, unattributed; bark, grapes and grape leaves. 8.5" high. *Courtesy of Michael G. Strawser, Majolica Auctions.* $150-165

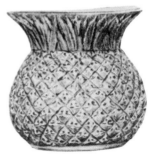

A piece of pineapple ware from Griffen, Smith & Co.'s 1884 catalog—the American version of this popular motif.

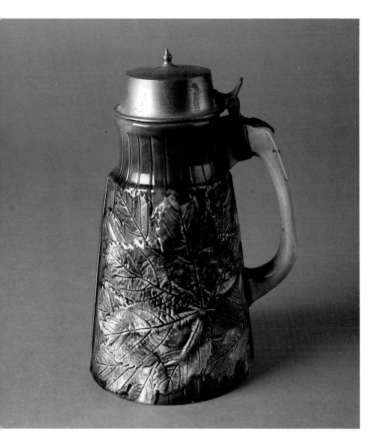

The detailed maple leaf is appropriate for this syrup dispenser, unattributed; maple leaf pattern with pewter lid. 7.5" high. *Courtesy of Michael G. Strawser, Majolica Auctions.* $315-345

Much of the fascination with nature evolved from the discoveries in many fields of natural history. Grape leaves and basket weave plate, unattributed; 7.25" high. *Courtesy of Michael G. Strawser, Majolica Auctions.* $100-110

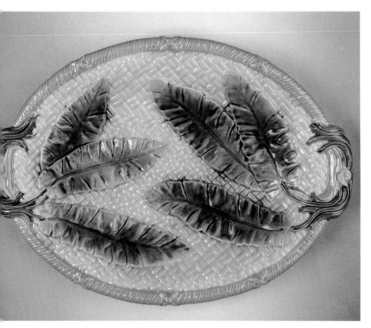

Banana leaf design platter with wicker background, unattributed. 14" x 10". *Courtesy of Michael G. Strawser, Majolica Auctions.* $450-495

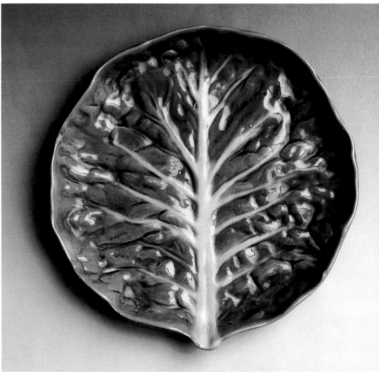

Very natural lettuce leaf plate, Portuguese; 7.5" dia. *Courtesy of Michael G. Strawser, Majolica Auctions.* $115-125

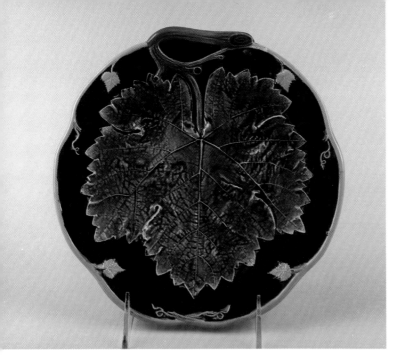

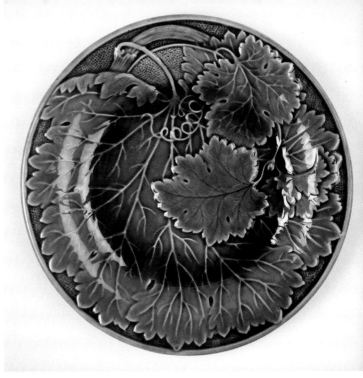

Grape leaf pattern plate; unattributed. 8.25″ dia. $150+

Green overlapping leaf plate, Portuguese; 9″ dia. *Courtesy of Michael G. Strawser, Majolica Auctions.* $100-110

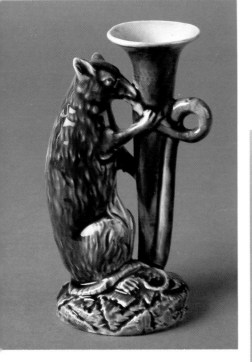

At times animals were given a comical bent as with this musical rat. Vase, unattributed; figural rat with horn, mottled glaze. 5.75″ high. *Courtesy of Michael G. Strawser, Majolica Auctions.* $625+

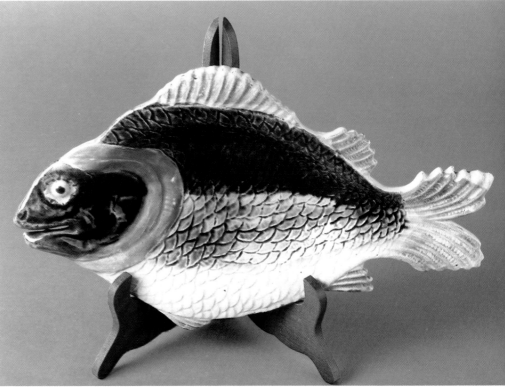

Animals were usually given natural portrayals. Platter, unattributed; deep dish fish form. 14″ x 9″. *Courtesy of Michael G. Strawser, Majolica Auctions.* $375+

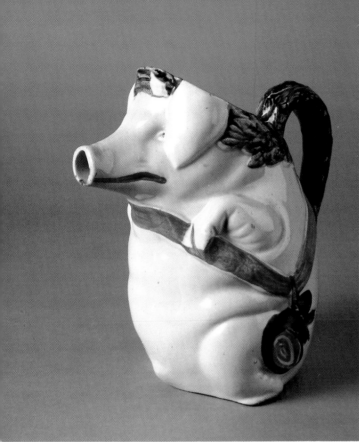

Some majolica was used as satire. This European made pig crowned with a hero's laurel and a ham-adorned sash was possibly poking fun at the poor or at Americans, both of whom ate large quantities of pork. The middle and upper classes in England avoided bacon because of its association with the lower class. Surely ladies and gentlemen in England would have found this pig amusing in this light. Pitcher, unattributed, figural pig. 8.25" high. *Courtesy of Michael G. Strawser, Majolica Auctions.* $425-470

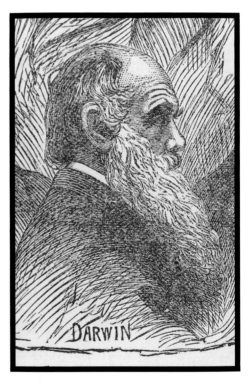

Charles Darwin, Josiah Wedgwood's most disconcerting grandson. His treatise *The Origins of the Species* was published in 1859, unsettling or offending many of those who read or heard about it.

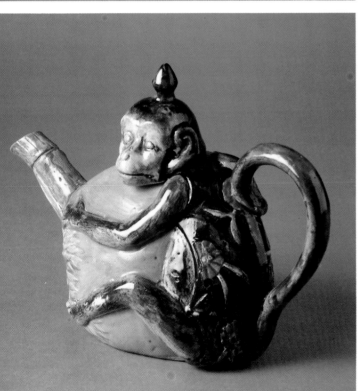

After Charles Darwin created a commotion over the issue of natural selection in his work *The Origins of the Species* in 1859, a number of potters took a satirical stab at Darwin's theory with a number of comical potted monkeys. Darwin put the monkey in the man - majolica manufacturers removed it. Teapot, Minton design from 1865; figural monkey. 6.5" high. *Courtesy of Michael G. Strawser, Majolica Auctions.* $4200-4600

Interest in exotic Japanese art forms developed following the 1862 International Exhibition in London in which Japanese ceramic wares were featured. Books on Japanese bird and flower prints were bought and studied, netsukes and other oriental ivories were examined, Japanese metalwork was investigated, and before long exotic, glamorous forms of oriental style in majolica graced Victorian table settings.[17]

Majolica's artisans created forms with an utter disregard for the purist's approach, crafting decorations in tune with its times and tastes and yet with an incredible and contradictory attention to detail in their naturalistic forms. Many pieces combine several different styles to create a design which appeared opulent to the middle class Victorian eye.[18]

Interest in exotic Japanese art forms developed following the 1862 International Exhibition in London which featured Japanese wares. Platter, Wedgwood; Oriental pattern with butterfly and dragonfly. 12" x 9". *Courtesy of Michael G. Strawser, Majolica Auctions.* $725-800

Chapter 2
History & Culture

The British Empire

By the middle of the nineteenth century, the British Empire was prospering, reaping the benefits of its world-wide colonization and manufacturing empires of the Industrial Revolution during the reign of Queen Victoria (1837-1901). In the realms of politics, commerce, finance and transportation, England had become a dominant force. Railroad expansion supported domestic interests in agriculture and commerce from within. The British Reform Movement was rebuilding the nation's infrastructure, revamping the political system and improving working conditions in England with new child labor laws. Import tariffs, its various colonies, and the British Navy looked after Britain's interests abroad. Dual boasts proclaimed that the sun never set in the British Empire and that wherever a British citizen was in trouble, the Navy would be there![1]

By the mid-nineteenth century, the British Empire was prospering under the reign of Queen Victoria. A Victorian portrait vase, unattributed, 6.5" high. *Courtesy of Michael G. Strawser, Majolica Auctions.* $150-165

British folk at home were fascinated by the exotic characters their explorers discovered.

CASEMBE DRESSED TO RECEIVE LIVINGSTONE.

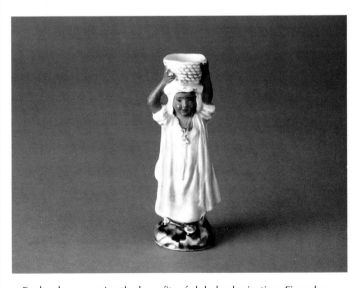

England was reaping the benefits of global colonization. Figural vase, unattributed; African woman with basket. 3.75" high. $95-105

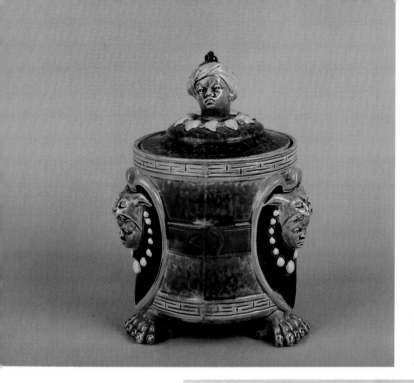

Britain's fascination for other cultures, as for other aspects of the natural world, is also apparent in majolica. Humidor, Holdcroft; dog-head headdresses, six-fingered hands, and the heads of some unfortunate natives—possibly Middle Eastern or North African. 7" high. *Courtesy of Michael G. Strawser, Majolica Auctions.* NP

British colonists prided themselves on maintaining the dignified facade of London life—in society, manners, dress and schedule—even in the most sweltering climates and with the most "savage" companions.

OUGANGA DOCTOR DISCOVERING A WITCH.

The Staffordshire potters felt amply secure. Their quest in the second half of the eighteenth century for an earthenware with a thinner, harder and whiter body to compete with Chinese export porcelain led Josiah Wedgwood to the perfection of creamware in 1762 and pearlware in 1779. These wares ensured England's domination of the ceramic marketplace as well, a position that was still secure a century later.[2]

In contrast, the European continent was in turmoil. A workers' revolution rocked France from 1848 to 1850. Louis Napoleon Bonaparte was elected President of the Assembly in December. Later, in 1851, Louis declared himself Emperor Napoleon III. During this brutal class war, in which 10,000 workers were killed. Industries catering to the wealthy died with them. French artisans fled to secure and powerful England, where their talents were readily accepted and put to good use. With this turn of events, majolica was born.[3]

Herbert Minton was the inheritor of his father's Minton Porcelain Manufacturing Company and its reputation for high quality wares. Herbert hired François Léon Arnoux, one of the French émigrés. Arnoux became Minton's art director and chief chemist when he arrived on English shores in 1848, an artisan with a long family tradition in pottery himself.[4]

Minton created majolica with Arnoux's new glaze colors and kilns. Aware of the gathering interest in Renaissance antiquities from the Continent, Arnoux created tasteful reproductions using his new techniques and vibrant colored glazes. Minton named the new wares majolica, harkening back to the romantic popular Italian Renaissance maiolica. This presented the middle class with an opportunity to own objects resembling the desirable but all-too-expensive priced Renaissance antiques. Once the attention of the general public was captured, Minton and Arnoux quickly parted company with historical accuracy to create wares in tune with popular taste of the day.

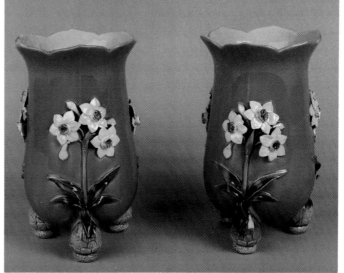

Some majolica was more in tune with the popular tastes of the day. Pair of footed vases, Minton, c. 1851; narcissus design. 7" high. Exactly twenty-five years later, Wedgwood's catalog featured a very similar item, with a more tapered neck and longer leaves. *Courtesy of Michael G. Strawser, Majolica Auctions.* $1125+ each

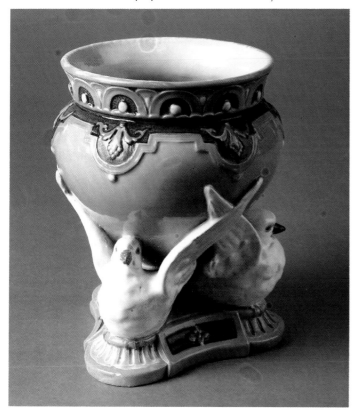

Urn, Minton; decorated with doves. 6" high. The coloration is typical of the glazes developed by Arnoux for Minton's Anglo-French style majolica. *Courtesy of Michael G. Strawser, Majolica Auctions.* $985+

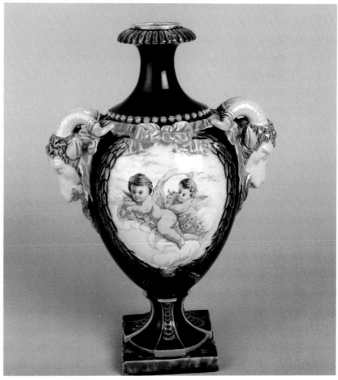

Early majolica forms particularly offered the middle class the opportunity to own objects resembling the desirable but all-too-expensive priced Renaissance antiques. Vase, George Jones; cobalt with cupids and rams' heads. 13.5" high. *Courtesy of Michael G. Strawser, Majolica Auctions.* $1175+

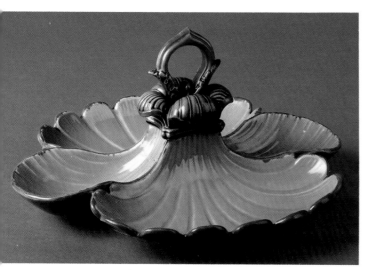

Four-part condiment dish, Minton. 11" x 9.5". An ornate historical form brightened by Arnoux's new glaze colors. *Courtesy of Michael G. Strawser, Majolica Auctions.* $425-470

Infused with the confidence of English prosperity and power, Prince Albert and Henry Cole, a colleague from the Royal Society of Arts, had launched plans in 1849 for an international exhibition in England for 1851. They sought a chance to compare English skill and craftsmanship to that of the rest of the "civilized" world.[5]

The importance of the various international exhibitions to the development of the British ceramic industry during the second half of the nineteenth century is difficult to overstate. Vast arrays of goods from manufacturers around the globe were on display. Firms participated in dozens of exhibitions by 1885 and some maintained special touring stocks of impressive majolica wares specifically for world-wide display. Styles and techniques were introduced and disseminated quickly through these events. Perceptive manufacturers could quickly pick up on promising developments by examining others' displays.[6]

The exhibitions were also competitions, driving manufacturers to invest in research and development, and employing the best designers, modelers and decorators to produce newly designed wares of high quality. Critical acclaim awaited the best manufacturers. Equally important, consumers by the thousands attended the exhibitions. If you had a new ware to sell, you could not ask for a better opportunity for introducing it. Minton took advantage of the opportunity, and majolica sales took off. A period of intense majolica innovation and production lasting from c. 1851 to 1890 had begun.

Wall plaques, unattributed from Continent; man and woman in rowboat scenes, with stylized floral borders. 8" x 6.75". While many Continental makers designed ware in imitation of British majolica, others presented distinctly *un*-English design styles. *Courtesy of Michael G. Strawser, Majolica Auctions.* $425-470 each

Minton's competitors were soon producing their own majolica wares. Large scale production began in England and then expanded outward into continental Europe and America as majolica caught on over time. With the introduction of majolica through the Staffordshire potteries, ceramic design swerved away from the traditional towards the whimsical and into a colorful era of innovation. By the 1870s, the English Staffordshire potters were established and recognized as the primary manufacturers of decorative earthenwares for the Western world. However, interest in their home market for majolica was waning, and British firms turned to the American export market for further sales. Meanwhile, during the third quarter of the nineteenth century both American and continental European manufacturers vied for their places in the majolica market.[7]

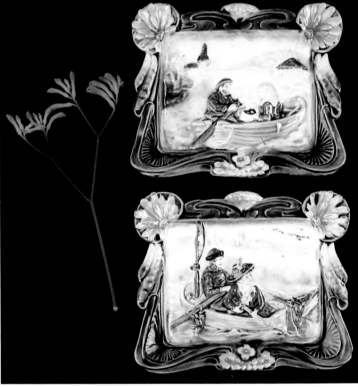

Large scale production began in England and expanded outward into continental Europe and America as majolica caught on over time. Platter, unattributed from Continent; holly and berry pattern with a cut-out rim. 14" x 9". *Courtesy of Michael G. Strawser, Majolica Auctions.* $400-440

Plate, unattributed from Continent; a bas relief castle with a stylized floral border. 6.25" dia. *Courtesy of Michael G. Strawser, Majolica Auctions.* $135+

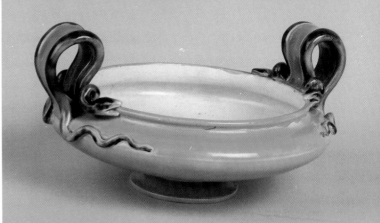

Bowl, Minton; snake handles with sleek color and design. 7.5" x 9". Another example of the potters' whimsical departure from historical design precedent. *Courtesy of Michael G. Strawser, Majolica Auctions.* $500-550

Large dish, unattributed; with blackberry decoration. 18" dia. Wonderful modern designs like these made their appearance when the Staffordshire majolica makers stopped relying on their archives for design inspiration. *Courtesy of Michael G. Strawser, Majolica Auctions.* NP

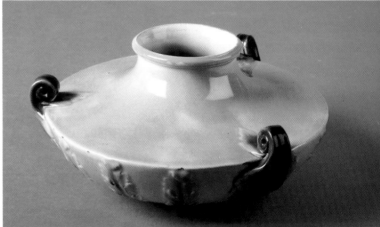

Vase, Minton; Grecian-style, low. This classically-formed piece shares the snake bowl's graceful design. *Courtesy of Michael G. Strawser, Majolica Auctions.* $300-330

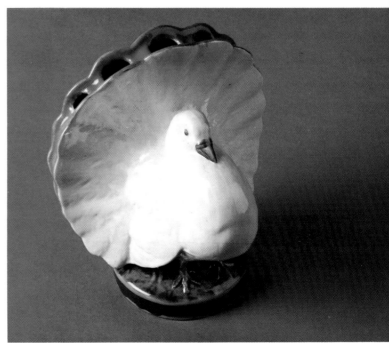

Vase, Minton; five-stemmed, dove motif. 6.5" high. *Courtesy of Michael G. Strawser, Majolica Auctions.* $1200+

America Discovers Majolica

By the nineteenth century, the American agrarian society, with husbands, wives, and children all working on their land together, was being replaced with industrial wage labor. A new social structure was created with two separate spheres: the world of work outside the home where the man of the house earned the bulk of the family income, and the domestic world within the home where the woman maintained the household and raised the children. This altered work world drew people to the cities as never before, further altering the fabric of society.[8]

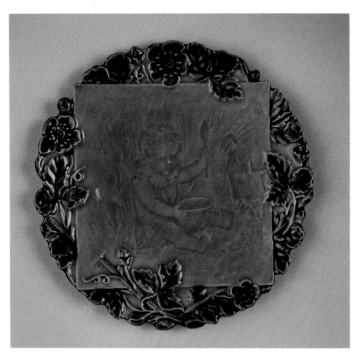

Plate, unattributed. 6.5" dia. A glimpse of rural family life—children too small to contribute to their families livelihood nonetheless spent the day in the fields, under their mothers' watchful eyes. This agrarian lifestyle was being replaced in nineteenth century America with industrial wage labor. *Courtesy of Michael G. Strawser, Majolica Auctions.* $135-150

By the 1860s, America's relatively recent rise of the urban middle class had been identified by *The New York Times* as including "professional men, clergymen, artists, college professors, shopkeepers, and upper mechanics." This gave the men and women of the emergent middle class a broad and varied cultural background. It was this newly empowered social group, with a rapidly changing daily lifestyle, that would soon provide a voracious market for foreign and domestic majolica wares.[9]

The middle class lifestyle was drastically affected by these technological changes. Refrigerated railroad cars, developed in the 1860s, made a wider variety of perishable goods available to a larger market at greater distances. Improved iceboxes in the home enabled housewives to refrigerate their perishable foods within the home. All these changes made daily life more lavish and more complex.[10]

Women also were finding increasing opportunities for paid employment. Decorating majolica wares was only one of the new avenues presented. More of the family's income was spent in consumer items, including majolica. Significant as well, more of what was being purchased reflected women's interests and taste.

By 1873 the economies of England and America were mired in depression. Luxury and status items including majolica could be done without, and English home sales diminished. Rising out of depression in 1878, America entered an era of affluence driven by developments of the Industrial Revolution. With money in their pockets, Americans developed a taste for luxuries. English producers turned again to America to sell their majolica; Britain had dominated the American home market from the colonial period on, and the American public firmly believed that English wares were better than their own.[11]

American potteries entered the majolica market in an attempt to change this perception about their qualities and tear part of their home market away from their dominant British counterparts. Thus, while Continental and Scandinavian firms tended to make inexpensive majolica wares for the export market and for tourists, American manufacturers had a different goal in mind.[12]

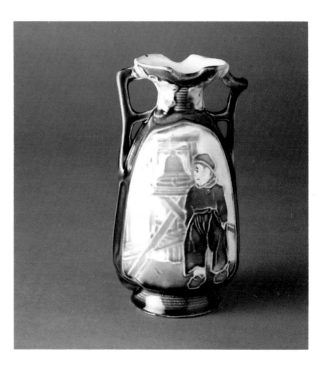

Vase, unattributed, Continental. 5.75" high. Many Continental firms focused on manufacturing inexpensive wares for export. *Courtesy of Michael G. Strawser, Majolica Auctions.* $100-110

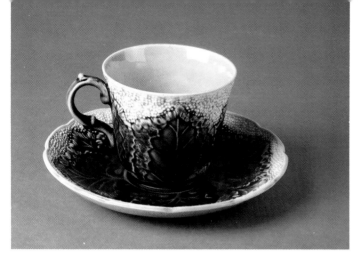

Tea cup and saucer, Wedgwood, cauliflower pattern. Cup, 3.5" dia.; saucer, 6" dia. Wedgwood first used the cauliflower pattern in its mid-1700s creamware. The green glaze invented by Josiah Wedgwood I for this line later turned out to be perfect for majolica. American consumers, well into the nineteenth century, considered English ceramics to be far superior to their native wares. *Courtesy of Michael G. Strawser, Majolica Auctions.* $315-345

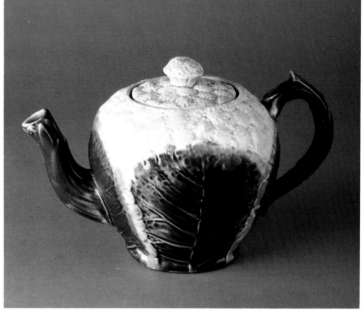

Cauliflower teapot, Griffen, Smith & Co. bearing "Etruscan" trade name; as portrayed in the 1884 catalog. 9" dia. x 6.5" high. *Courtesy of Michael G. Strawser, Majolica Auctions.* $1230-1350

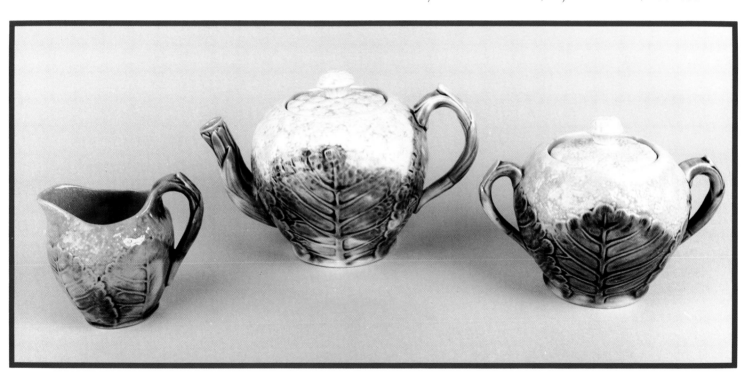

Tea set, Griffen, Smith & Co. bearing "Etruscan" trade name, in the cauliflower motif. Teapot, 6" high; sugar bowl, 5" high; creamer, 4" high. American potters efforts to compete with the English often led them to mimic the best designs from across the sea, like the well-established Wedgwood cauliflower line. *Courtesy of Michael G. Strawser, Majolica Auctions.* Teapot: $1230-1350; sugar: $565+; creamer: $430-470

From Griffen, Smith & Co.'s 1884 catalog, examples of their well-received cauliflower line. The New York City Pottery was the first American company to initiate the popular pattern, but Griffen, Smith & Co. produced it in great variety and volume.

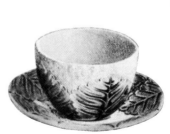

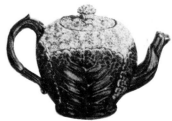

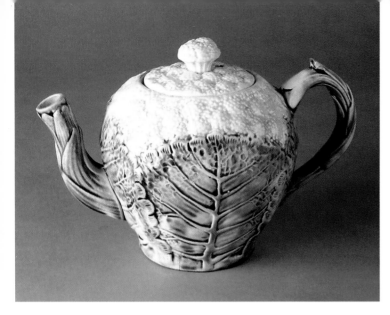

Another cauliflower motif teapot with a different glaze treatment. Griffen, Smith & Co.; 5" x 9". *Courtesy of Michael G. Strawser, Majolica Auctions.* $1230-1350

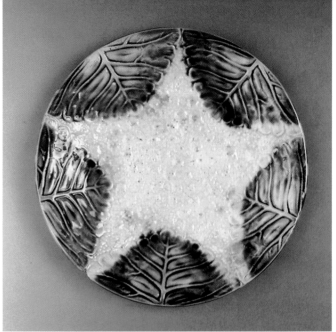

Plate, Griffen, Smith & Co., Etruscan; cauliflower pattern. 9" dia. *Courtesy of Michael G. Strawser, Majolica Auctions.* $375-425

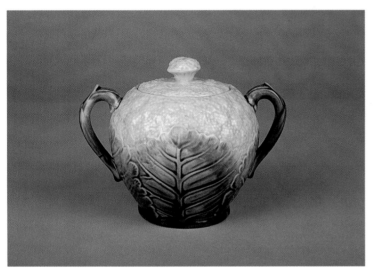

Cauliflower sugar bowl, Griffen, Smith & Co. 5" h. *Courtesy of Michael G. Strawser, Majolica Auctions.* $565+

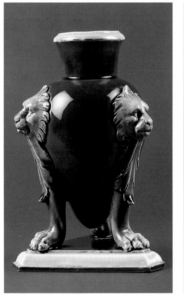

Vase, Griffen, Smith & Co., c. 1884; amphora-shaped, with three lions. 6.75" high. NP

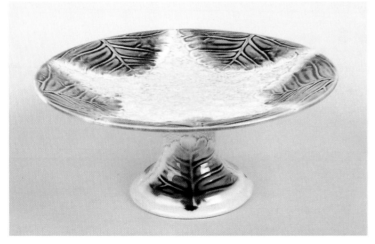

Rare cake stand, Griffen, Smith & Co.; cauliflower pattern. 9" dia. x 4" high. *Courtesy of Michael G. Strawser, Majolica Auctions.* $600+

From Griffen, Smith & Co.'s 1884 catalog, the same item, painted in a less restrained fashion!

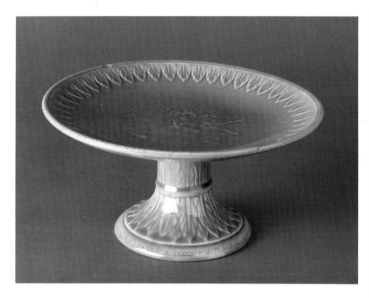

Compote or tazza (ornamental cup with a large flat or shallow bowl on a stem base or low foot, with or without handles), Griffen, Smith & Co.; "Classic" motif in the usual sepia glaze color. 8.25" dia. x 4" high. *Courtesy of Michael G. Strawser, Majolica Auctions.* $355-395

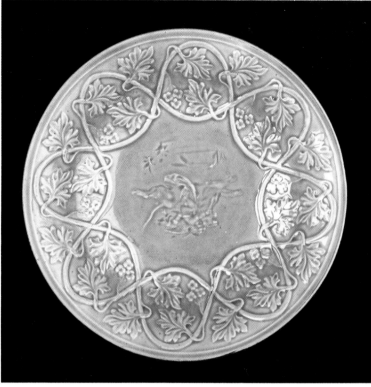

Plate, Griffen, Smith & Co.; "Classic" illustrated center with intertwined foliage border. 10" dia. *Courtesy of Michael G. Strawser, Majolica Auctions.* $295-325

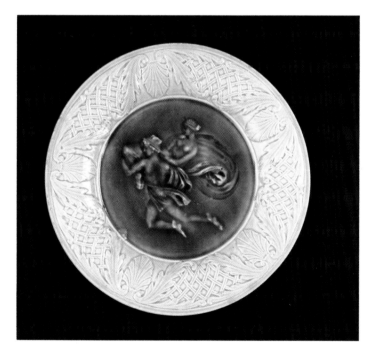

Plate, Griffen, Smith & Co.; "Classic" pattern, with an especially delicate impressed border. 9" dia. *Courtesy of Michael G. Strawser, Majolica Auctions.* $280-310

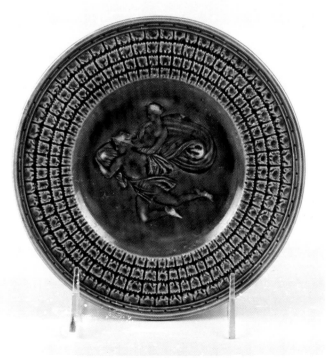

Plate, Griffen, Smith & Co.; the "Classic" pattern. 7" dia. American potters used classical motifs and trade names in an effort to dispel the impression that their work was rustic and unsophisticated. $280-310

In 1861 the United States Congress placed high duties on most imported ceramics in an attempt to help domestic production. As a result, many British potters opened factories in the United States, thereby avoiding the duties. As revolution brought French talent to England, so the 1861 duties brought British potters to America.[13]

In 1875 the first meeting of a new American society, the National Association of Potters, was convened in Philadelphia. Officials from over seventy American factories attended. There, potters resolved to create original works in original designs to meet the needs of American consumers rather than copying foreign patterns. American majolica was one result of this resolution.[14]

In 1876 the Centennial Exposition in Philadelphia did for American manufacturers what the Crystal Palace Exhibition had done for Minton. The 1876 Exhibition was the largest in America, housed in 180 buildings it featured domestic and foreign artistic, industrial and academic achievements. Examples of both English and American majolica were there. Several skilled American potters including James Carr and J.E. Jeffords took the opportunity to introduce thousands of Americans to American majolica wares. American demand for majolica took off. Established American potters in the northeast and midwest responded and new potteries sprung up to take advantage of the rising market. Major centers including Jersey City and Trenton, New Jersey; Bennington, Vermont; New York City; Phoenixville, Pennsylvania; Baltimore, Maryland and other opportune locations in the Carolinas and the midwest produced majolica. Dining rooms and parlors all over America were soon dotted with the ever-colorful majolica wares.[15]

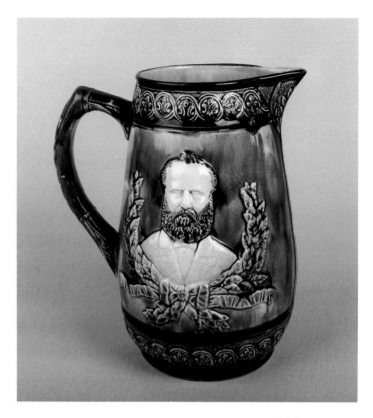

Ulysses S. Grant (General, Commander-in-Chief of the Union armies from 1864-65 in the American Civil War and two-term President of the United States from 1868-76) Centennial pitcher, unattributed; mottled background, cobalt trim. 10" high. *Courtesy of Michael G. Strawser, Majolica Auctions.* $1250+

Three-handled vase, W.T. Copeland & Sons, produced for the 1876 American Centennial Exposition in Philadelphia, Pennsylvania; decorated with eagles and crests reading "1876 Centennial Memorial," "1776 Declaration of Independence" and "Washington, Father of Our Country." British potters like Copeland found American expositions to be just as important as the earlier European ones had been. NP

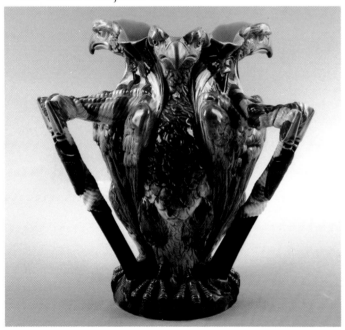

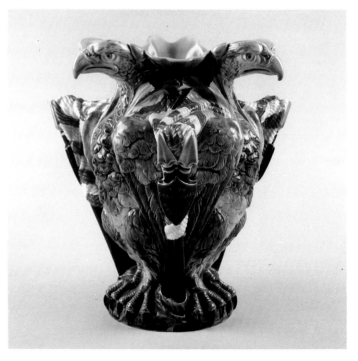

However, less interested in Renaissance antiquities than European consumers, Americans preferred more modern patterns influenced by natural designs. Utilitarian wares were also more popular than the ornate conservatory or garden pieces encumbered with dolphins or cherubs. Many American majolica wares reflected the popularity of the Japanese designs exhibited at the 1876 Exhibition as well.

The firm of Griffen, Smith & Hill of Phoenixville, Pennsylvania grew to become the largest and most influential American manufacturer of majolica. Opening in 1879, these partners were well positioned with their "Etruscan Majolica" to take advantage of the rising American demand. Griffen, Smith & Hill produced what has been considered by some the best American majolica. They used the World's Industrial and Cotton Centennial Exposition in New Orleans in 1884 as their opportunity to let America know about it. An intense American majolica craze was on, destined to last through most of the decade, and the growing railroad network gave potters access to the larger American market.[16]

During the 1880s, demand reached a fever pitch and majolica was overproduced. The result was a market glutted with a great deal of poorly produced majolica and a loss of public esteem for the product. Production dropped in the 1890s. Some American and Continental firms continued to produce majolica until World War I when production came to a halt. Majolica had seen its day; the craze was over, and the ware was part of history.[17]

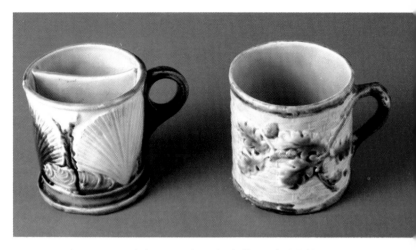

Rare shaving mug (left), unattributed; shell motif. Drinking mug (right), Griffen, Smith & Co.; acorn motif. Both 3.5" high. More natural motifs, crucial for the American market. *Courtesy of Michael G. Strawser, Majolica Auctions.* Left: $850+; right: $375-425

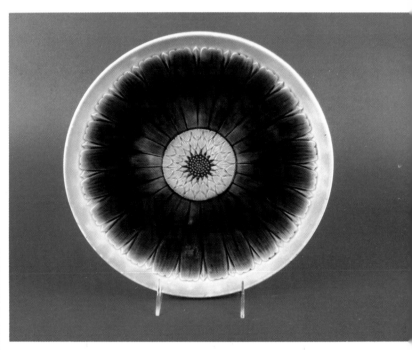

Listed in the Griffen, Smith and Co. 1884 catalog as a berry tray in the "Cosmos" floral pattern, Griffen, Smith & Co. $300+

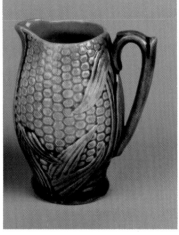

Creamers, Griffen, Smith & Co., Etruscan; differing quality in both molding and painting. 4" high. Natural themes like these were better-received in the United States than Anglo-French, Palissy-style or historic revivalism were. Corn was a particularly popular design in America as corn and pork were the two great staples of the nineteenth century American diet. *Courtesy of Michael G. Strawser, Majolica Auctions.* $200-220 each

"GSH" manufacturer's mark on back of the floral berry tray. The Griffen, Smith & Co. initials continued to be used as an impressed mark long after Mr. Hill left the firm and the name was legally changed to Griffen, Smith & Company.

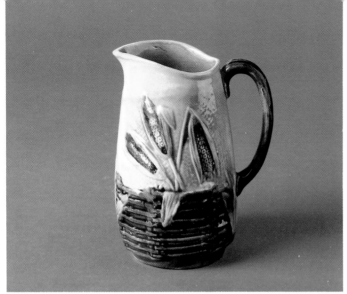

Small pitcher, unattributed; rustic basket and corn patterning. 6" high. *Courtesy of Michael G. Strawser, Majolica Auctions.* $125-135

No frills barrel-shaped salt and pepper shakers, unattributed. 4" high. NP

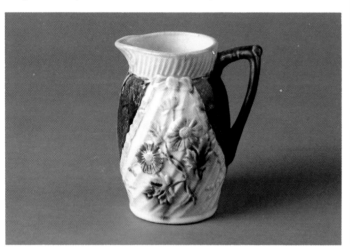

Small pitcher, unattributed; floral and drapery motif. 5" high. A simple, useful piece, more attractive to American audiences than elaborate decorative ware. *Courtesy of Michael G. Strawser, Majolica Auctions.* $125-135

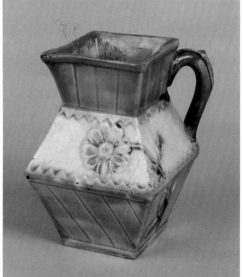

Simple turquoise pitcher, unattributed; four-sided. 5" high. *Courtesy of Michael G. Strawser, Majolica Auctions.* $425+

Creamer, unattributed; bamboo and fern motif. 3.5" high. Another sturdy piece, particularly suited to the American temperament. *Courtesy of Michael G. Strawser, Majolica Auctions.* $100-110

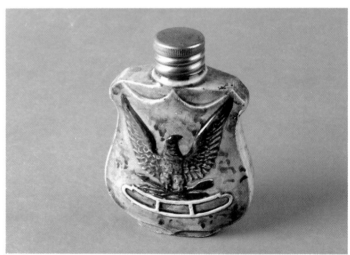

Flask, unattributed; applied eagle. 3.75" high. Both useful (for the surreptitious tippler) and attractive (for the patriot). Eagle designs were particularly common in America during times of strife when patriotic fervor rose. *Courtesy of Michael G. Strawser, Majolica Auctions.* $125-135

Plate, unattributed; rose in center. 5.75" dia. *Courtesy of Michael G. Strawser, Majolica Auctions.* $100-110

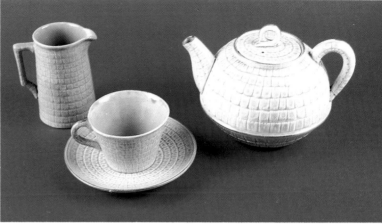

Tea set: teapot, creamer, sugar bowl, cup & saucer, Griffen, Smith & Co., marked "GSH" on saucer; stylized corn pattern. Teapot, 5.75" high x 8" wide. NP

Covered sugar, Griffen, Smith & Co., Etruscan trade name; Wild Rose pattern. 3.5" high. *Courtesy of Michael G. Strawser, Majolica Auctions.* $300-330

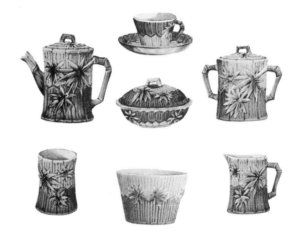

The Japanese designs shown at the 1876 exhibition caught on in America; these bamboo and fern items appeared in Griffen, Smith & Co.'s catalog for the 1884 exhibition in New Orleans.

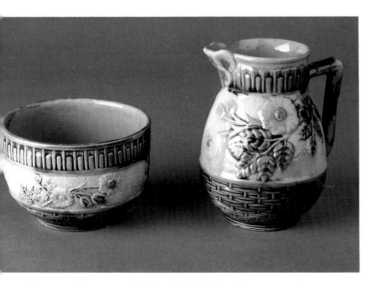

Cream and sugar set, Griffen, Smith & Co., Etruscan trade name; Wild Rose. Open sugar bowl, 2.5"; butterfly-lipped creamer, 4.5". *Courtesy of Michael G. Strawser, Majolica Auctions.* $250+

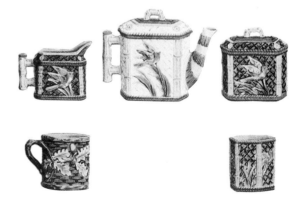

More Japanese design influence shown in Griffen, Smith & Co.'s 1884 catalog; the bird and bamboo motif.

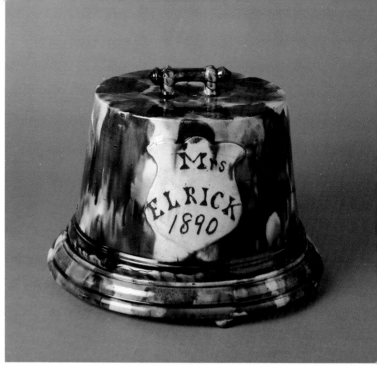

Cheese dome, marked "Mrs. Elrick, 1890," mottled glaze. 9" dia. x 7.5" high. By this date, majolica's popularity meant tremendous overproduction, glutting the market and lowering the public's perception of the ware's quality. *Courtesy of Michael G. Strawser, Majolica Auctions.* $600+

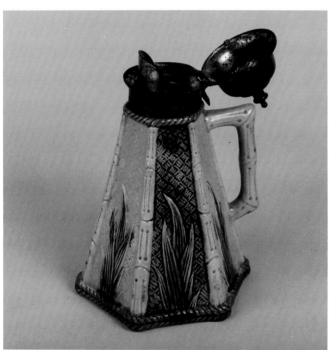

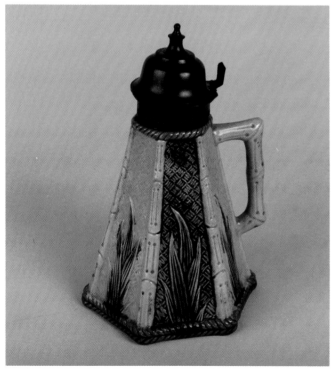

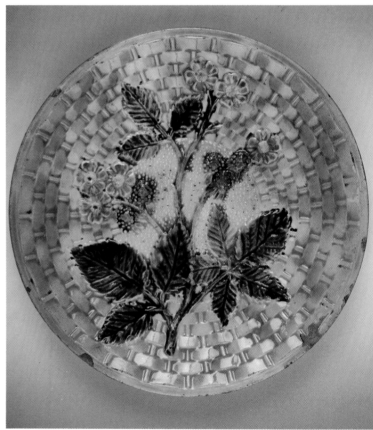

Syrup dispenser, Griffen, Smith & Co., Etruscan; Japanese bamboo motif, pewter lid. *Courtesy of Michael G. Strawser, Majolica Auctions.* $600-700

Plate, unattributed, basketweave and blackberry pattern. 10.5" dia. With the overproduction of majolica came a profusion of poorly produced, inexpensive pieces. *Courtesy of Michael G. Strawser, Majolica Auctions.* $200-220

Plate, unattributed, floral design. 8″ dia. Many pieces from this period of production were unmarked; few manufacturers had reputations strong enough to guarantee sales. *Courtesy of Michael G. Strawser, Majolica Auctions.* $175-195

Fruit bowl, unattributed; fruit cluster decoration. 8.5″ dia. As the craze for majolica faded, so did its color scheme. Glaze was often used sparingly on pieces meant to be sold at low prices. *Courtesy of Michael G. Strawser, Majolica Auctions.* $90-100

Tray, unattributed; basket, fern and floral pattern. Because little majolica could be sold at high prices, and because bright colors were no longer attracting great numbers of customers, few manufacturers were willing to "waste" money on more colored glaze than was necessary. Pieces with white or ivory backgrounds and pale colors became predominant. 6″ x 6″. *Courtesy of Michael G. Strawser, Majolica Auctions.* $50-60

Small mug, unattributed; fence and floral motif. 3″ high. In the final years of the craze, cheaply produced majolica wares were given away as premiums at American stores. *Courtesy of Michael G. Strawser, Majolica Auctions.* $115-125

Majolica and the Social Graces

The Dinner Party

By mid-century, Victorian food consumption was evolving into a social ritual. The dinner party was the pinnacle of that evolution.

At the formal social dinner party, people were seated around the table in an order that would not offend anyone. Etiquette books of the day spent many pages instructing women on how to accomplish this and to ensure use of all the right wares during a meal of up to ten courses.

On such an occasion majolica was served with the following fare: English majolica, preferably argenta, was to be used first for the 'flying dishes,' oyster or marrow pates. The decorative motifs on the majolica must include fish, shells or marine plants, and in the best possible taste, a combination of all three. A majolica salad set was recommended next for the salad, beetroot, vegetables, and mustards. The preferred majolica salad dish had a tall shape with paneled sides featuring raised images of lobsters, vegetables and other appropriate and tasty items. Majolica served well again for sardines, celery, anchovies, plain butter and cheese. Sardines had their own special majolica dish to emphasize that this delicacy of the latter half of the nineteenth century was being served. Majolica dessert dishes (or glass) appeared again at the meals end when two ices, cherry-water and pineapple cream, with whatever fruit was in season.[18]

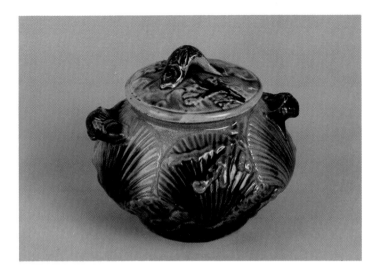

Covered sugar bowl, unattributed; shell, seaweed and fish motif - the best possible combination of the three marine motifs popular at Victorian dinner parties. Seafood's new accessibility and popularity made pieces like this absolutely crucial for those hoping to impress. 4.5". *Courtesy of Michael G. Strawser, Majolica Auctions.* $300-330

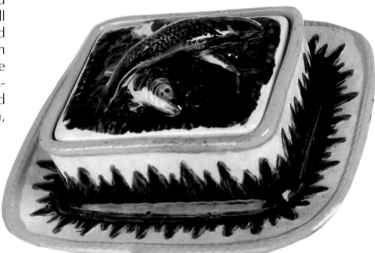

Sardine box, unattributed. 9" x 8". A hostess would be devastated if her guests overlooked the trouble she took to procure sardines, a *de rigeur* delicacy; dishes like these were intended to make certain they noticed! *Courtesy of Michael G. Strawser, Majolica Auctions.* $1550-1700

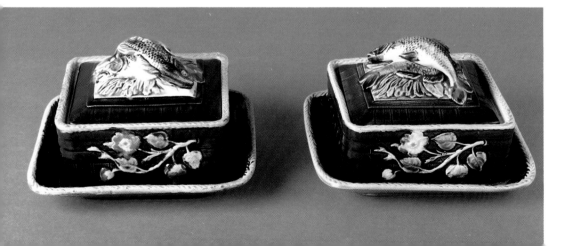

Sardine boxes with underplates, unattributed; cobalt and floral patterning. 9" x 7". As important as having sardines for your dinner party guests to eat was, having a self-explanatory vessel for both serving them and hiding the nasty tin they came in was even better! *Courtesy of Michael G. Strawser, Majolica Auctions.* $1550-1700 each

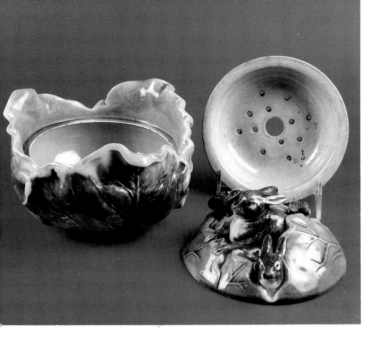

Covered butter dish, unattributed; chipped ice was placed in bottom, and the cold butter was held over it on the pierced tray to prevent melting during the meal. 5" high. $900+

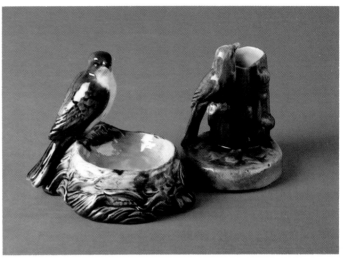

Individual salt (left), Holdcroft; figural bird 4.25" high. Toothpick holder (right), unattributed; figural bird. 4.5" high. More services for the individuals dining pleasure. *Courtesy of Michael G. Strawser, Majolica Auctions.* Left: $675+; right: $150-165

Majolica wares are specified for courses that did not demand much hard use. A low fired earthenware, majolica was not particularly durable. It also was handy for small accent pieces.

After 1850 a footman carried whatever dish was currently being served to your side and whisked it away to keep the table clear of serving dishes, but little individual table pieces added to the sumptuous effect. While the eighteenth century had been an era of more communal dining, particularly in America, the nineteenth century stressed individuality. At the table individual butter plates and individual table salts were provided. A sugar bowl, cream pitcher and syrup pitcher were also present. These items were all produced in majolica. They were relatively low in cost and yet bold and distinctive.[19]

Individual salt, Griffen, Smith & Co., Etruscan trade name; pond lily form. 3" high. *Courtesy of Michael G. Strawser, Majolica Auctions.* $215-235

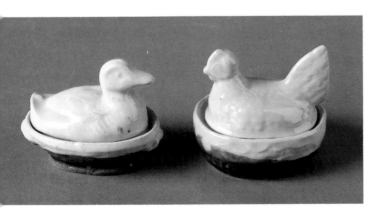

Covered salts, unattributed; hen and duck on baskets. Each 2" long. Everyone could salt their meal to taste from these whimsical individual salts. *Courtesy of Michael G. Strawser, Majolica Auctions.* $50-60 each

From Griffen, Smith & Co.'s 1884 catalog, an illustration of their pond lily individual salt.

Another form of Griffen, Smith & Co.'s pond lily individual salt, from the 1884 catalog.

Once a diner removed some cold butter from the covered butter dish, he or she needed some place to put it. Majolica butter pats were perfect for the job. All of the following butter pats measure roughly 3"-3.5".

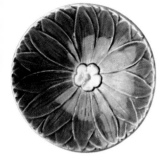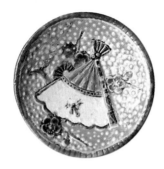

Green pond lily pat; Fielding fan and insect butter pat with an English Registry Mark. *Courtesy of Michael G. Strawser, Majolica Auctions.* Left: $375+; right: $250+

Portuguese leaf pat with handle; Geranium leaf pat; Wicker and begonia leaf pat, chip on front. *Courtesy of Michael G. Strawser, Majolica Auctions.* $75-85 each

Griffen, Smith & Co. butter pats: Green pond lily pat and a later style Geranium leaf pat, pink border. *Courtesy of Michael G. Strawser, Majolica Auctions.* Left: $130-145; right: $165-185

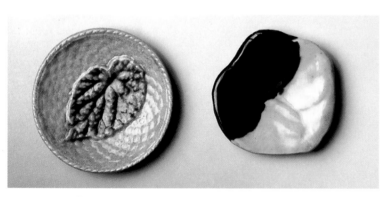

Griffen, Smith & Co. "Etruscan" begonia leaf on wicker pat; cobalt and yellow pansy pat. *Courtesy of Michael G. Strawser, Majolica Auctions.* Left: $275+; right: $95-105

Morning glory on napkin butter pat with handle, unattributed. 3.75". *Courtesy of Michael G. Strawser, Majolica Auctions.* $135-150

Two unattributed butter pats and a third by Griffen, Smith & Co. *Courtesy of Michael G. Strawser, Majolica Auctions.* Left: $95-105; center: $125-135; right: $135-165

Game Pie Dishes

In England, game pie dishes (readily found produced in majolica) were introduced simply to fill an early nineteenth century void (a sad lack of pie crusts caused by the scarcity of flour during the Napoleonic War) but what they contained made them special and impressive. From 1671 to 1831 English law had restricted the hunting of game to the aristocracy and the gentry. Until 1881 no tenant farmer could kill game stocked by the rural landowner for his hunting pleasure, even to prevent the loss of the farmer's crops. In an increasingly industrialized island nation, with public grazing land and forests rapidly diminishing, hare, partridge, pheasant, and grouse were hard to come by and much sought after. The poor supplemented their income trapping game for the London black market. Game was considered a great delicacy and a thoughtful gift, and black market game was best; the animal in question was always in better condition as it had been trapped with wires or nets for secrecy rather than being shot.[20]

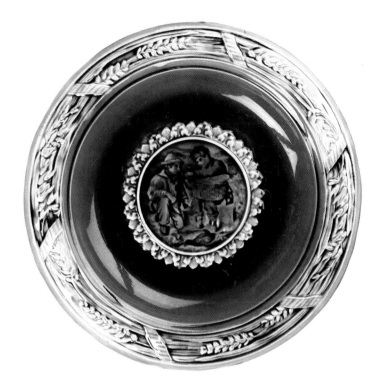

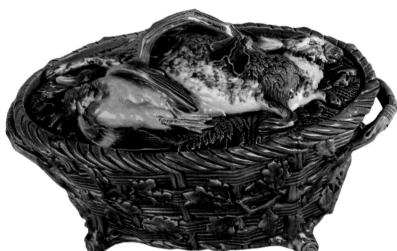

Large bread tray, unattributed; wheat border. 12.5". The hunting scene in the center medallion may well be a *poaching* scene. Without guns and dressed casually, these gents illustrate why poached game from the black market was considered the best eating in England. The game was trapped with nets or wires for secrecy. As a result the meat was undamaged and in high demand. *Courtesy of Michael G. Strawser, Majolica Auctions.* $735-810

Game pie dish, Minton; Hare and Duck ornament. Despite its humble origins in times when there was little flour in England to make real crusts for game pies, this large form became a dish for only the most elite of dinners and diners. Game was considered a great delicacy as it was very hard to come by if you did not happen to have a large, game stocked country estate. So if this dish appeared at the Victorian table, eyes were sure to light up and the occasion would be well remembered. 14" long x 7" high. *Courtesy of Michael G. Strawser, Majolica Auctions.* $5200+

Game pie dish, George Jones; pheasant pattern. 10.5" long x 8" high. The stylized decoration is typical of George Jones' work. Finally, the presence of the game pie dish at the table suggested you either had your own country hunting grounds or the appropriate necessary high connections to legally procure these delicacies. *Courtesy of Michael G. Strawser, Majolica Auctions.* $3000+

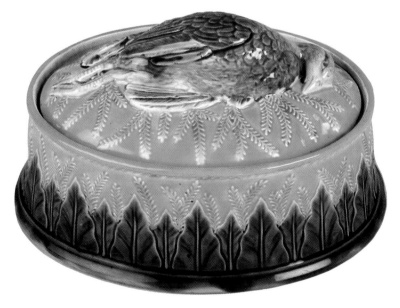

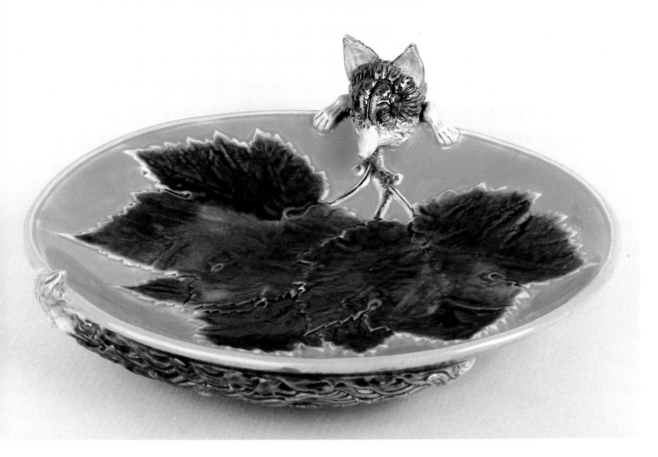

Server, George Jones, fox motif. 11.5" long. Aside from the allusion to the story of the fox and the sour grapes, any English citizen familiar with the fox hunt would find another meaning in this George Jones server. At the end of the hunt, the hounds cornered and devoured the fox. When the hounds were done, all that was left was the head ("mask"), paws ("pads") and tail ("brush") which were awarded as trophies. That is all that is visible of the fox in this piece and the significance was not likely to be lost on avid fox hunters. *Courtesy of Michael G. Strawser, Majolica Auctions.* $1500+

Class friction in rural England was aggravated by the restrictive access to this coveted food. Well aware of the tension, rural landowner who stocked game on their property for their own enjoyment sometimes invited neighbors on "hunts." Allowing the neighbors to kill and carry off a small amount of the estates' game helped assuage some of this friction. The surrounding farmers would chafe less under the laws forbidding them from killing the landowners animals when they strayed from the estate, creating a nuisance and causing considerable crop damage, when they were sure that from time-to-time they would be allowed to eat a few themselves.[21]

The presence of the game pie dish at the dinner table suggested you had either your own land on which to hunt or the high connections necessary to legally obtain these much appreciated delicacies. Certainly polite company would not entertain the idea that their hostess had procured them through disreputable means.

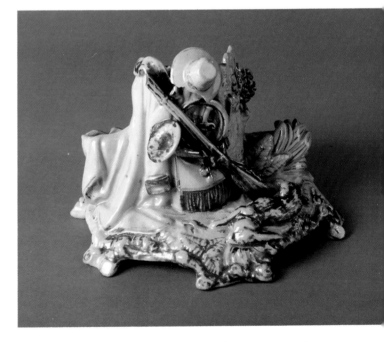

Cigarette and match holder with striker, unattributed; hunting scene. 5" high x 8.5" wide. This American-looking piece displays a different, more rugged ideal of the hunt. *Courtesy of Michael G. Strawser, Majolica Auctions.* $125-135

Household Goods

A visitor exploring the Victorian host and hostess' home was likely to find the bright glint of majolica scattered throughout everywhere, drawing the eye and presenting the appearance of wealth. Vases, fern stands, candelabra, dining room centerpieces and wall brackets were among the larger majolica wares capturing attention first. The more aggressive and uncouth visitor's further exploration might uncover majolica dressing table sets, trinket trays, figurines, match boxes and smoking wares.[22]

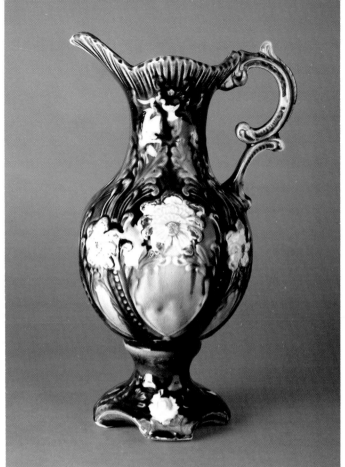

Ewer, unattributed. 13" high. *Courtesy of Michael G. Strawser, Majolica Auctions.* $175-195

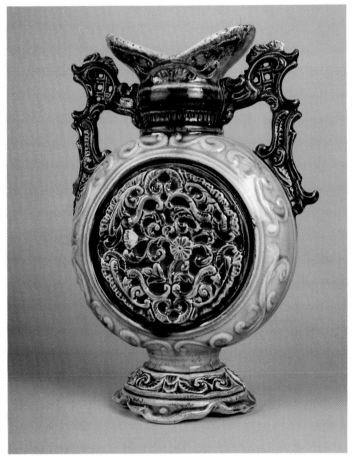

A visitor exploring the Victorian host and hostess' home would likely find the bright glint of majolica scattered everywhere. Vase, unattributed, English; ornate, with openwork. 11" high x 8" wide x 3" deep. A piece like this was sure to draw attention. *Courtesy of Michael G. Strawser, Majolica Auctions.* $85-95

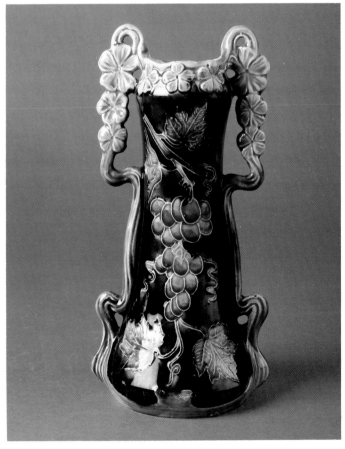

Vase, unattributed; grapevine motif with iridescent glaze. Stylized decoration lends a modern air. 8.5" high. *Courtesy of Michael G. Strawser, Majolica Auctions.* $150-165

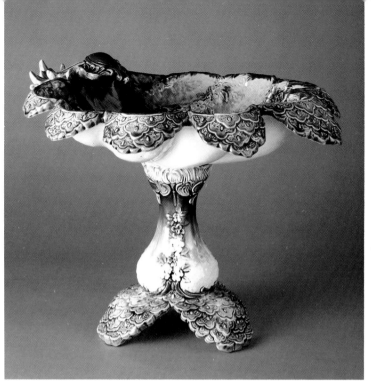

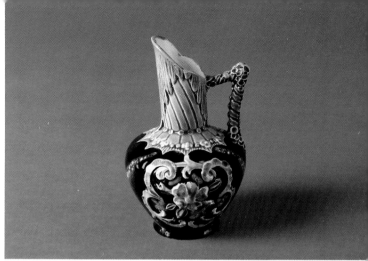

Ewer, Continental; cobalt with elegant decoration. 5". *Courtesy of Michael G. Strawser, Majolica Auctions.* $100-110

Large comport, unattributed; seashell motif. Very detailed, with an aura of antiquity and wealth. 13" high x 16.5" x 15.5". *Courtesy of Michael G. Strawser, Majolica Auctions.* $435+

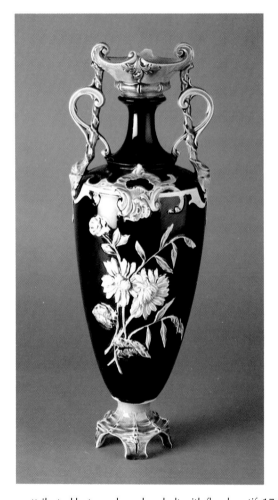

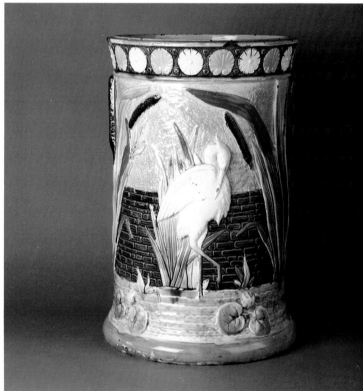

Umbrella stand, unattributed; stork and rushes in a stylized design. Striking as well as convenient at any front door. 18.5" high. *Courtesy of Michael G. Strawser, Majolica Auctions.* $525-600

Vase, unattributed but numbered; cobalt with floral motif. 17.25" high. *Courtesy of Michael G. Strawser, Majolica Auctions.* $375-415

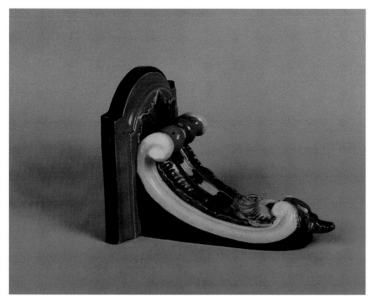

Wall bracket, Worcester. 7" high x 5" x 5". Pieces like this frequently graced conservatory walls. $525-600

Another impressive wall bracket, Minton. Art Nouveau styling. 13" x 10" x 8". *Courtesy of Michael G. Strawser, Majolica Auctions.* $985+

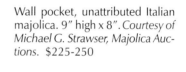

Wall pocket, unattributed Italian majolica. 9" high x 8". *Courtesy of Michael G. Strawser, Majolica Auctions.* $225-250

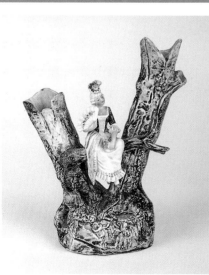

Continental vase featuring a woman amidst the trees. 7" h. *Courtesy of Michael G. Strawser, Majolica Auctions.* $300-330

Possible figural inkwell, unattributed. 4.5" x 3.5". *Courtesy of Michael G. Strawser, Majolica Auctions.* $300-330

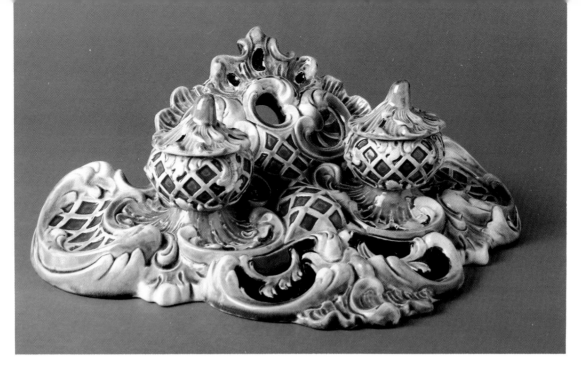

Inkwell set in two parts, unattributed; morning glory lids. This would draw attention and add to the formidable feel of a large Victorian desk. 13" long x 5" high. *Courtesy of Michael G. Strawser, Majolica Auctions.* $925+

Penny banks, (left) unattributed from Austria; lady's head; (right) unattributed, Continental; angry child's face. 3.5" and 4" high. *Courtesy of Michael G. Strawser, Majolica Auctions.* Left: $125-135; right: $175-195

Hand warmer; unattributed. "Coming Thru The Rye." Approximately 6" high. A large Victorian home could be a cold place in mid-winter. NP

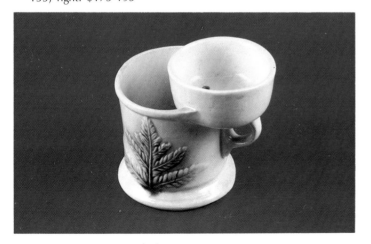

Shaving mug, unattributed. Approx. 4" high. Majolica use reached into the family's private chambers, even into the bathroom. Only a very uncouth and nosy guest would find this while snooping in the family's private quarters! NP

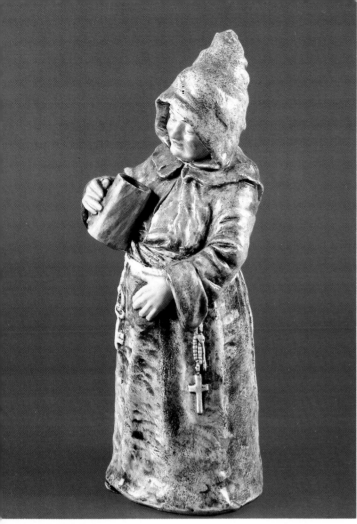

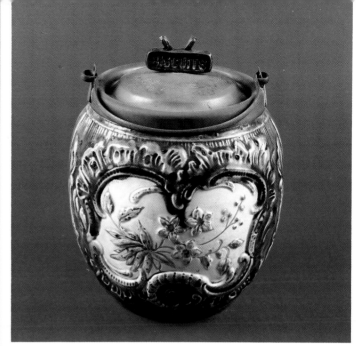

Biscuit jar, unattributed. 7.5" high. NP

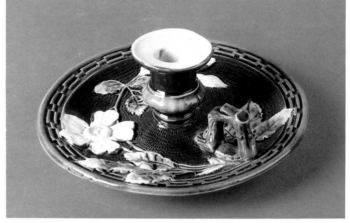

Rare chamber stick, unattributed; cobalt and floral pattern. 7" dia. x 2.5" high. *Courtesy of Michael G. Strawser, Majolica Auctions.* $840+

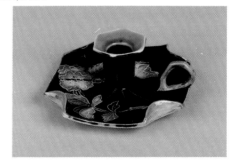

Another chamber stick, unattributed, Continental; cobalt, finely modeled and glazed. 5.75" sq. x 2.25" high. *Courtesy of Michael G. Strawser, Majolica Auctions.* $200-220

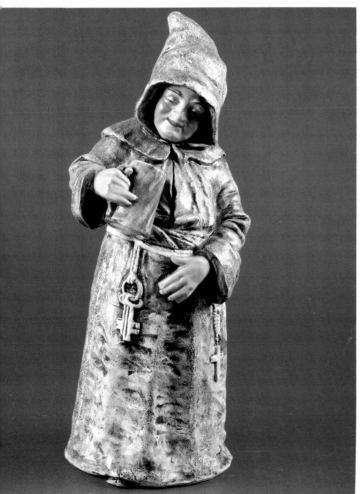

Bell, unattributed; a wonderfully well modeled tippler monk. 11" high. The same figural monk also appears as a humidor. $350+

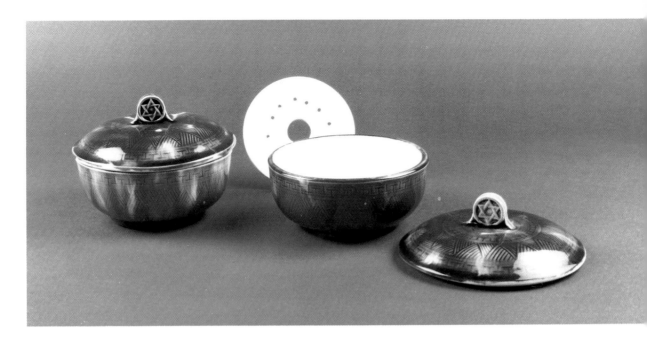

Two soap dishes, Griffen, Smith & Co.; drainer shown in back settles in to the base of the dish and supports the soap. 4.25" high x 4.5" dia. These were part of a bath set which also included a water pitcher and a basin. NP

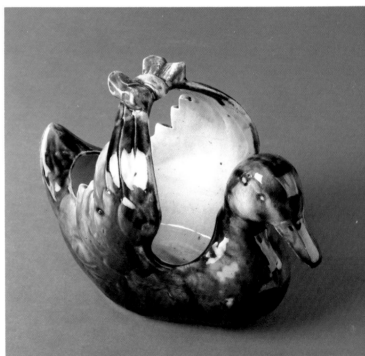

Unusual duck basket, unattributed; mottled 9.5" long x 6.5" high. *Courtesy of Michael G. Strawser, Majolica Auctions.* $315-345

Covered box, Minton; cobalt. 8" x 6". For trinkets or jewelry. *Courtesy of Michael G. Strawser, Majolica Auctions.* $860+

Smoking Wares

Majolica manufacturers also provided calling card plates in colorful designs. In the increasingly complex Victorian world, communication had become ritualized as well. During the day, a lady left her home with calling cards and a footmen. Calling cards were embossed with the name of the individual presenting the card. The lady delivered her cards to households she wished to be associated with; the lady of that house was then obliged to at least return a card of her own to whomever had left one with her. This card could then be placed in a prominent public location in the front hall or on the mantle to impress visitors with evidence of the social circles in which the family moved. The brightly glazed majolica calling card plate was sure to draw the eye to a collection of cards.[23]

In the rapidly evolving social order of the nineteenth century, where women were the high priestesses of the "cult of domesticity," majolica must have been a welcome addition to the home. It's lustrous appearance and suggestion of luxury purchased at the affordable price of earthenware must have delighted the women who brought it home. It is interesting to note that majolica was a ware painted and purchased primarily by women.

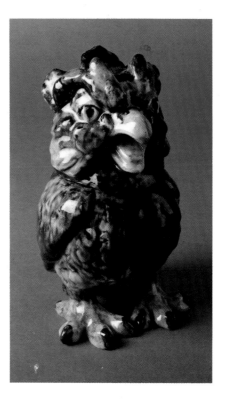

Calling cards received from prominent families would be placed in public locations at home to impress visitors with evidence of the social circles in which the family moved. Placing them on a bright majolica calling card tray would insure the cards were noticed. Example from the Griffen, Smith & Company 1884 catalog.

After a good meal, dinner guests separated. The ladies went off to the drawing room for coffee or tea and the gentlemen might smoke, something they would not be allowed to do with ladies present, even with their permission. This also gave them a chance to exchange off-color stories. Humidor, unattributed; a mottled parrot made to hold loose tobacco. 7.5" high. *Courtesy of Michael G. Strawser, Majolica Auctions.* $275-300

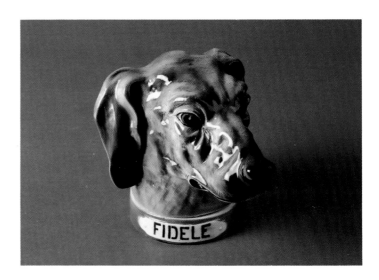

Humidor, unattributed; figural dog's head. 5" high. *Courtesy of Michael G. Strawser, Majolica Auctions.* $375+

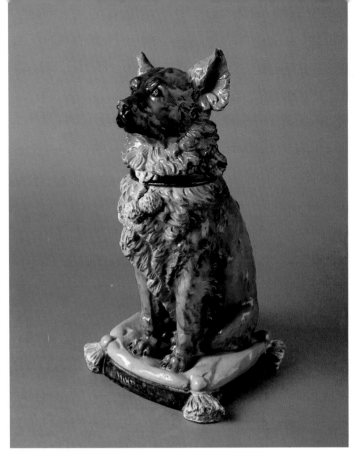

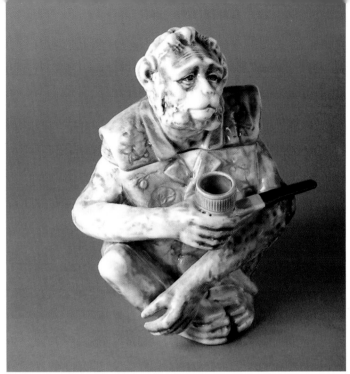

Humidor, unattributed, from Austria; figural monkey with detachable head and shoulders in mint condition. 8.5" high. *Courtesy of Michael G. Strawser, Majolica Auctions.* $775-850

Humidor, unattributed; dog's head detaches. 13" high. Cigars were introduced in the 1790s from the Caribbean and were taken up by wealthy men early in the nineteenth century. Cigarettes were available in the 1830s but did not really catch on until the second half of the century. The earliest cigarettes available were manufactured in London and New York. *Courtesy of Michael G. Strawser, Majolica Auctions.* $1485+

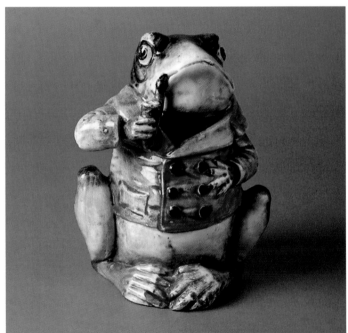

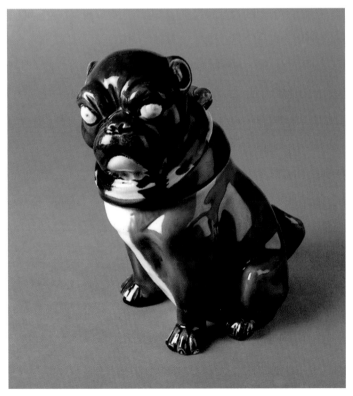

Humidor, unattributed; a dapper frog. 7" high. *Courtesy of Michael G. Strawser, Majolica Auctions.* $465-495

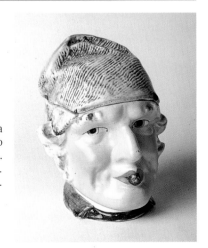

A cigar smoking man in a multi-colored hat tobacco jar, unattributed. 5.5" h. *Courtesy of Michael G. Strawser, Majolica Auctions.* $250-275

Humidor, unattributed; figural pug dog. 8" high. *Courtesy of Michael G. Strawser, Majolica Auctions.* $450+

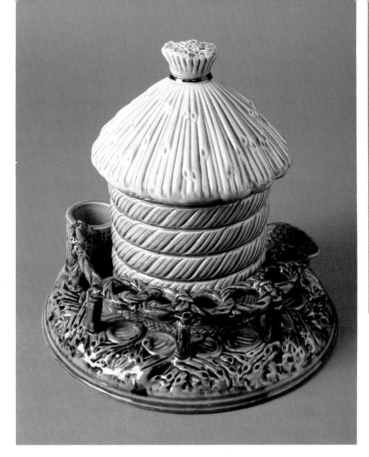

Beehive humidor, unattributed; with cigar holder. 9" high. *Courtesy of Michael G. Strawser, Majolica Auctions.* $865+

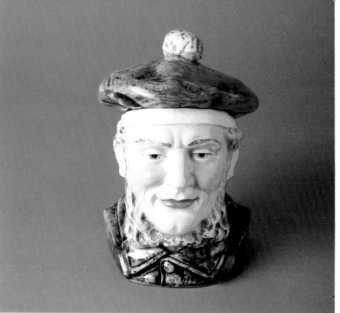

Humidor, unattributed, a Scottish rogue, with removable cap. 7" high. *Courtesy of Michael G. Strawser, Majolica Auctions.* $375+

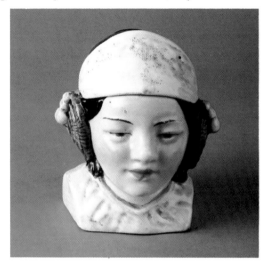

Humidor, unattributed, figural Asian lady's head. 5" high. *Courtesy of Michael G. Strawser, Majolica Auctions.* $300+

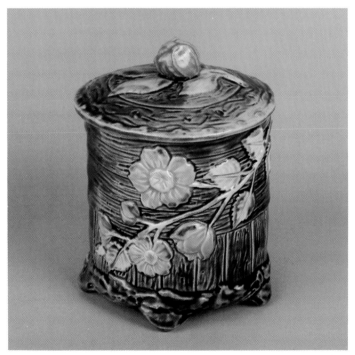

Humidor, unattributed; fence and floral pattern. 5.5" high. *Courtesy of Michael G. Strawser, Majolica Auctions.* $315+

Humidor, Griffen, Smith & Co.; Shell and Seaweed pattern. 5" dia. x 6.75" high. Part of an extensive line of sea-motif pieces. $950+

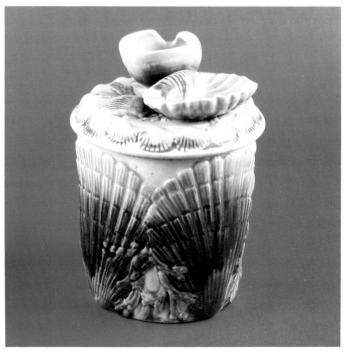

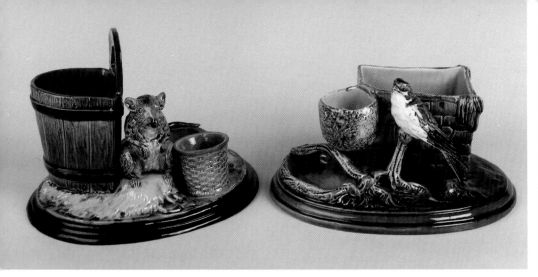

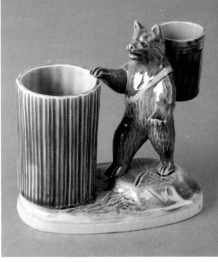

Where there are smokers (not to mention candles, oil lamps and later gas lamps, etc.) there are matches and match holders. Wilhelm Schiller & Sons; bird and mouse. Each piece 8" long. *Courtesy of Michael G. Strawser, Majolica Auctions.* Left: $750+; right: $565+

Match holder, Holdcroft style; figural bear with mottled backpack and barrel. 3.5" high. *Courtesy of Michael G. Strawser, Majolica Auctions.* NP

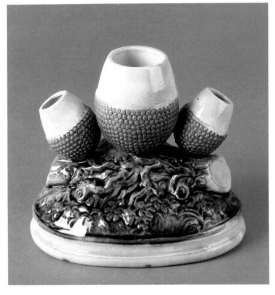

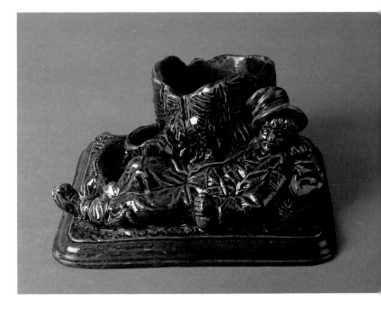

Match holder, unattributed; acorn form. 4.5" high. *Courtesy of Michael G. Strawser, Majolica Auctions.* $675+

Match holder, unattributed; monochrome Happy Hooligan scene. 7" long x 6" wide x 3.5" high. *Courtesy of Michael G. Strawser, Majolica Auctions.* $215-235

Smoking companion, Sarreguemines, c. 1890. 12.5" long x 5.5" high. The galley roof lifts up for matches, the ridged border around the base serves as a striker, and the holes on deck hold a cargo of cigars. *Courtesy of Michael G. Strawser, Majolica Auctions.* $500-550

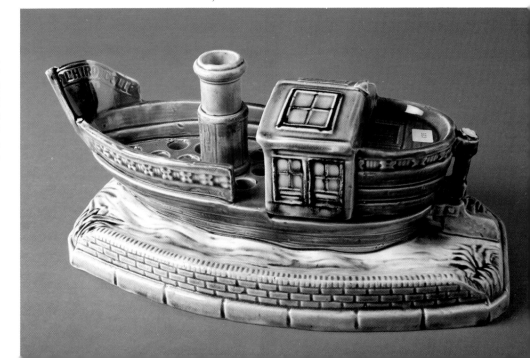

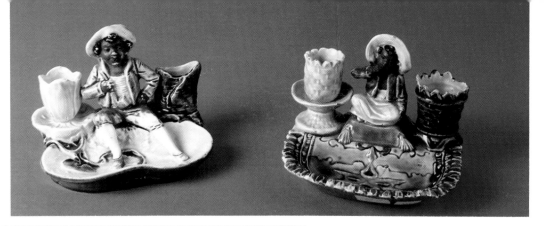

Two match holders, unattributed; seated black boys in tropical scenes, with strikers and ashtrays. Both 5.5" wide. *Courtesy of Michael G. Strawser, Majolica Auctions.* Left: $445-545; right: $425-465

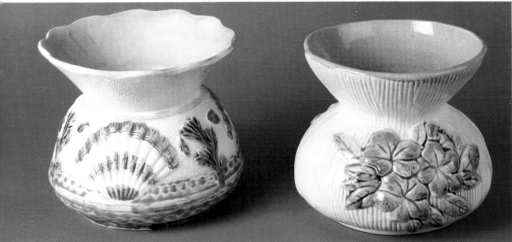

In America the spittoon was put out in the often futile hope the chewer would notice and use it. Highly visible majolica examples might have had better track records, but often chewers either ignored them or missed, much to the disgust of the non-chewing public and foreign visitors, who found the nasty black juice everywhere. Two spittoons, unattributed; (left) shell and seaweed, (right) floral 8" dia. and 6.5" dia. *Courtesy of Michael G. Strawser, Majolica Auctions.* $280+ each

Men seemed to be particularly oblivious to the presence of spittoons on American trains. Chewers spat everywhere and sometimes it was difficult for travelers to view the scenery or find a clean seat as a result. Two spittoons, unattributed. (left) 8.5" x 2.5", (right) 7" x 4.5". *Courtesy of Michael G. Strawser, Majolica Auctions.* $280+ each

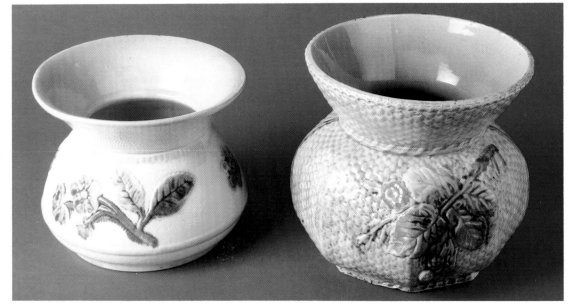

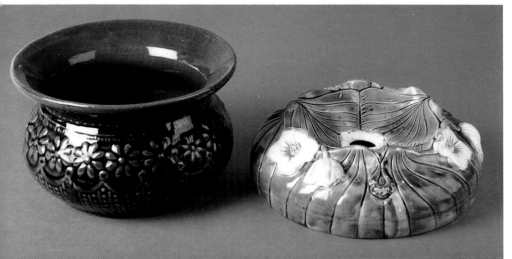

Left: floral spittoon, unattributed, 6" high. Right: pond lily spittoon with largely closed top to hide the vile juice, attributed to Holdcroft. *Courtesy of Michael G. Strawser, Majolica Auctions.* Left: $280+; right: $150-165

69

The People Behind The Colors

"Part of the people just worked for the money, but others really cared about their work." - Mary Murphy, painter of majolica for Griffen, Smith & Co.[24]

Majolica's brightly colored glazes and the flair with which those glazes were applied are its most eye-catching qualities. Those glazes were applied mainly by teenage women from lower class working families, laboring ten to twelve hours a day, six or seven days a week, for under ten cents an hour.[25]

On a typical production day, a skilled master painter or decorator would provide a well-painted example of each of the different pieces as a model for the rest of the painters. These painters copied the model to the best of their abilities with varying results. One problem with the application of majolica glazes is that the color was not the same when applied as when fired. This could lead to some peculiar mistakes.[26]

One of the women who painted glaze decorations for Griffen, Smith and Company in Phoenixville, Pennsylvania recalled:

"We each had our camel's hair brush and the little pots of majolica paint sitting before us. We painted the ware blue in order to get a pink; deep rose changed to blue; black would turn out a deep brown. I was only eleven years old when I first started working... I was the youngest of the painters and the shortest... Mr. Smith didn't want to hire me, but it was ne-

Griffen, Smith & Co.'s popular pond lily plate. Because each piece was hand-painted, few looked exactly like this portrayal in the 1884 catalog. The quality of the result depended on the skill and experience of the individual artisan.

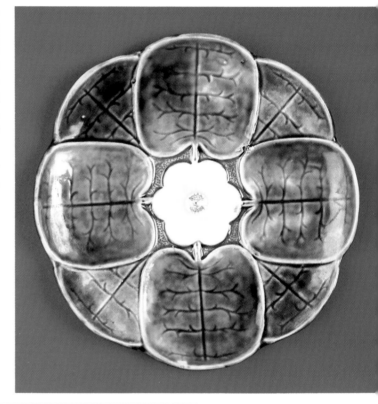

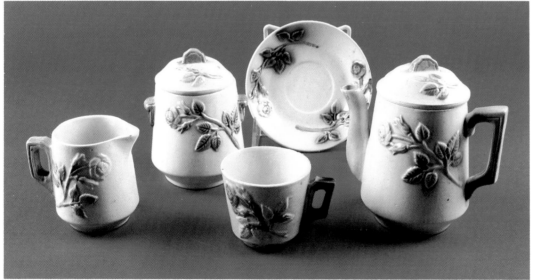

Plate, Griffen, Smith & Co., Etruscan trade name with initials "JHD" on base; pond lily design. 8" dia. *Courtesy of Michael G. Strawser, Majolica Auctions.* $290-320

Child's tea set: teapot, creamer, sugar bowl, cup & saucer, unattributed. Teapot, 5.5" high; saucer, 4.75" dia. Some Victorian children spent long hours playing with tea sets; others had to work hard for a living painting them. NP

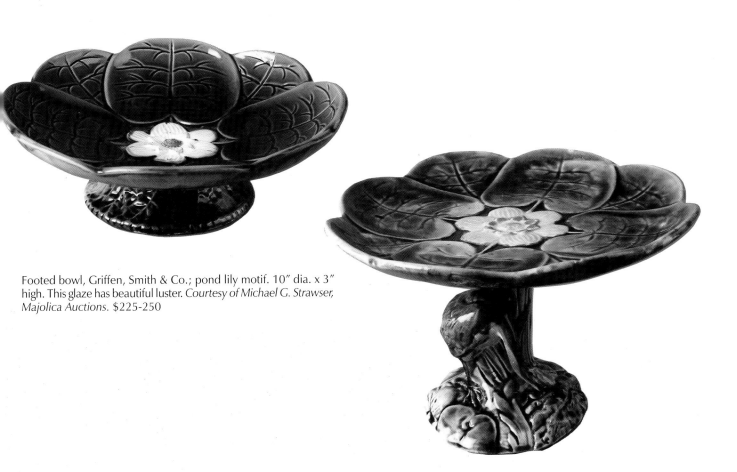

Footed bowl, Griffen, Smith & Co.; pond lily motif. 10" dia. x 3" high. This glaze has beautiful luster. *Courtesy of Michael G. Strawser, Majolica Auctions.* $225-250

Cake stand, in Griffen, Smith & Co.'s pond lily pattern with stork on foot. 10" dia. x 6" high. *Courtesy of Michael G. Strawser, Majolica Auctions.* $425-465

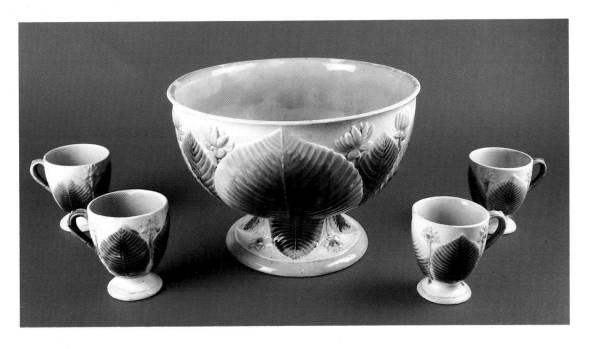

Punch bowl with cups, Griffen, Smith & Co. Bowl, 11.5" dia. x 8" high; cups, 4" high. Painters must have had a difficult time envisioning their final products; the unfired glazes they applied looked nothing like these delicately colored final products. Still, this one perfectly matches the catalog's promise (see page 72). $2250+

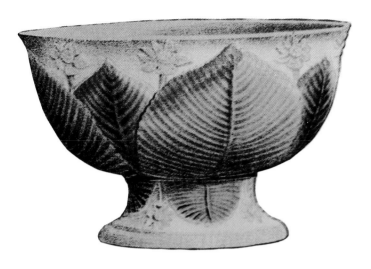

Illustration of Griffen, Smith & Co. punch bowl, from 1884 catalog.

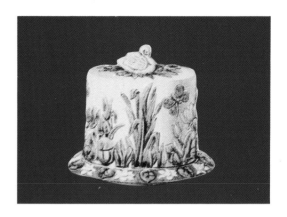

Illustration of the Etruscan covered cheese keeper in its usual color, with a white background; from the 1884 Griffen, Smith & Co. catalog.

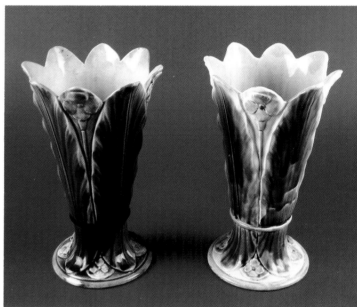

Two celery vases from the same mold, Griffen, Smith & Co., c. 1879; leaf and floral pattern. Note the significant differences in paint color and application. NP

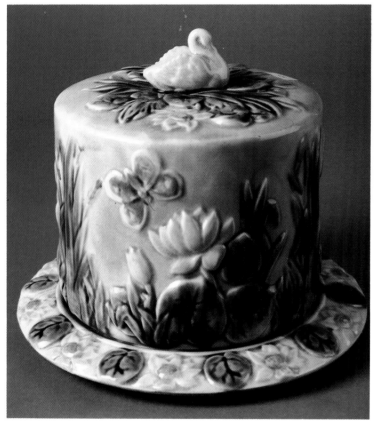

Rare covered cheese keeper, Griffen, Smith & Co., marked "Etruscan;" swan motif on a rare pink background, pink interior, mottled center on plate. 7" high. *Courtesy of Michael G. Strawser, Majolica Auctions.* NP

Illustration of the celery vase from Griffen, Smith & Co.'s 1884 catalog.

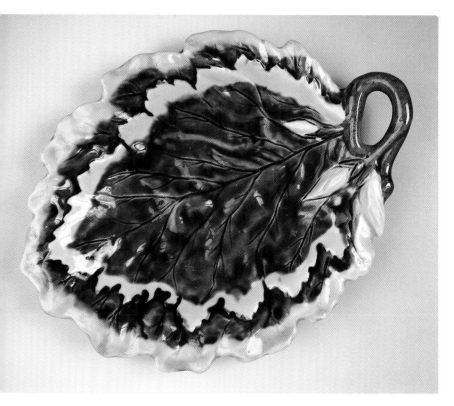

Bread tray catalog illustration, Griffen, Smith & Co., 1884.

Bread tray with handle, Griffen, Smith & Co.; oak leaf motif. 11.5" x 9". A crisp, clear application. *Courtesy of Michael G. Strawser, Majolica Auctions.* $565-625

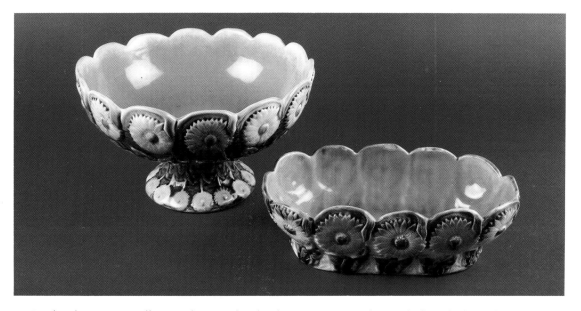

Bowl and comport, Griffen, Smith & Co.; bowl is shown in 1884 catalog. Both glaze shades and precision of painting differ in these pieces. $330+ each

cessity that prompted me to apply for the job. I used to do roses, carnations, and forget-me-nots."

This young artist went on to describe an argument she had with Mr. Smith over switching to a piece work pay schedule rather than receiving a flat pay rate of $5.00 a week. She won the argument, and apparently did fairly well with the piece work rate, stating: "I'll never forget the Christmas I came home with a $19.75 pay check."[27]

The worst problem facing the painters was lead poisoning. Raw majolica glazes used during the latter half of the nineteenth century contained deadly lead. However, manufacturers were certain lead-less glazes were much too inferior for use. Friction between management and labor over this issue furthered the decline of majolica in the late 1800s as strikes coupled with falling profits closed some factory doors forever.[28]

Inspirations and Movements Influencing Design

"The great multitude deserves the best of everything, and in the long run is the best judge of it. For art must be popular, enjoyed by people, suggested by the people ... furnishing a deep foundation for the highest cultivation of popular taste." - Horatio Greenough, sculptor.[29]

Greenough's quote seems to sum up majolica potters' philosophy towards pattern designs for their wares. As movements and tastes shifted through the fifty-odd years of majolica production, the wares themselves shifted to keep pace with the trends.

1. Maiolica

When Herbert Minton christened his ware majolica he was conjuring up romantic images in the Victorian minds of Italian fifteenth century maiolica. Searching history for Victorian inspiration was a popular pastime activity by mid-century, as Minton was well aware. Early 1850s majolica copied the shapes and decorations of Italian maiolica artifacts. The common decorative forms were borrowed from majolica for early majolica forms as well, including weapons, armor, musical instruments, interlaced lines and foliage, oak and other leaves, flowers, ornaments ending in human figures or heads, and landscapes. Marriage plates with central portraits were also copied. However, Minton's sense of historicism did not extend to production techniques, which were thoroughly modern.

The common decorative forms were borrowed from maiolica for early majolica forms as well, included weapons, armor, musical instruments, interlaced lines and foliage, oak and other leaves, flowers, ornaments ending in human figures or heads, and landscapes. Marriage plates with central portraits were also copied. After the 1850s, majolica evolved away from this initial influence. The landscape forms, however, resonated with Victorian Romanticism which coupled the natural world with human nature as a projection of an artist's state of mind. This projection was seen as creating a source of moral, emotional and aesthetic truth. Romanticism balanced the picturesque with the naturalistic and real.[30]

Urn, unattributed, early Italian in the style of actual *majolica*; serpentine handles, gargoyle-style heads in polychrome paint. 22" high. *Courtesy of Michael G. Strawser, Majolica Auctions.* $1200+

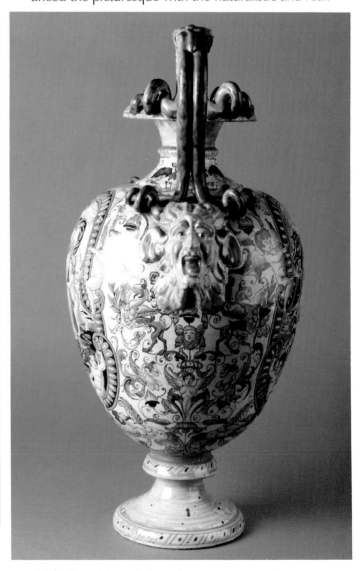

A side view of the *majolica*-style urn.

2. Palissy

Rumaging through Western civilization's historical basement, Léon Arnoux drew inspiration from the works of Bernard Palissy during majolica's formative period. Palissy, a thirty-two year old Frenchman with a bent for naturalism, trained in glass painting and surveying techniques, settled in Saintes in 1532 after traveling through Germany and the Low Countries. In Saintes, Palissy became fascinated with potting techniques. He experimented with recreating the tin glaze of Italian maiolica. While the attempts ruined him financially, his final success was the foundation for all the colorful glazes to follow. Patronage in 1548 by Anne de Montmorency, the Constable of France gained him repute and the chance to develop three periods of his work. His earliest work was known for its brilliant enamels, the second for rustic enameled earthenware, statuettes, dishes, ewers, and vases with naturalistic molded and painted decorations. His representational works applied to earthenwares included fossil shells, fish, shells, plants and reptiles are most often associated with Palissy today. In his third period, Palissy explored geometric designs in relief with pierced borders. To the nineteenth century Romantics, his works-both centuries old and often encrusted with flora and fauna-were irresistible. They combined the Victorian love for the patina of by-gone ages with naturalism, very appealing to a society finding itself ever more encumbered by the trappings of a technological age.[31]

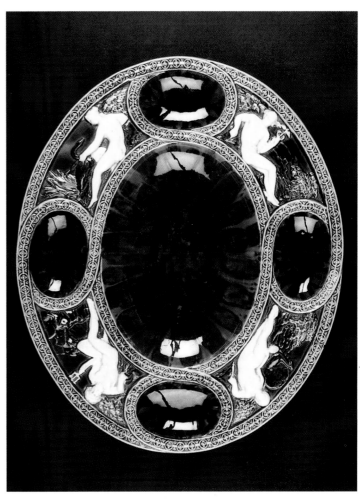

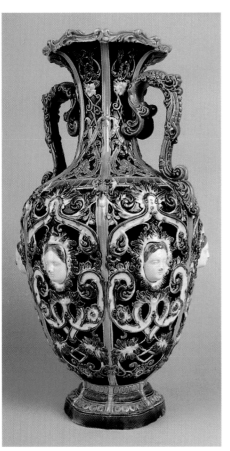

Urn, unattributed; Palissy-style majolica. 15" high. Léon Arnoux was intrigued by the original Palissy ware he discovered in archive records, as well as by the reproductions made by potters earlier in Arnoux's own century. *Courtesy of Michael G. Strawser, Majolica Auctions.* $1000+

Platter, Minton; Greco-Roman, modeled after Palissy's earliest classically styled work. Glazes were sometimes fashioned to imitate malachite, tortoiseshell and other elegant materials. 15" x 12.5". *Courtesy of Michael G. Strawser, Majolica Auctions.* $1400+

Palissy ware crab plaque. 7" d. *Courtesy of Michael G. Strawser, Majolica Auctions.* $1000+

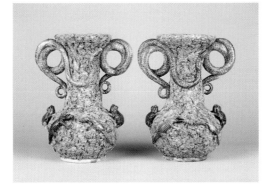

A pair of Palissy ware vases with serpent handles made by the Portuguese firm Mafra and Son. 10.5" h. each. *Courtesy of Michael G. Strawser, Majolica Auctions.* $750+

In the 1830s, French potters revived Palissy wares; some so well that it is impossible to separate the nineteenth century revival from its sixteenth century inspiration. As the century wore on and Palissy's work grew in popularity on the continent, the Portuguese also potted wares inspired by, but not exactly copied from, his work. In England, Palissy's popularity is attributed to the 1852 publication of a biography on the man and his works by Henry Morley.[32]

Original Palissy wares drew high prices from avaricious antiquarians and copies produced sprightly sales as well. Is it any wonder Léon Arnoux chose to emulated his sixteenth century countryman's work in majolica wares?

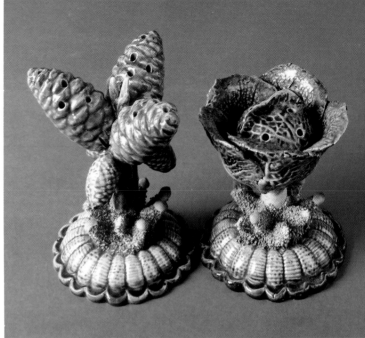

Salt and pepper set, Portugal; pine cone and lettuce leaf motifs. Towards the end of the 19th century, Portuguese potters became the primary makers of Palissy-inspired majolica. *Courtesy of Michael G. Strawser, Majolica Auctions.* $375+ each

3. Historicism

Historicism led to motifs patterned after Gothic, Elizabethan and Tudor designs. Practicality led potters to reuse patterns they had previously produced in earlier ware types as well.[33]

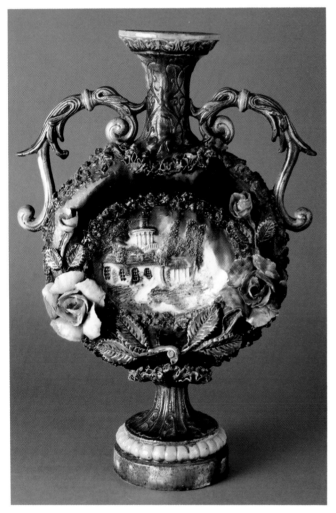

Extremely unusual humidifier, French, signed Francois Maurice. As were many French potters in the early 1800s, Maurice was strongly influenced by Palissy's rustic, naturalistic period. 18" high x 12" wide x 2" thick. *Courtesy of Michael G. Strawser, Majolica Auctions.* $275-375

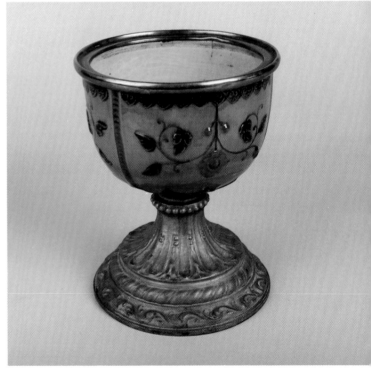

Oil lamp base, unattributed; majolica and cast iron. 7.5" high. This piece has a medieval look about it. *Courtesy of Michael G. Strawser, Majolica Auctions.* NP

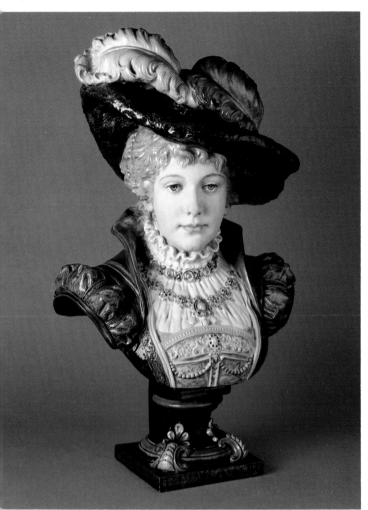

4. Natural History

The passion for natural history had Victorians chronicling the planet's flora, fauna and sea life, creating museums for their discoveries and illustrated volumes on the natural sciences. This passion sent majolica's designers to botanical gardens and the London zoo, sketch pads in hand, for inspiration.[34]

Dish, unattributed; corn leaf form and coloring. 8.5" x 6". *Courtesy of Michael G. Strawser, Majolica Auctions.* $115-125

Bust of stylish woman, unattributed. 24" high. Images from recent centuries also drew the Victorian imagination. *Courtesy of Michael G. Strawser, Majolica Auctions.* This piece sold for $4700 at auction.

Two pitchers, unattributed; ears of corn. 7.5" high and 9" high. Straightforward naturalistic motifs were a very popular aspect of majolica; corn patterns, especially well-liked in America where corn was a dietary staple and very successful cash crop, were made by many manufacturers. *Courtesy of Michael G. Strawser, Majolica Auctions.* Left: $300-330; right: $350-385

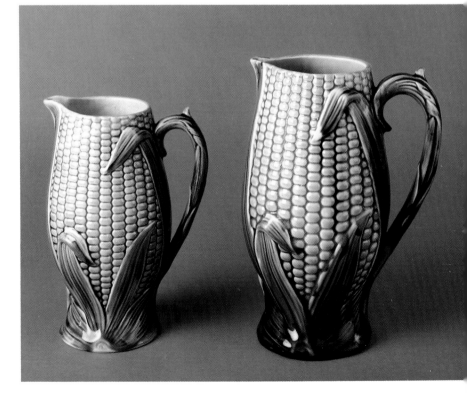

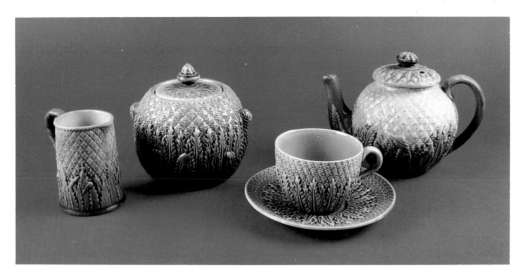

Tea set: teapot, creamer, sugar bowl, cup & saucer, unattributed; pineapple theme. Teapot: $1055-1170

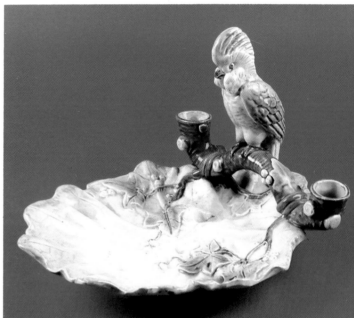

Cockatiel tray, unattributed. NP

Pitcher, unattributed; owl figurine. 6.5" high. The Victorian passion for naturalism included an appreciation for some not-quite-scientific portrayals of wildlife. *Courtesy of Michael G. Strawser, Majolica Auctions.* $400+

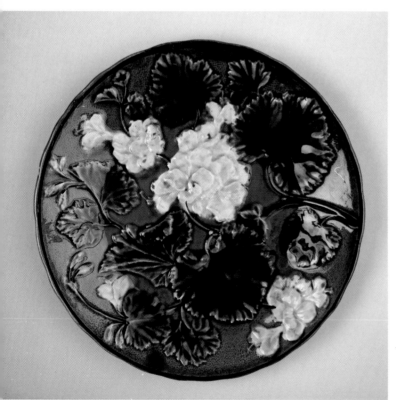

Plate, unattributed; geranium decoration. 7.5" dia. *Courtesy of Michael G. Strawser, Majolica Auctions.* $275+

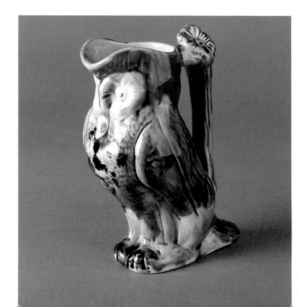

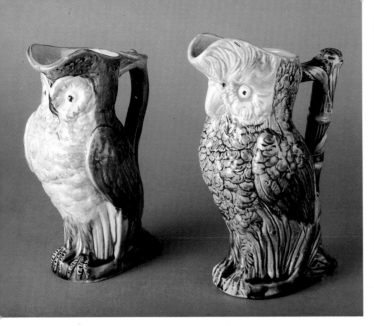

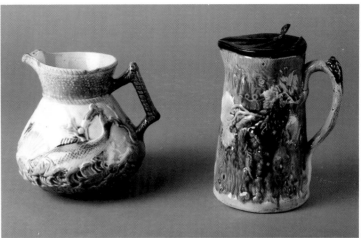

Pitchers, unattributed; (left) fish design, (right) grape, grape leaves and bark design with pewter lid. 6.5" and 7.5" high. *Courtesy of Michael G. Strawser, Majolica Auctions.* Left: $175-195; right: $350-385

Pitchers, unattributed; owl motif, one with a bamboo handle. 9.25" high and 8.75" high. A number of British makers, along with the American Morley & Co., are known for their owl pitchers in this style. *Courtesy of Michael G. Strawser, Majolica Auctions.* Owl: $400+; parrot: $515-575

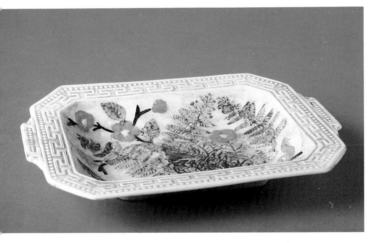

Platter, unattributed, Portuguese; scallop shell design with particularly rich color work. 13.5" x 11". *Courtesy of Michael G. Strawser, Majolica Auctions.* $135-150

Platter, unattributed; fern motif with Greek key border. 10.5" x 8". *Courtesy of Michael G. Strawser, Majolica Auctions.* $225+

Leaf plate, unattributed. 8" dia. *Courtesy of Michael G. Strawser, Majolica Auctions.* $110-120

Plate, unattributed; cobalt with fish and seaweed. 14" x 11". *Courtesy of Michael G. Strawser, Majolica Auctions.* $1500+

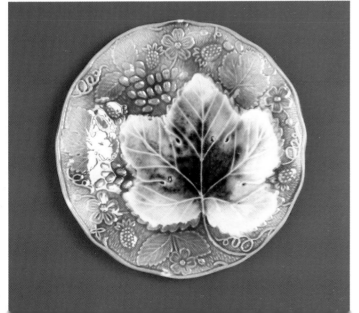

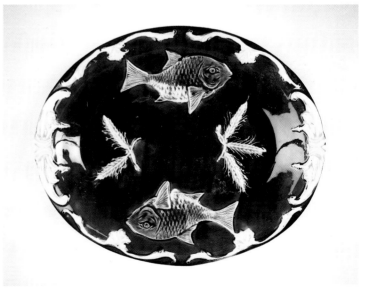

By the last quarter of the nineteenth century, the desire for simpler forms developed. The early heavily detailed majolica was replaced with less flamboyant and high-relief encrusted objects. Nature continued to play a part in majolica motifs, not in the detailed designs of Palissy but more in the spirit of Japanese designs and those of the Aesthetic, Arts and Crafts and later Art Nouveau movements.

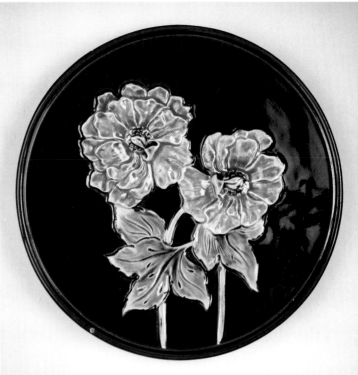

Plate, unattributed; bold, simplistic floral design on cobalt. 10" dia. *Courtesy of Michael G. Strawser, Majolica Auctions.* $300+

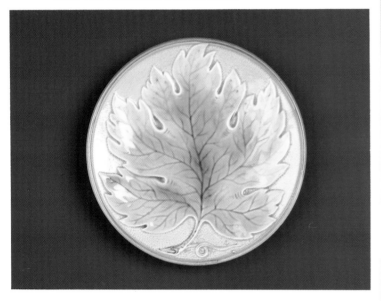

Plate, unattributed; delicate monochrome maple leaf. 6.5" dia. Simpler or more stylized forms began to gain in popularity as majolica evolved. *Courtesy of Michael G. Strawser, Majolica Auctions.* $85-95

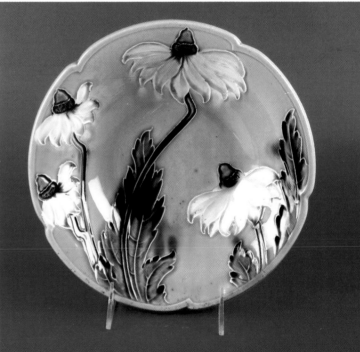

Bowl, marked "StF G" in a circle; dynamic, stylized floral pattern. 9.5" dia. $100-110

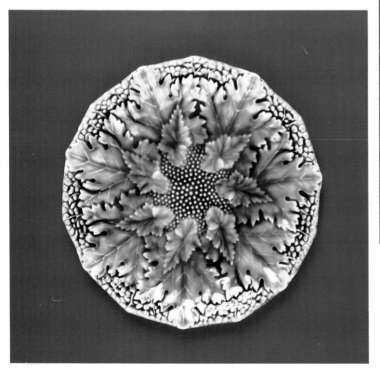

Plate, Zell; a highly stylized but nonetheless organic design. 8" dia. *Courtesy of Michael G. Strawser, Majolica Auctions.* $85-95

Impressed "StF G" mark on the back of the floral bowl.

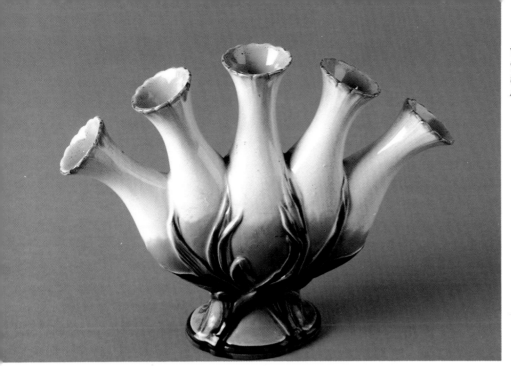

Vase, Minton; five-stemmed. 8″ high x 9.5″ wide. Delicate and simple. *Courtesy of Michael G. Strawser, Majolica Auctions.* NP

5. Japanese

Japanese motifs entered into English majolica after the South Kensington Exhibition of 1862 and the Paris Exhibition of 1867. It caught the English popular imagination as Chinese export porcelain had a century before. In majolica this fascination was expressed in stork, fan, prunus blossom and pine branch shapes. Most of these motifs appeared on argenta wares, majolica with cream colored grounds. These were very popular at the time but were made under the intense pressures of the early 1880s American majolica craze. As a consequence, many were poorly manufactured, even by the better potters.[35]

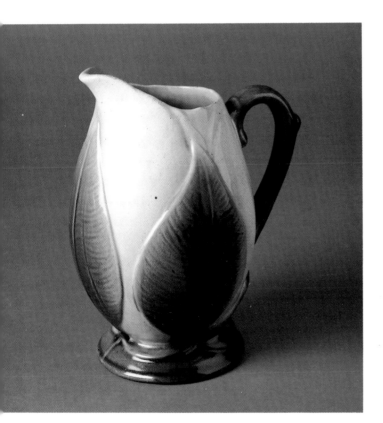

Pitcher, unattributed, possibly English; sleek pond lily motif. 6.5″ high. *Courtesy of Michael G. Strawser, Majolica Auctions.* $250-275

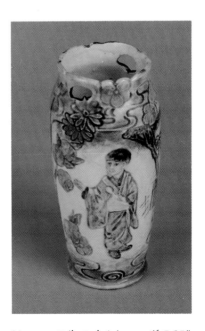

Vase, unattributed; Asian motif. 5.25″ high. *Courtesy of Michael G. Strawser, Majolica Auctions.* $75-85

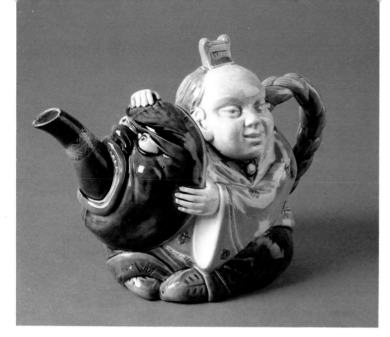

Teapot, Minton, 1876; figural "Chinaman." 7.5" side x 5.5" high. Exposure to Asia influenced designers in different ways to create popular ware in the *japonisme* or *chinoiserie* styles. Some used bastardizations of Asian art styles; others portrayed Western stereotypes of Asian scenes and people. *Courtesy of Michael G. Strawser, Majolica Auctions.* $2200-2420

Platter, Wedgwood; Japanese prunus blossoms and cloud pattern. 9" x 12". *Courtesy of Michael G. Strawser, Majolica Auctions.* $790-985

Sardine box, Wedgwood; in an Asian style. 8" x 7". After the 1862 and 1867 exhibitions, some designers did take Asian aesthetic principles to heart, creating more spare, delicate and balanced pieces. *Courtesy of Michael G. Strawser, Majolica Auctions.* $925+

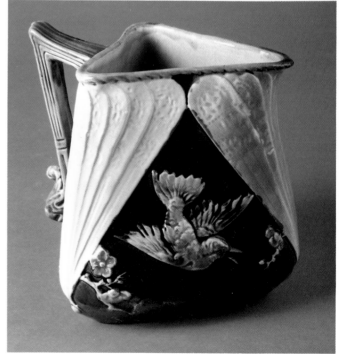

Triangular pitcher, unattributed, English registry mark; cobalt, with bird and fan motif. 6" high. *Courtesy of Michael G. Strawser, Majolica Auctions.* $675+

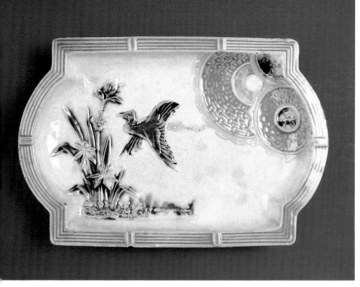

Platter, unattributed; iris and crane motif. 10.5" x 7". *Courtesy of Michael G. Strawser, Majolica Auctions.* $470-520

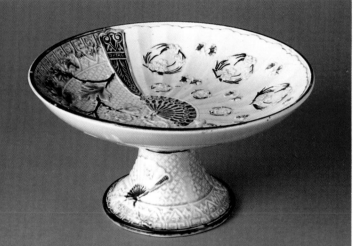

Comport, Tazza; fan and floral motifs. 9" dia. x 4.75" high. *Courtesy of Michael G. Strawser, Majolica Auctions.* $175-195

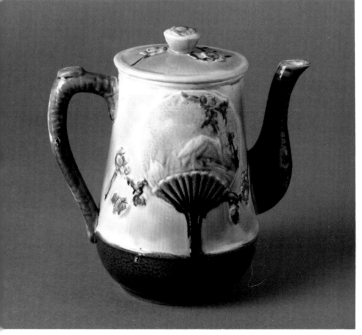

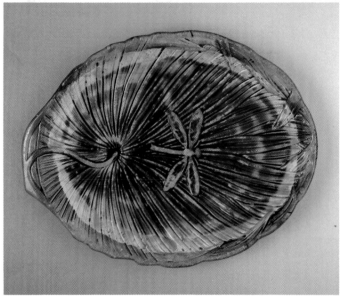

Sugar bowl, unattributed; Japanese fan motif. 5.5". *Courtesy of Michael G. Strawser, Majolica Auctions.* $210-230

Platter, unattributed; lily pad and dragonfly design. 11.5" x 9". *Courtesy of Michael G. Strawser, Majolica Auctions.* $230+

Coffee pot, unattributed; crane and fan motif with cobalt base. 8" high. *Courtesy of Michael G. Strawser, Majolica Auctions.* $275-300

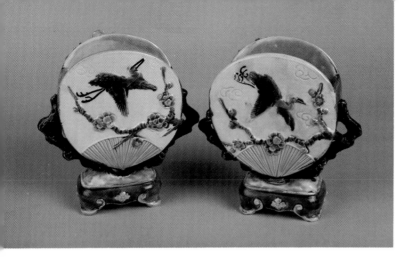

Two vases, unattributed; Asian flying cranes and prunus blossoms painted on front sides, applied roses on the reverse. 6.25" high. *Courtesy of Michael G. Strawser, Majolica Auctions.* $500+ each

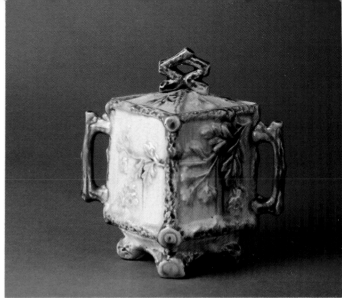

Covered, footed sugar, unattributed; angular, Asian tree-bark design on a light argenta-type ware. 6". *Courtesy of Michael G. Strawser, Majolica Auctions.* $125-135

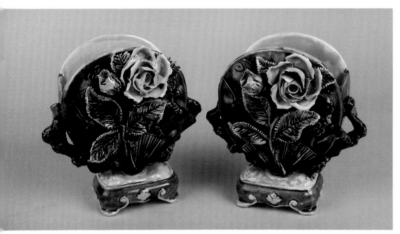

Reverse of round Asian flying crane vases.

Basket, unattributed; three-parts, cobalt with cockatoos and bamboo. 7.5" high. *Courtesy of Michael G. Strawser, Majolica Auctions.* $625+

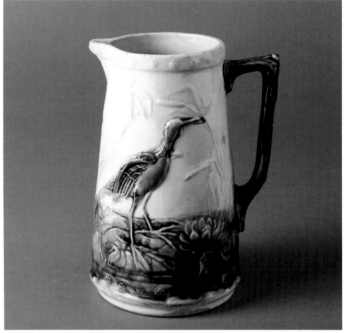

Pitcher, unattributed; stork with bamboo and water lily. 7" high. Note the white argenta background glaze. *Courtesy of Michael G. Strawser, Majolica Auctions.* $275-300

Waste bowl, unattributed; another argenta piece, with basket and prunus blossom motifs. 5.75" dia. x 3" high. *Courtesy of Michael G. Strawser, Majolica Auctions.* $50-60

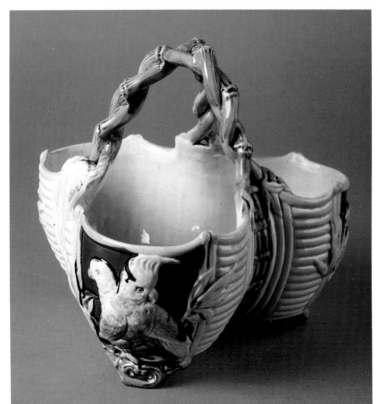

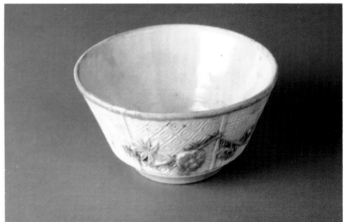

6. The Aesthetic Movement

While the Industrial Revolution brought lower prices and social change to the Western world, it also brought the ugliness of an industrialized world. The Aesthetic Movement was a social and artistic reaction to that ugliness with its sunflower and peacock motifs. It favored simplicity of design, largely shunning the flamboyance of earlier majolica. During this period, manufacturers produced argenta ware.[36]

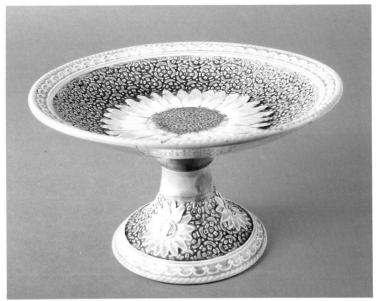

Comport, unattributed; sunflowers in center and around base, with a richly molded background texture. 9.25" dia. x 4.25" high. *Courtesy of Michael G. Strawser, Majolica Auctions.* $250-275

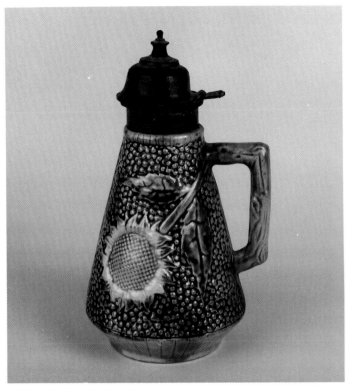

Syrup dispenser, Griffen, Smith & Co. "Etruscan;" cobalt with the Aesthetic Period sunflower and a pewter lid. 8.5" high. *Courtesy of Michael G. Strawser, Majolica Auctions.* $600-700

From Griffen, Smith & Co. catalog, some sunflower wares.

Five-stemmed bud vase, Minton; the peacock was another favorite motif of the Aesthetic period. 10.5" high, 10" wide. $2100+

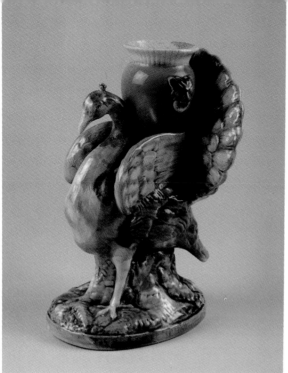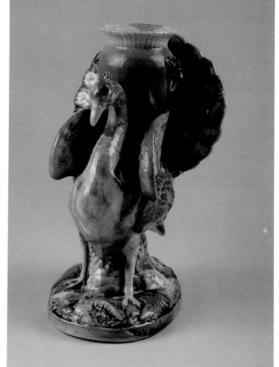

Vase, unattributed; figural peacock. 8" high. NP

7. Art and Crafts

During the last quarter of the nineteenth century, Arts and Crafts styles came into favor, characterized by curved designs taken from the natural shapes of flowers and plants. Gone were fancy embellishments and excessive decorative techniques. This was highly stylized nature, graced with a simplicity of design. Japanese art was influential during this period as well.

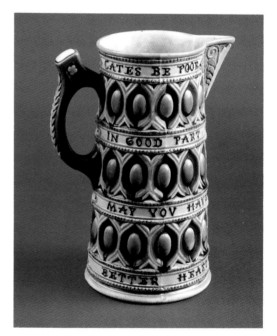

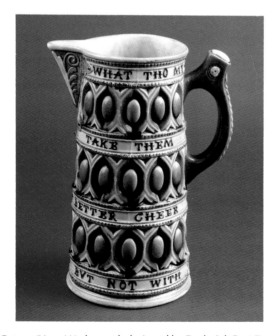

The "Caterer" jug, Wedgwood, designed by Frederick Bret Russel c. 1868; "What tho my gates be poor/Take them in good part/Better cheer may you have/but not with better heart." 7.5" tall. The Arts and Crafts movement called upon medieval inspiration for this jug. $640-710

Bottom of the "Caterer" jug, with Wedgwood mark, Russel's personal mark, and English registry mark.

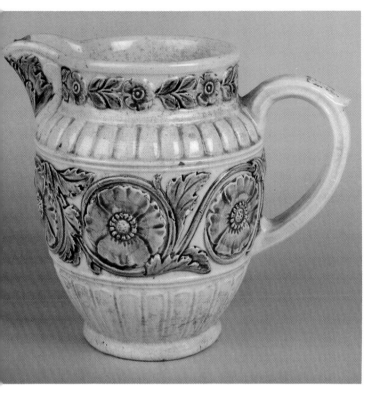

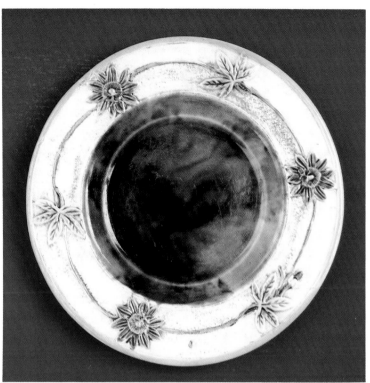

Pitcher, unattributed; homespun-look Arts and Crafts period pattern. 8" high. *Courtesy of Michael G. Strawser, Majolica Auctions.* $175+

Plate, unattributed; leaves and cornflowers in a simple Arts and Crafts style, 10.5" dia. *Courtesy of Michael G. Strawser, Majolica Auctions.* $85-95

8. Art Nouveau

The end of the Victorian majolica years overlapped the beginning of the style called Art Nouveau, a gracefully fluid, stylized evolution of natural art motifs. The soft glazes of majolica were remarkably well suited to Art Nouveau's soft lines. The new worldwide popularity of this French style gave majolica manufacturers their last impetus to create fresh, original designs (especially on the Continent), but it was not enough to curtail majolica's continuing decline.

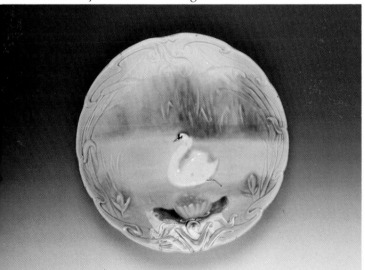

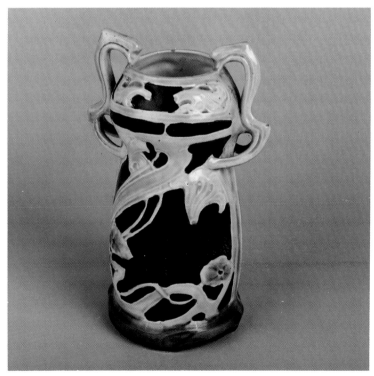

Plate, unattributed, probably French; Art Nouveau makes a subtle appearance in the molded border. 6.5" dia. *Courtesy of Michael G. Strawser, Majolica Auctions.* $295-325

Vase, unattributed, Continental; vividly Art Nouveau. 8" high. *Courtesy of Michael G. Strawser, Majolica Auctions.* $150-165

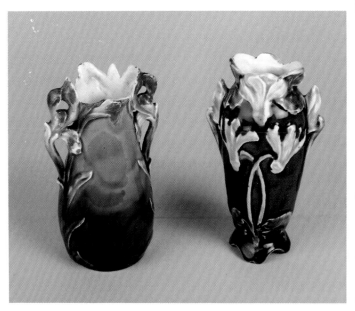

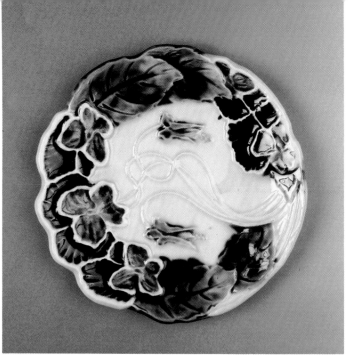

Two vases, unattributed, Continental. Both approximately 5.5" high. *Courtesy of Michael G. Strawser, Majolica Auctions.* $150-165 each

Plate, Continental; Art Nouveau pansy decoration. 6.75" dia. *Courtesy of Michael G. Strawser, Majolica Auctions.* $155-170

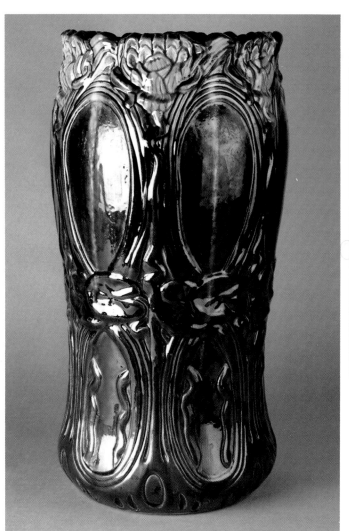

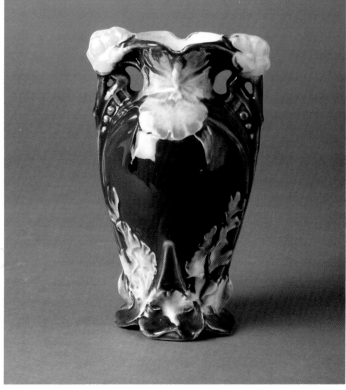

Vase, Continental. 6" high. *Courtesy of Michael G. Strawser, Majolica Auctions.* $150-165

Umbrella stand, unattributed; the swirl of Art Nouveau, in cobalt and gold. 27" high. *Courtesy of Michael G. Strawser, Majolica Auctions.* $500+

Majolica wares were manufactured in abundance for a relatively short period of time. Many potters, both large and well known or small and obscure, produced the ware. Smaller firms purchased the worn molds of larger works and continued decorative motifs that may have been falling from fashion. Many of these smaller establishments also did not mark their wares; it did not profit them to identify themselves if they had no reputation to work with. On the other hand, it helped them if the pieces they made from old molds were mistaken for the wares of the larger and esteemed firm. No doubt small American firms also left their wares unmarked in the hopes of being mistaken for the preferred English wares.

American firms produced wares similar to those Minton and Wedgwood had introduced and of more current taste. One challenge for American potters was to prove to a skeptical public that their wares could be as good or better than their British counterparts.

All of this makes dating unmarked and unattributed majolica wares difficult at best. Many times the most you can hope for is to know the date of earliest possible production.

Dating Majolica with Manufacturer's Marks

Majolica from large British potteries, some of America's better firms, and some from the Continent bear distinctive manufacturer's marks. The marks in majolica usually include the manufacturer's name and/ or the symbol of the company and were applied in one of several ways. Most were impressed with a stamp into the soft earthenware bodies of unfired wares, as was the Minton name or the Griffen, Smith & Hill cartouche. Other manufacturer's marks were scratched the unfired ware, painted on the surface before or after glazing, or transferred at the same time as the painted tin-glaze decorations and then fired in the kiln.

By knowing when certain terms first appeared on specific marks, a great deal of information may be gleaned from the manufacturer's marks. The following guidelines provide the key elements of English and American mark identification on marked majolica wares up to the turn of the twentieth century.

No impressed or printed name marks were in use prior to 1755. Some earlier wares and majolica may look very similar, but before 1755 none bore impressed or printed name marks. 1775

Garter-like marks of round or oval shape are first used in 1840. 1840

Registration marks (see discussion below) came into use with manufacturer's marks in 1842 and ceased to be used after 1883. The diamond-shaped registration mark was an English designation indicating that a design or process had been registered. 1842-1883

"Royal" in the manufacturer's trade name was used on many English marks after 1850. post-1850

"Limited" or any standard abbreviation on English wares was incorporated into manufacturer's marks post-dating an 1855 act establishing them and this term does not actually appear in used before 1860. post-1855

"Copyright" indicates a design, name or material 1859

is registered under United States copyright laws from 1859 to the present. It is usually a 20th century mark.

"Trade Mark" has been applied to English pieces in accord with the Trademark Act of 1862 and was England post-1862
applied to American wares after 1875. post-1875 U.S.

"Copyright Reserved" on a mark dates from 1877 and is a legal term used on English wares. 1877

"England" in the mark indicates a date after 1880, and generally after 1891, on export wares. post-1880

Registration numbers originate in 1884 (see below). They are English designation which indicates that a design or process has been registered. — 1884

"Made In" begins use in 1887 and continues to be used. English law required imported wares to be marked with these words and the country name. — 1887

"Warranted" was used in several ways. In the United States and England it appears as part of the company name in the 1890s. — 1890

"Made in England" is a twentieth-century designation only required on wares exported from England. — 1900

"Patented" occurs from 1900 onward as well. "Patented" signifies that a patent was granted by the United States Patent Office. — 1900

Patent number on the base of the holy font.

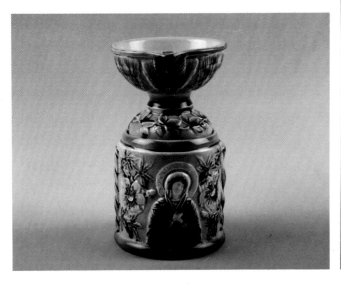

Holy water font and dispenser, unattributed American, marked with an American patent number, two pieces. 6.5" high. NP

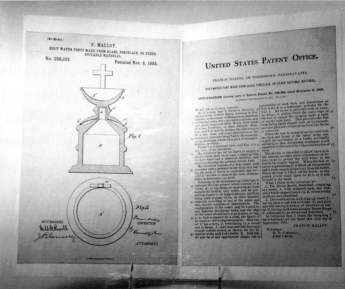

Patent for holy water font.

"U.S. patent" was used after 1901 to denote that the design or method is patented in the United States. This term is also found on wares made outside the United States. — post-1901

"Patent applied for" dates from 1902 to the present. It signifies that a patent application has been filed with the United States Patent Office. — 1902

When presented with majolica wares without marks, you need to rely on knowledge of the manufacturers and their patterns, vessel forms and the general periods during which major social movements effected majolica designs.[1]

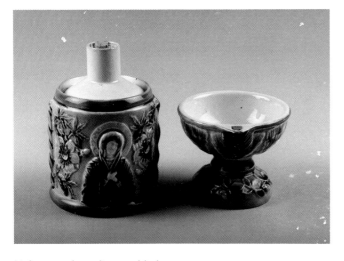

Holy water font, disassembled.

Registration Marks

English registration marks are possibly the most complete and useful marks for dating English majolica. Since 1842, English decorative art designs have been registered at the British patent office; however, not every registered piece is marked.

A diamond-shaped mark was used between 1842 and 1883. The information within the diamond changed after 1867. In 1884 the diamond-shaped marks were dropped in favor of simpler registry numbers (Rd. No.), indicating the year the piece was registered in a numeric sequence beginning in 1884 with the number 1. Registry numbers provide the earliest possible date of manufacture.[2]

The diamond-shaped registry marks from 1842-1867 contain letters and numbers to indicate:

the large Rd is an abbreviation for "registered"

the Roman numeral in the circle at the top of the mark represents the type of material from which the piece was produced

the Roman numeral in the top inside section of the diamond represents the year the piece was registered

the Arabic numeral in the right section represents the day of the month the piece was registered

the Arabic numeral in the section at the base represents the parcel number, which is a code indicating the person or company who registered the piece

and the letter in the left section represents the month the piece was registered.[3]

In 1868, the numbers and their locations changed:

the large Rd and Roman numeral above the diamond remain unchanged the Arabic numeral in the top inside section of the diamond represents the day of the month the piece was registered

the letter in the right-hand section represents the year the piece was registered

the letter in the bottom section signifies the month the piece was registered

and the Arabic numeral in the left-hand section represents the parcel number.[4]

The tables below provide the code numbers and letters on the diamond-shaped registry marks.[5]

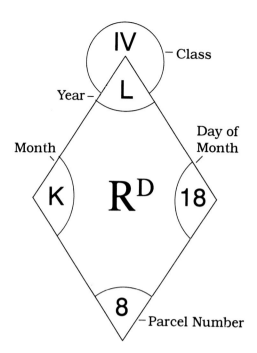

**Registration Mark
1842-1867**

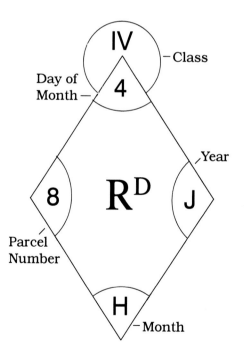

**Registration Mark
1868-**

Table 1

Type of material or class

I-metal II-wood
III-glass IV-ceramics

Table 2

Month of the Year of Manufacture

C-January I-July
G-February R-August
W-March D-September
H-April B-October
E-May K-November
M-June A-December

Table 3

Year of Manufacture-1842-1867

1842-X	1851-P	1860-Z
1843-H	1852-D	1861-R
1844-C	1853-Y	1862-O
1845-A	1854-J	1863-G
1846-I	1855-E	1864-N
1847-F	1856-L	1865-W
1848-U	1857-K	1866-Q
1849-S	1858-B	1867-T
1850-V	1859-M	

Table 4

Year of Manufacture-1868-1883

1868-X	1874-U	1879-Y
1869-H	1875-S	1880-J
1870-C	1876-V	1881-E
1871-A	1877-P	1882-L
1872-I	1878-D	1883-K
1873-F		

After 1883, the diamond marks were discontinued and a simpler marking system was instituted, providing only the Rd number and coded year of registration. The numbers simply ascend consecutively from number 1 in 1884. This mark appears on decorative art manufactured in England after 1884.

Table 5

Partial Guide to Design Registry Numbers 1884-1915

Year	-	First Registry Number of Each Year
1884	-	1
1885	-	20000
1890	-	142300
1895	-	248200
1900	-	351600
1905	-	447800
1909	-	548920
1915	-	644935

British Majolica

During the second half of the nineteenth century, dozens of the potting firms in the Staffordshire region (there were over 130 by 1851) made contributions to majolica. Short histories of a number of these firms, both large and small, accompany the examples of their majolica wares presented here. Some majolica wares may never be identified with certainty, however, as many of the smaller firms found no benefit in marking their majolica wares.

The larger and more established firms tended to set the trends and create the demand for majolica. The smaller firms tended to follow in the footsteps of their larger competitors, imitating their successes more often than creating new designs or forms of their own.

John Adams & Company

From 1864 to 1873, John Adams and Company produced majolica in abundance in Hanley, England. Between 1873 and 1886, with the acquisition of a new partner, the firm became Adams and Bromley Pottery. They continued to produce a wide variety of majolica wares including bread trays, cheese bells, teapots, vases, garden seats and fountains.[1]

John Adams & Company Marks
Their manufacturer's marks "J. ADAMS & CO" or "ADAMS & CO." are found impressed on their wares.

Banks and Thorley

Banks and Thorley was established in 1873 at Hanley. In 1887 the name changed to Banks and Company, and in 1888 to Edward Banks. The company produced majolica bread trays, cheese bells, tea services, dessert sets, jardinieres and other assorted ornamental pieces. Two known patterns for Banks and

Creamer, possibly Banks and Thorley's *Bamboo and Basketweave* pattern. 3" high. *Courtesy of Michael G. Strawser, Majolica Auctions.* $310-340

Thorley are *Bamboo and Basketweave* and *Fern, Floral and Bow*.[2]

Banks and Thorley Marks
As was common with many smaller establishments, Banks and Thorley apparently used no manufacturer's mark. Registration numbers on the bases of their wares date from the mid-to late-1880s. The bases themselves are either white, cream, or yellow.

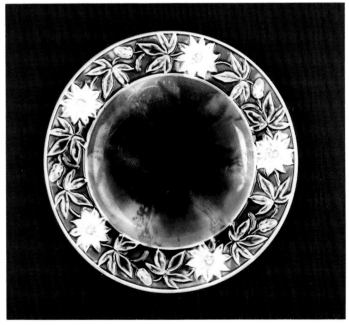

Rare signed plate, Adams & Bromley; floral with mottled glaze center. 9.75" dia. *Courtesy of Michael G. Strawser, Majolica Auctions.* $600+

Brown-Westhead, Moore & Company

Located in Cauldon Place, Hanley, England, Brown-Westhead, Moore & Co. concentrated their efforts in the overseas market for majolica, especially as they headed into the 1880s and local demand was waning. Using exhibitions to their advantage, the firm made significant inroads in the American market between 1876 and 1900.

The company took advantage of French talent, employing the painter Antonin Boullemier during the 1880s. Their early majolica was sumptuous, with a cream colored body bearing thickly painted, lustrous glazes in natural colors and themes. Brown-Westhead, Moore and Company's early efforts were praised by the critics; their later exports were considered too conventional.

Brown-Westhead, Moore & Company was known for their basket-weave comport supported on a tripod base molded in the appearance of bent twigs.[3]

Brown-Westhead, Moore & Co. Marks

Their impressed manufacturer's marks varied from the full company name to "B.W.M. & Co." and "B.W.M." (1862-1904).

William Brownfield

Pair of bud vases, Brown-Westhead, Moore & Co.; elegant cobalt with bamboo supports. 8" high. *Courtesy of Michael G. Strawser, Majolica Auctions.* $375+

Spoon warmer, Brown-Westhead, Moore & Co.; robin's egg form. 8" long x 5" high. *Courtesy of Michael G. Strawser, Majolica Auctions.* $800+

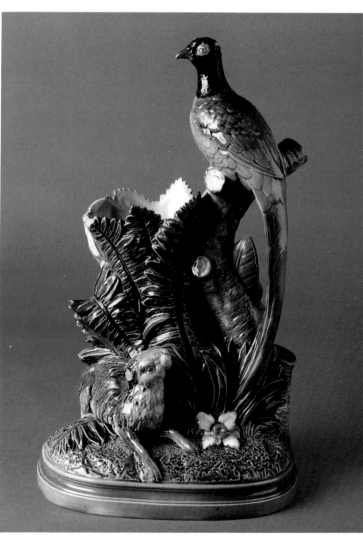

Vase, Brownfield & Sons, with double globe mark and English Registry Mark; pheasant and hare motif. 14" high. *Courtesy of Michael G. Strawser, Majolica Auctions.* $1050+

William Brownfield's pottery in Cobridge, Staffordshire, England was manufacturing majolica by the early 1870s and continued until the factory was closed and demolished in 1900. By 1872 the company had hired an art director trained at Minton, Louis Jahn. During the 1880s, the company had roughly 600 individuals employed to manufacture decorative earthenwares. While the company's primary interest was transfer printed wares, majolica was made in quantities for home sales and for the export markets in Europe, Canada and the United States. The most common examples of Brownfield majolica to be found include figural teapots, dessert services, bird-shaped pitchers, and urns.[4]

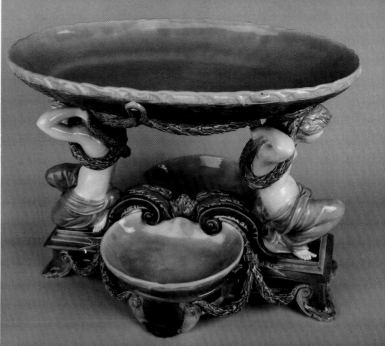

Centerpiece, Copeland; classically-sculpted women support an elegant dish. 11.5" high x 14.5" long x 9" wide. Copeland produced elegant pieces for their participation in all of the major exhibitions. *Courtesy of Michael G. Strawser, Majolica Auctions.* $9750+

Impressed Brownfield and Sons double globe and impressed manufacturer's marks (1871-1891) on bottom of Brownfield vase.

William Brownfield Marks

The company had a variety of impressed and printed marks. A simple impress of the company name "BROWNFIELD" was first used in 1860 and continued in use for the life of the firm. A very elaborate mark featuring both halves of the globe surrounded by a banner including the company name "BROWNFIELD & SON" was used for twenty years beginning in 1871. A registry mark was sometimes present.

W. T. Copeland & Sons

This company, located in Stoke-on-Trent, England, came under the control of William Taylor Copeland in 1847. It had been founded by Josiah Spode in the late eighteenth century. In 1867 William was joined by his four sons, adding "& Sons" to the firm letterhead.

Copeland produced a well-received porcelain line and some earthenwares. The size of the firm rivaled Minton but their majolica production was far less, centering mostly on table wares. Some of their majolica was so delicate it was mistaken for porcelain.

Copeland received royal patronage and was involved in all of the major exhibitions of the late nineteenth and early twentieth centuries. [5]

W. T. Copeland & Sons Marks

The firm used a variety of printed and impressed manufacturer's marks and almost all of their majolica is marked. A common majolica mark is the impressed "COPELAND" name in capital letters. Often this mark was accompanied by an English registry mark. (see Chapter III, registry marks)

William De Morgan

William De Morgan established a pottery in Merton, England in the early 1870s. Most of De Morgan's majolica output was in ornamental wares such as tiles and vases.[6]

William De Morgan Marks

De Morgan's manufacturer's mark consisted of the letters "DM" located above a tulip with two leaves. Sometimes the initials of an artist accompany the mark.

S. Fielding & Company

Established by Simon Fielding in 1870 at Stoke-on-Trent as the Railway Pottery, the company produced a wide range of decorative earthenware. In 1878, Simon's son Abraham took over the management of the company and by 1879 had changed the name to S. Fielding and Son. By 1880 the firm was potting majolica in the Argenta style, plain bodies with limited majolica glaze decoration, which Wedgwood had found popular.

The company produced majolica for regular use and decorative wares. Both their shell and hummingbird patterns proved very popular.[7]

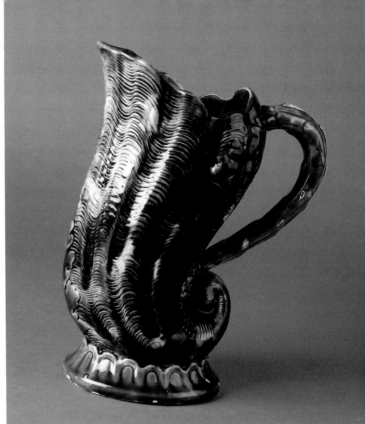

Pitcher, Fielding, with English Registry Mark, 1883; their very popular seashell figural. 10.25" high. *Courtesy of Michael G. Strawser, Majolica Auctions.* $695-765

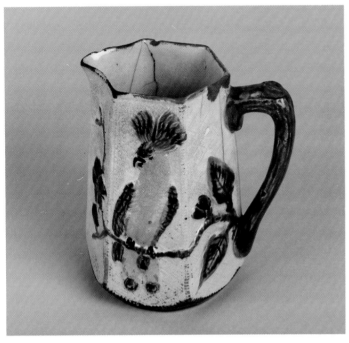

Pitcher, Fielding; six-sided, argenta-type ware with parrot. 6.25" high. *Courtesy of Michael G. Strawser, Majolica Auctions.* $480+

Butter pat, Fielding. *Courtesy of Michael G. Strawser, Majolica Auctions.* $250+

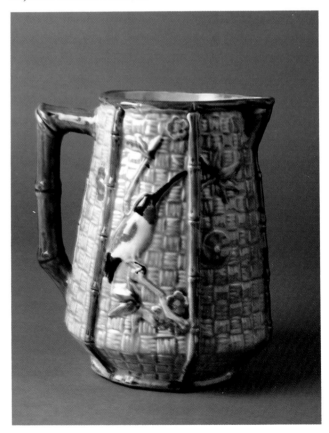

Pitcher, Fielding, with English Registry Mark; hummingbird design. 7.5" high. *Courtesy of Michael G. Strawser, Majolica Auctions.* $600+

S. Fielding & Company Marks

Not all of S. Fielding & Co. majolica was marked. Some was impressed with "FIELDING" (c. 1879) or variations of "SF & Co." (1880-1917).

Thomas Forester & Sons, Ltd.

Called the Church Street Majolica Works when it first opened in Longton, England in 1877, Thomas Forester soon changed his company's name to the Phoenix Works, in 1879. The name Thomas Forester & Sons was not assumed until 1883. They were known for "salt-rolled" majolica, gurgling fish pitchers, and applied three-dimensional flowers "à la Barbotin," modeled after French majolica. All of the major British design motifs were represented in their wares, which they marketed energetically in the Untied States.

In 1895, an observer noted that the pottery had the capacity to produce 12,000 floral art pots each week, helped by at least one machine which could turn out two a minute. While the company's advertisement of majolica per se had ceased by 1889, they continued to produce the same types of ware, of respectable if not particularly good quality, at least until World War One.

Thomas Forester & Sons Marks

The company's marks are known to include a Phoenix and a "TF&SLTD" imprint, though no piece of majolica has ever been found so marked, or with an English registry mark. In later years, the mark "Foresters England" was used.

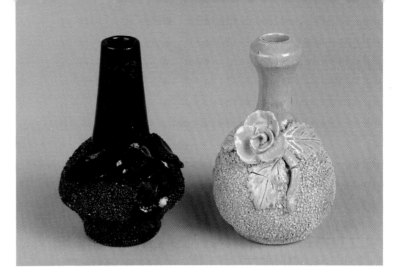

Two vases, unattributed; salt-rolled glaze, one in cobalt, the other in a vibrant yellow. 4.5" high. Salt rolling produced this unusual surface texture. *Courtesy of Michael G. Strawser, Majolica Auctions.* $60-70 each

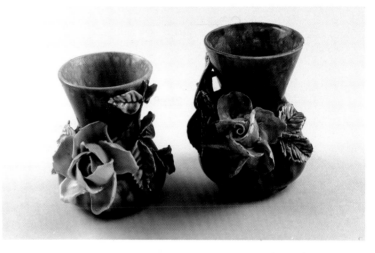

Two small, smooth-glazed vases, unattributed, "a la Barbotin." *Courtesy of Michael G. Strawser, Majolica Auctions.* $60-70 each

Joseph Holdcroft

Known for excellent work, Joseph Holdcroft, like George Jones, was another Minton apprentice. His eighteen years working with Minton in various capacities during the Arnoux majolica period left an impression on Holdcroft. He established two works of his own, the first in 1868 (about which little is known) and the second in 1870, the Sutherland Pottery at Daisy Bank in Longton, where he specialized in domestic earthenwares, including majolica.

Holdcroft produced a wide variety of high quality household wares including plates, trays, footed bowls, serving spoons, syrups and pitchers. Holdcroft took advantage of the rise in overseas demand. A large portion of his majolica wares were designed with the North American, South American and Australian markets in mind.

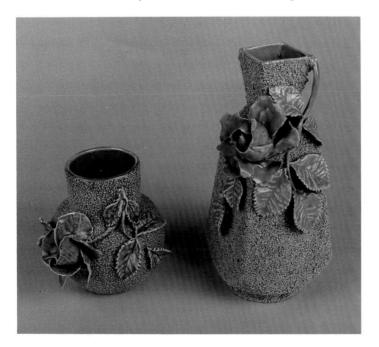

Vibrant burgundy and yellow salt-rolled vases, unattributed; salt-rolled glaze with applied roses. 4.5" and 8.5" high. *Courtesy of Michael G. Strawser, Majolica Auctions.* Left: $60-70; right: $80-90

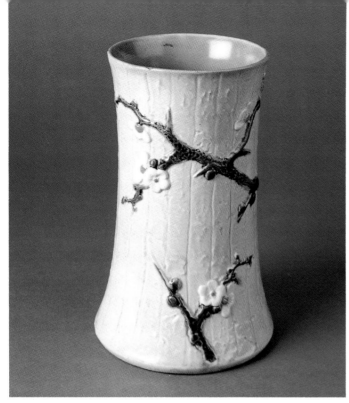

Salt, Holdcroft; figural monkey. 4.5" high. Take *that*, Charles Darwin! *Courtesy of Michael G. Strawser, Majolica Auctions.* $1400+

Vase, Holdcroft; dogwood motif. 8.5" high. *Courtesy of Michael G. Strawser, Majolica Auctions.* $350+

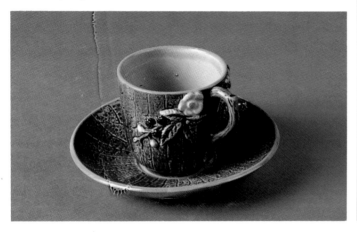

Tea cup and saucer, Holdcroft; bark and blackberry motif. 3.75" high. *Courtesy of Michael G. Strawser, Majolica Auctions.* $315-330

Candy dish, Holdcroft; seashell motif. English Registry Mark on back. 7" x 5". *Courtesy of Michael G. Strawser, Majolica Auctions.* $125-135

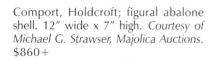

Comport, Holdcroft; figural abalone shell. 12" wide x 7" high. *Courtesy of Michael G. Strawser, Majolica Auctions.* $860+

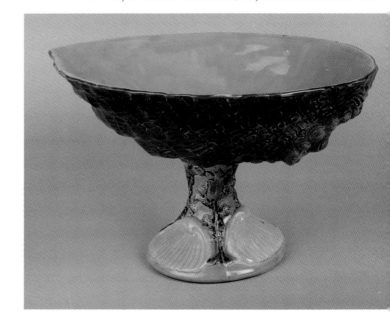

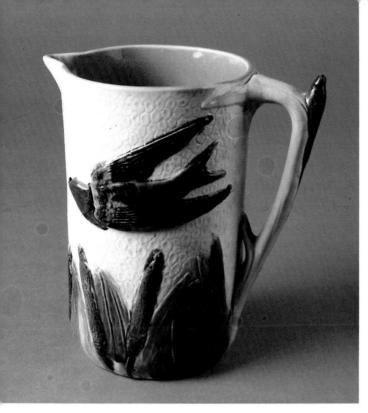

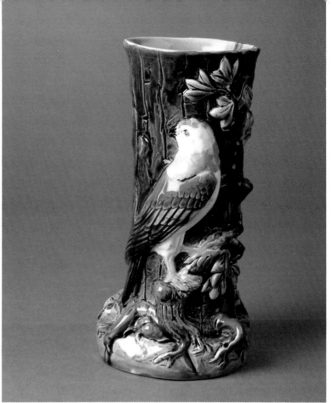

Pitcher, Holdcroft; bird in flight with cattails. 6" high. *Courtesy of Michael G. Strawser, Majolica Auctions.* $225-250

Vase, Holdcroft; figural bird on stump. 7.5" high. *Courtesy of Michael G. Strawser, Majolica Auctions.* $450+

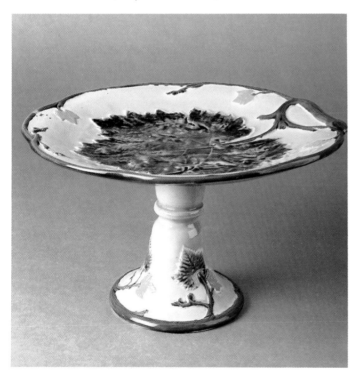

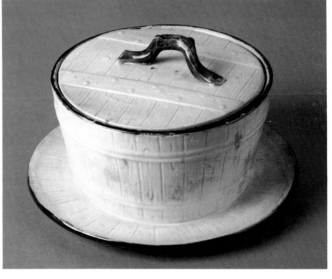

Butter tub, Holdcroft-style; attached underplate, turquoise interior. 6.5" long x 4.5 high. *Courtesy of Michael G. Strawser, Majolica Auctions.* $185-205

Compote, Holdcroft; maple leaf motif. 9.5" dia. x 6" high. *Courtesy of Michael G. Strawser, Majolica Auctions.* $565+

Two syrup dispensers, (left) Holdcroft and (right) unattributed; Both feature floral and foliage designs with patterned backgrounds and pewter lids. *Courtesy of Michael G. Strawser, Majolica Auctions.* $500+ each

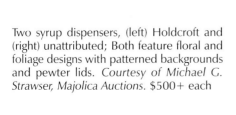

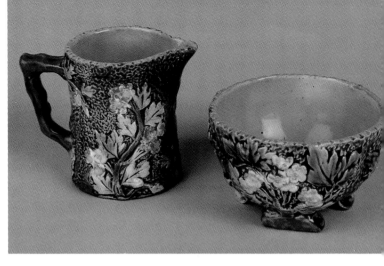

Holdcroft tended to follow in George Jones' footsteps, producing many majolica wares modeled after Jones' designs. The bodies and glaze colors also were similar and Holdcroft similarly enjoyed the rustic style Jones used so well, especially in the use of common English birds. As with many other firms, Holdcroft also looked back to earlier nineteenth century wares for designs to be transformed with majolica glazes.[8]

Joseph Holdcroft Marks

The manufacturer's marks of Holdcroft and Jones were similar as well; Holdcroft sometimes used a small impressed JH monogram in a circle. Other Holdcroft marks included the impressed "HOLDCROFT" name or at times simply the initial J.

Creamer and sugar bowl set, George Jones. Creamer, 3" high. *Courtesy of Michael G. Strawser, Majolica Auctions.* $310-330

From the George Jones & Sons pottery established at Stoke-on-Trent in 1861, George Jones rivaled the Minton factory for top honors in majolica production. George Jones had apprenticed at the Minton factory in the early 1850s when majolica was in its infancy. He was exposed to the designs of Léon Arnoux and instilled with the company's high standards. His firm was unique among the Staffordshire potters, however, as a specialist in majolica. This colorful ware accounted for over 70 percent of Jones & Sons production in 1875.

George Jones, like many other firms, made use of exhibitions to present his wares. However, he did not display them as widely as either Minton or Wedgwood.

Jones produced a wide range of forms, concentrating on useful wares rather than ornamental pieces. These included ashtrays, jardinieres, footed centerpieces, cheese plates, caviar servers, oyster plates, sardine boxes, menu and place card stands and spittoons.

One of George Jones & Sons most popular patterns was the rustic and naturalistic "Dogwood," registered in 1873. Other familiar patterns include "Iris and Lily" and "Dogwood and Woven Fence." His wares are known for their use of English birds, including robins, wrens, finches, kingfishers and sparrows. Other optional "nature" decorations could be added for a price, including a line of butterflies in full relief. Jones had a whimsical side as well and include "pun" patterns including a "Punch" bowl. The bases of George Jones wares were frequently glazed in a mottled tortoiseshell pattern of green and brown.

By 1880 when the demand for majolica was declining in England, George Jones diversified his line and vastly diminished his range of majolica wares.[9]

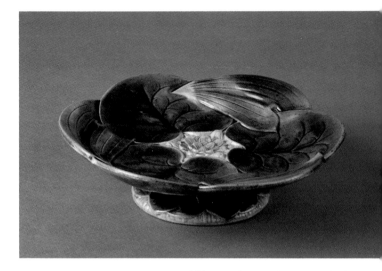

Comport, George Jones; pond lily motif. 8.5" dia. x 2.5" high. *Courtesy of Michael G. Strawser, Majolica Auctions.* $470-520

Vase, George Jones; lily of the valley pattern. 8.5" tall. *Courtesy of Michael G. Strawser, Majolica Auctions.* $2000+

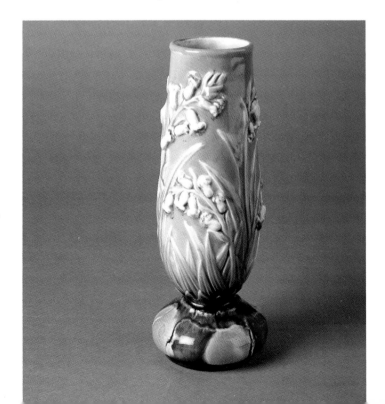

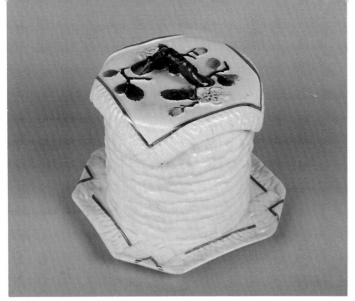

Jam jar, George Jones; apple blossom design. *Courtesy of Michael G. Strawser, Majolica Auctions.* $675+

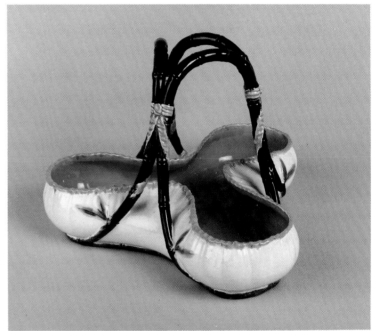

Cheese dome, George Jones; picket fence and floral motif. 10.5" dia. x 7.5" high. *Courtesy of Michael G. Strawser, Majolica Auctions.* $3225+

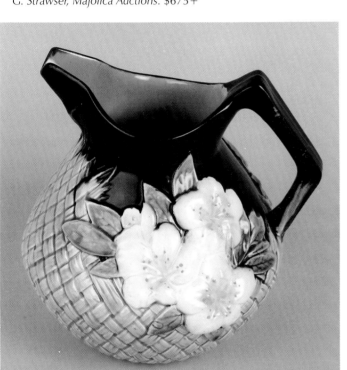

Pitcher, George Jones; cobalt with basket and floral pattern. 7.5" high. *Courtesy of Michael G. Strawser, Majolica Auctions.* Sold in October 1999 at auction for $1700.

Basket, George Jones; trefoil with bamboo handles. 7" high. *Courtesy of Michael G. Strawser, Majolica Auctions.* $1255-1380

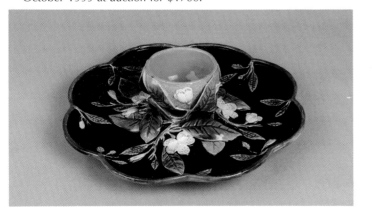

Strawberry server, George Jones; cobalt. 11" long. *Courtesy of Michael G. Strawser, Majolica Auctions.* $2725+

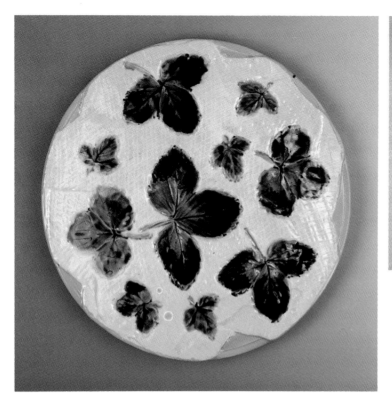

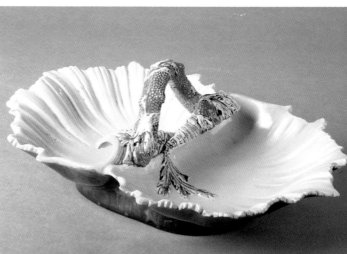

Two-part basket, George Jones; shell and seaweed theme. 13" long x 9" wide x 4.5" high. *Courtesy of Michael G. Strawser, Majolica Auctions.* $565+

Plate, George Jones; strawberry motif. 8" dia. *Courtesy of Michael G. Strawser, Majolica Auctions.* $625+

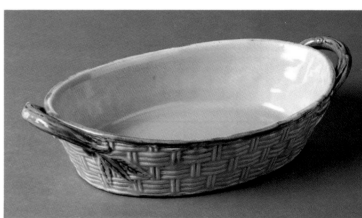

Two-handled basket, George Jones; underside is mottled glaze. 10" x 5". *Courtesy of Michael G. Strawser, Majolica Auctions.* $250-275

GJ manufacturer's mark (1861-1873) on strawberry plate; the glaze on the back is mottled, typical of George Jones' ware.

Basket, George Jones; footed and handled. 9.5" dia. *Courtesy of Michael G. Strawser, Majolica Auctions.* $565+

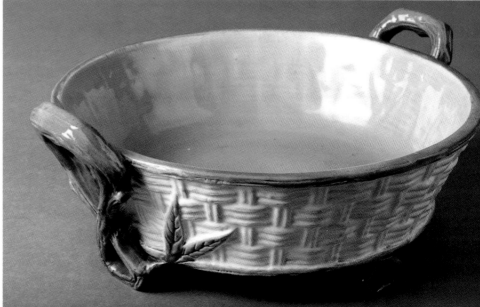

Bowl with basket handles. George Jones; mottled interior, basketweave sides. 13" x 9.5". *Courtesy of Michael G. Strawser, Majolica Auctions.* $315-330

Cheese dome, George Jones, c. 1873, *Dogwood and Woven Fence* pattern. 10.5" dia. x 10.5" high. *Courtesy of Michael G. Strawser, Majolica Auctions.* $5000+

Low cheese dome, George Jones; *Dogwood* design from the 1870s. 5" high x 10" dia. *Courtesy of Michael G. Strawser, Majolica Auctions.* $2425+

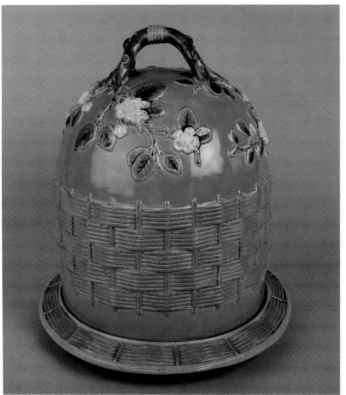

Cheese dome, George Jones; *Dogwood and Woven Fence* design. 13" high. *Courtesy of Michael G. Strawser, Majolica Auctions.* $5000+

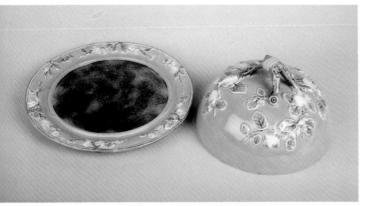

Inside the George Jones cheese dome, a mottled plate.

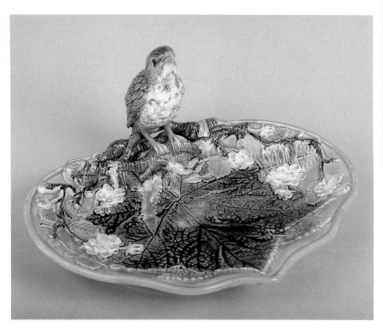

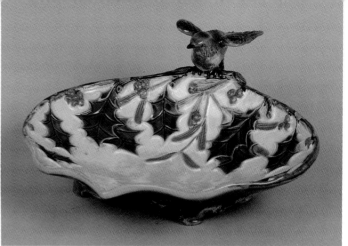

Sweetmeat dish, George Jones; holly pattern. 8" across. *Courtesy of Michael G. Strawser, Majolica Auctions.* $1500-1850

Server, George Jones; figural thrush. 10.5" across x 6" high. *Courtesy of Michael G. Strawser, Majolica Auctions.* $1500-1850

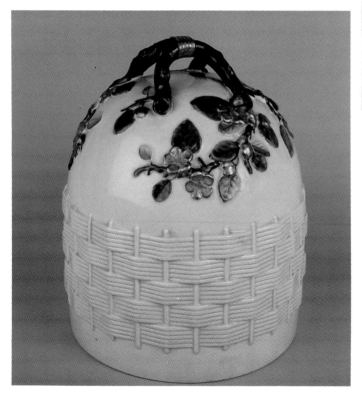

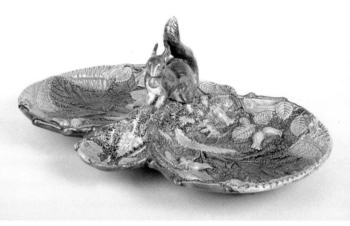

Double server, George Jones; squirrel with nut. 14" across. *Courtesy of Michael G. Strawser, Majolica Auctions.* $1500-1850

Cheese dome cover, George Jones; *Dogwood and Woven Fence* design on argenta-type ware. 11" high. *Courtesy of Michael G. Strawser, Majolica Auctions.* $5000+ complete.

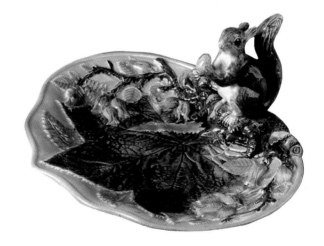

"George Jones" Squirrel server. *Courtesy of Michael G. Strawser, Majolica Auctions.* $1175-1500

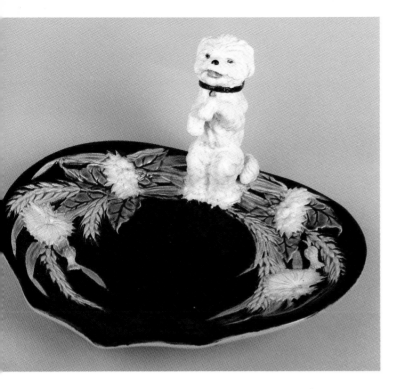

Server, George Jones; white terrier ornament. 10" long x 4.5" high. *Courtesy of Michael G. Strawser, Majolica Auctions.* $1500-1850

"GJ" manufacturers mark (1861-1873) and English registry mark on bottom of "Punch" bowl.

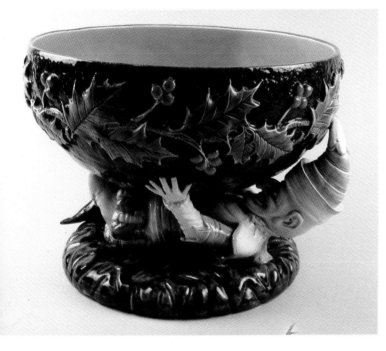

"Punch" bowl, George Jones, marked "GJ" with English Registry Mark. 11.5" dia. x 9" high. Punch, the drink rather than the stick wielding puppet, was quickly assimilated when first introduced in England, taking no more than twenty-five years for full acceptance. It reminded the British of possets and syllabubs, drinks with long and happy English associations. Surprisingly, tea took between 150 and 200 years to be taken to heart. Tea had no English predecessor and was therefore exotic and suspect. $7500-8000; this author has seen one example valued at $22,000.

George Jones & Sons Marks

Often a small unglazed spot remained on the base of these wares into which was painted or scratched a design or batch number. George Jones design numbers were consecutive, but do not indicate the manufacture date for individual pieces since many popular designs remained on the market for years. Majolica design numbers were mostly four digits beginning in the low 1000s in the early 1860s and ascending to the upper 6000s by the 1890s. During the peak of production, in c. 1874, the numbers range between 2000 and 3000.

At times the design number was the only mark on a George Jones piece. Frequently, however, the more informative and familiar impressed and underglazed GJ monogram within a circle is present. This may appear in a raised cartouche. After 1874, "& Sons" was added below the monogram.

Samuel Lear

Samuel Lear constructed a small pottery in Hanley, England by c. 1877, producing both domestic china and earthenwares. In 1882 the establishment expanded, adding both majolica and jasperwares fashioned after Wedgwood patterns to the company's inventories. The operations ceased in 1886 due to business failures.

Common majolica patterns recognized as Lear's today include *Sunflower and Urn, Pond Lily and Rope,* and *Lily of the Valley.* Lear's majolica is also recognizable by the light weight of the ware and the frequent use of geometric background patterns.[10]

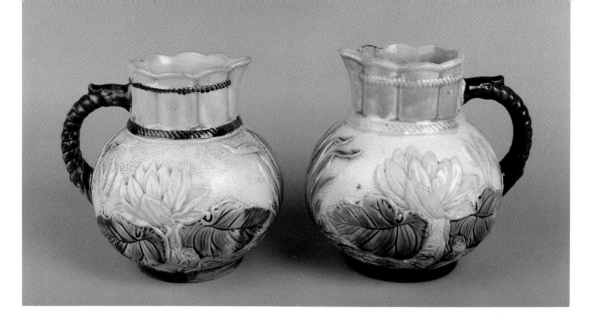

Pitchers, Samuel Lear; *Pond Lily and Rope* pattern. 7" high. *Courtesy of Michael G. Strawser, Majolica Auctions.* $350-385 ea.

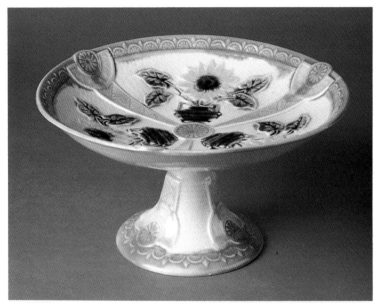

Compote, Samuel Lear; *Sunflower and Urn* design. 9" dia. x 5" high. *Courtesy of Michael G. Strawser, Majolica Auctions.* $825+

Teapot and handled open sugar bowl, teapot unattributed and sugar by Samuel Lear; both *Pond Lily and Rope* designs. 4" high and 4.5" high. *Courtesy of Michael G. Strawser, Majolica Auctions.* Teapot: $425+

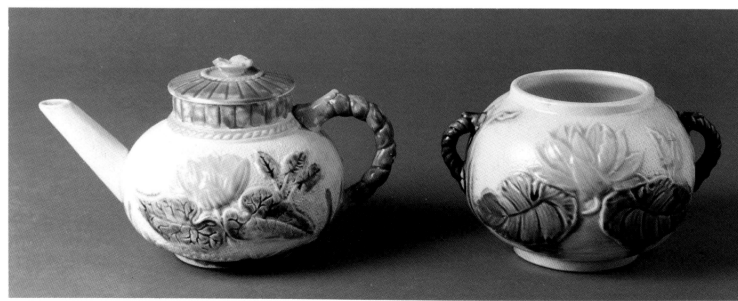

Samuel Lear Marks

Samuel Lear apparently was very sparing with the use of the "LEAR" company mark. The mark was impressed on the company's jasperware and earthenware from 1877 to 1886. According to Karmason and Stacke only one marked example of Lear's majolica is known to date.

Minton Porcelain Manufacturing Company

Herbert Minton, working in concert with his French art director Léon Arnoux and principle designer Thomas Kirby, set the standard for all the manufacturers who followed during majolica's fifty plus year term as a popular ware. The majolica Minton produced has been considered the finest examples of the ware.

Thomas Minton, Herbert's father and founder of the firm, managed to collect a vast array of antique ceramics. These became the inspirations for many of Herbert Minton's early reproductions and revivals. However, when Léon Arnoux arrived he brought fresh ideas and innovative techniques with him which were more desirable to a public with increasingly sophisticated tastes to match their rising incomes.

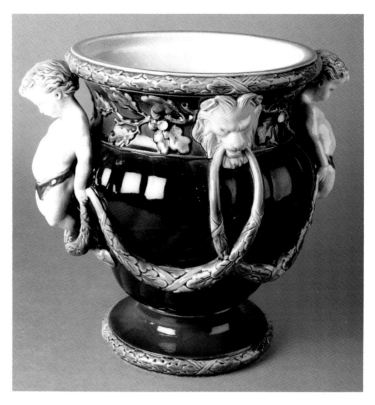

Wine cooler, Minton; cobalt with cherubs and lions. 10.5" high. *Courtesy of Michael G. Strawser, Majolica Auctions.* $4500+

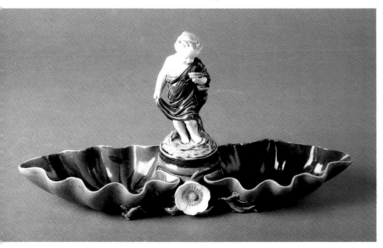

Sweetmeat dish, Minton; cherub figurine. 15" long x 7.5" high. Thomas Minton's collection of ceramics provided designers with centuries of inspiration. *Courtesy of Michael G. Strawser, Majolica Auctions.* NP

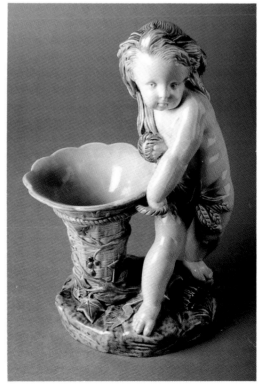

Putto figure (design and term from Italy [pl. putti], figure of a young boy, nude or nearly nude) with basket, Minton. 11" high. *Courtesy of Michael G. Strawser, Majolica Auctions.* $2800+

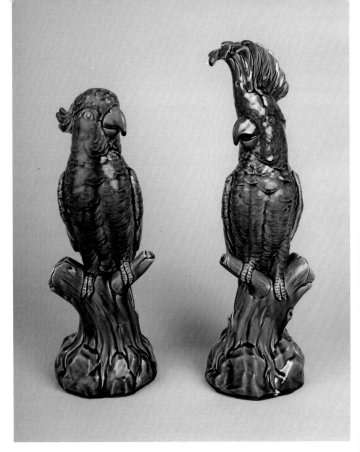

Parrot figurines, Minton. 12.5" high and 14" high. Léon Arnoux introduced fresh ideas and innovations found more desirable to the increasingly sophisticated public taste. *Courtesy of Michael G. Strawser, Majolica Auctions.* $800-1100 ea.

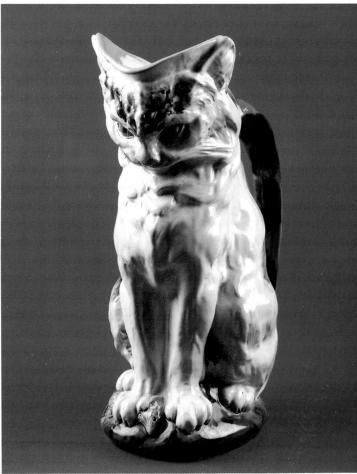

Another view of the Minton cat pitcher.

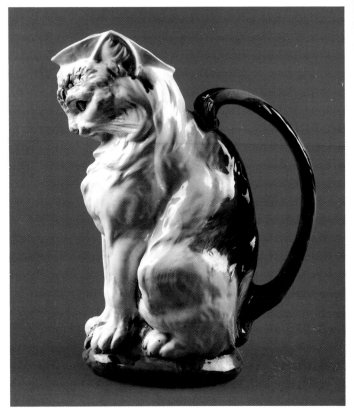

Pitcher, Minton; figural cat with unfortunate mouse (under paw!). 10" high. $5500-6500

MINTONS manufacturer's mark on the cat pitcher; this piece dates later than 1871 when the S was added to the MINTON mark. The registration mark indicates a registry date of 1876.

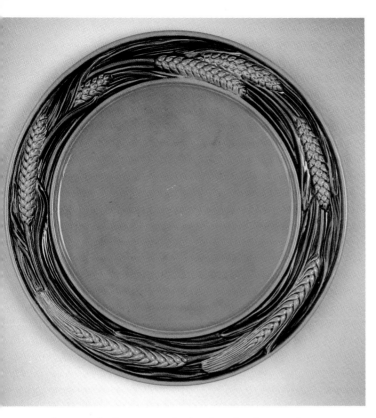

Bread tray, marked Minton on back; wheat border. 13" dia. *Courtesy of Michael G. Strawser, Majolica Auctions.* $1365+

MINTON manufacturer's mark (c. 1862-1871) on back on Minton bread tray and circular year cipher dating to 1872.

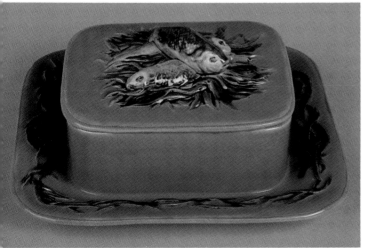

Sardine box, Minton; attached underplate. 8.5" x 7.75". *Courtesy of Michael G. Strawser, Majolica Auctions.* $2435+

The Minton firm did well with majolica and other projects. By the time of Herbert Minton's death in 1858, the firm was among the largest decorative ceramic manufacturers anywhere, with over 1500 employees. The Minton firm regularly hired new and established artisans from both England and Europe, keeping their innovations in majolica ever fresh with new ideas. By the fourth quarter of the nineteenth century, two hundred of these 1500 employees were enamelers, most of whom were involved in decorating majolica. Although expensive to produce hand-painted wares requiring expensive new molds for each new and innovative design, Minton's had the resources to manufacture a vast and diverse majolica line - everything from small dinner wares to massive fountains.

It was fortunate for the company that Herbert Minton had seen the value of international exhibitions early. By the mid-1870s, majolica's popularity in England was waning. Minton and other Staffordshire firms as well as other European and American firms introduced majolica at the 1876 Philadelphia Exhibition to many thousands of Americans. Once again majolica was a hit and, despite sagging home sales, Minton was able to conduct a brisk international trade through the American majolica craze of the late 1870s and 1880s.

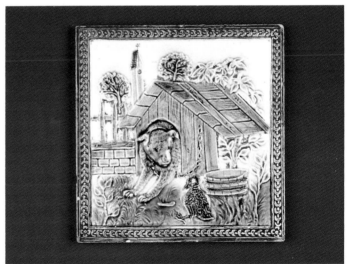

Tile, Minton; dog and bird scene. 6" square. *Courtesy of Michael G. Strawser, Majolica Auctions.* $250-275

Manufacturer's mark from back of Minton dog tile; printed MINTONS, LTD., impressed MINTONS, ENGLAND mark dating between c. 1890-1910.

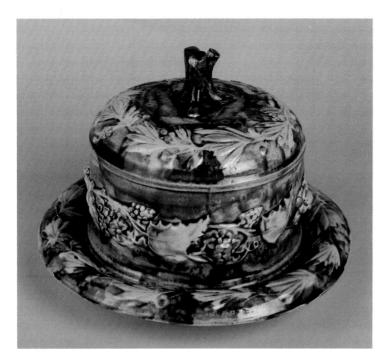

Cheese dome, unattributed, English. 10" dia. As the years went by, potters with less rigid standards of quality began to produce a great deal of majolica. *Courtesy of Michael G. Strawser, Majolica Auctions.* $275-300

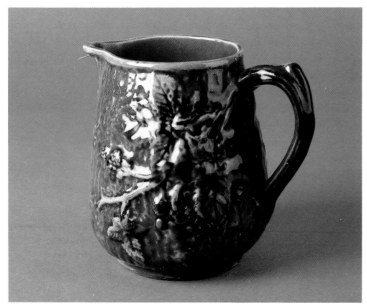

Pitcher, unattributed, from England; blackberry design. 6" high. *Courtesy of Michael G. Strawser, Majolica Auctions.* $275+

By the 1890s majolica production decreased sharply at Minton and most other firms. Governments were pressuring firms to reduce the use of lead glazes hazardous to their enamelers' health, making the production of majolica difficult at best. More importantly, public taste turned towards other ceramic forms as society itself was shifting into new habits and rituals to greet the new century. The Victorian age was drawing to a close and majolica's popularity was ending with it.[11]

Minton Marks

Most of Minton's wares were marked. In 1842, date ciphers indicating the potting year began, generally accompanied by an impressed capital letter indicating the month the ware was potted. A personal potter's mark may also appear as a letter. In 1862, the firm began impressing the name MINTON in all capital letters on all of their earthenwares. In 1872, the impressed name changed to MINTONS.

Moore Brothers

Moore Brothers of Longton, England was in operation from 1872 to 1905. While Bernard and Samuel Moore did not produce majolica in quantity, theirs was a quality product. Their majolica was often designed in a Japanese style.[12]

Moore Brothers Marks

The manufacturer's mark was impressed or incised "MOORE" or "Moore". They were also known to paint "MOORE BROS." on their wares. Thomas Goode and Company, a London ceramics dealer, distributed much of the Moore Brothers wares and their mark may also appear.

Royal Worcester

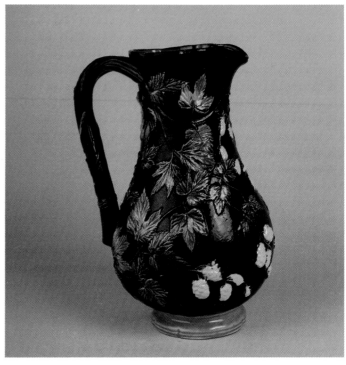

Hops pitcher, Royal Worcester; cobalt. 9" high. *Courtesy of Michael G. Strawser, Majolica Auctions.* $750+

Worcester Royal Porcelain Company, Ltd. was founded in 1751 by Dr. John Wall in Bristol and is still in business today at Worcester. Concentrating largely on decorative porcelains, earthenwares were a small part of the business. Their majolica patterns and decoration were considered to be quality work. They produced wares with dolphin motifs including dolphin comports and candlesticks.[13]

Royal Worcester Marks

Their manufacturer's marks used a circle with the Royal Worcester name, impressed on all their wares beginning in 1862.

Shorter and Boulton

Located in Stoke-on-Trent, Shorter and Boulton began producing majolica in 1879. Their pedestrian quality majolica wares were manufactured primarily for the American and Australian markets and included flower stands and vases, tea and breakfast services, trays, and jugs. The Bird & Fan, registered on March 17, 1881, was one of the firms most popular designs. Shorter and Boulton registered patents through 1882.[14]

Shorter and Boulton Marks

While the company did not use a name mark, the British Registry mark is frequently found and factory numbers and letters were always used.

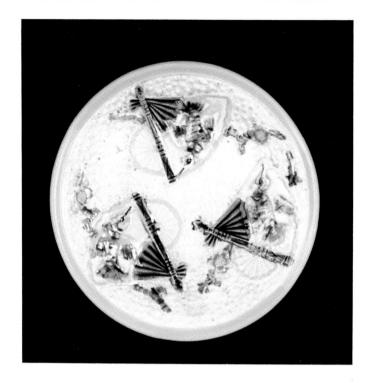

Sauce dish, Shorter & Boulton; bird and fan design. Both with English Registry Mark on back. Sauce dish, 5" dia. *Courtesy of Michael G. Strawser, Majolica Auctions.* $65-75

Edward Steele

Edward Steele specialized in majolica at his Hanley, England pottery. Not well known, Steele operated his factory from 1875 to 1900. The wares were of average quality and included both useful and ornamental majolica. Known Steele designs include a series of frog-shaped, mouth-pouring pitchers glazed in green and brown. The frog sits on a lily pad and the stem curls up to form the handle. Steele also produced elaborate centerpieces.[15]

Edward Steele Marks

As was the case with many small firms, Steele saw no particular use for a manufacturer's mark.

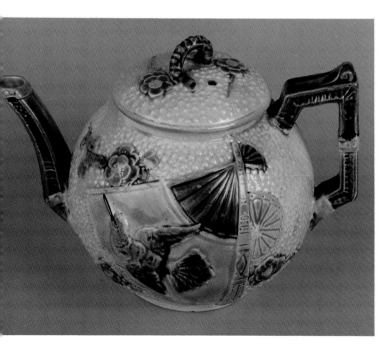

Teapot, Shorter & Bolton; bird and fan motif. 6.5" high. *Courtesy of Michael G. Strawser, Majolica Auctions.* $660-725

Daniel Sutherland & Sons

Daniel Sutherland & Sons operated from Fenton, England from 1863 to c. 1883. The factory produced all the standard majolica forms including sardine boxes, covered butter dishes, bread plates, pitchers and tea and coffee services.[16]

Daniel Sutherland & Sons Marks

While no marked majolica examples have been found to date, their manufacturer's mark was "S & S."

Wardle and Company

Wardle and Company of Hanley produced majolica and other earthenwares from 1871 to 1910. Wardle designs include naturalistic design motifs more common on earlier English majolica. The quality of the wares was fine.

The company also produced a fern and bamboo pattern in dinner wares, syrups, tea services, pitchers, mustache cups and more as well as a bird and fan pattern. Both reflect the rising interest in Japanese patterns. The sunflower was also used as a decorative motif, recognizing the rise of the Aesthetic movement. In 1882, Wardle and Company also produced a very fine shell and seaweed pattern tea service.[17]

Platter, Wardles; bamboo and fern motif with a cobalt center. 13" x 11". Wardles produced an extensive line of bamboo and fern ware, including a tea set c. 1875. *Courtesy of Michael G. Strawser, Majolica Auctions.* $825+

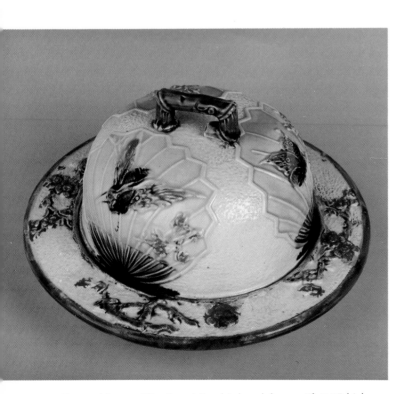

Covered butter, Wardles; Asian bird and fan motif. 5.5" high. *Courtesy of Michael G. Strawser, Majolica Auctions.* $450+

Dish, possibly part of the Wardles bamboo and fern line. 6.5" dia. x 4.5" high. *Courtesy of Michael G. Strawser, Majolica Auctions.* $450+

Wardle and Company Marks

Their designs were registered and bear the British Registry mark. The firms mark was also present in the form of a "WARDLE" impress.

Wedgwood

Wedgwood, the firm established by Josiah Wedgwood in the mid-eighteenth century and known for excellent wares, entered the majolica market in 1862. The company had struggled with a financial downturn in the 1850s which had made Francis Wedgwood, the owner, resistant to research and development projects during that decade. However, with the introduction of his three sons into the firm in the 1860s, that attitude changed. His oldest son, Godfrey, is credited with the introduction of majolica, along with other new and innovative designs, into the Wedgwood production line.

Wedgwood's early wares are similar to Minton's. This is no surprise as Wedgwood was hiring some of Minton's better-known designers and modelers for freelance majolica assignments. Minton and Wedgwood part company in majolica designs by 1880, when Wedgwood offered over 350 elaborate majolica wares of their own including specialized innovative and whimsical tablewares.

Wedgwood was almost unrivaled in their vast production of useful majolica wares for the table and the home. The decade of the 1870s was an intense period of production for the firm. The company responded to popular demand with a variety of majolica glazed ware christened Argenta which had a natural off-white body and colored majolica glazes applied to cast relief ornament. Formal and spare in decoration, Argenta reflected the interest in Japanese de-

Plate, marked Wedgwood; peacock feathers motif, c. 1878. 6.5" dia. *Courtesy of Michael G. Strawser, Majolica Auctions.* $390-435

Wedgwood impressed manufacturer's mark on peacock plate. This is the standard mark appearing with all wares marked with a three letter date mark as the PQG mark visible here. These are used from 1860 beginning with the letter Q. The first letter should indicate the month but is occasionally misplaced with the second letter. The third letter indicates the year. In this case, the G is the year 1878.

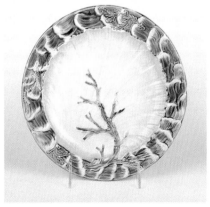

Wedgwood ocean plate with a green border. *Courtesy of Michael G. Strawser, Majolica Auctions.* $300-330

Plate, Wedgwood; grape leaf and basketweave. 8.75" dia. This piece is uncharacteristically delicate for majolica, but close examination reveals the usual wash of soft glaze colors over the intricately molded form. *Courtesy of Michael G. Strawser, Majolica Auctions.* $565+

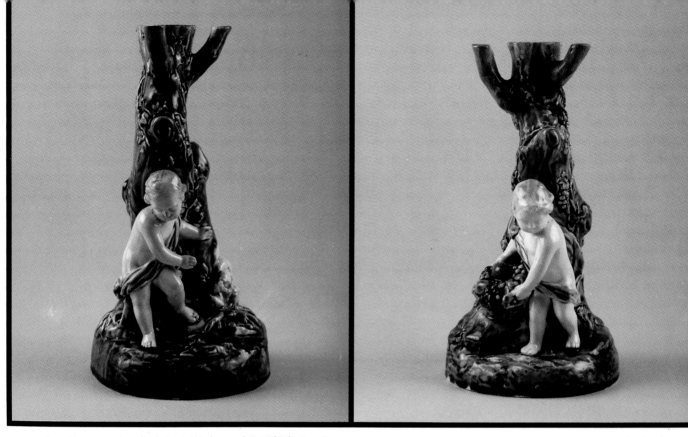

Pedestal base (top bowl missing), Wedgwood. 9.5" high. Figurines tended to be recycled from other lines of ware, and were sometimes combined with other elements to make new "sculptural" forms for majolica. NP

Pedestal base with fruit basket, Wedgwood. 9.5" high. The models have used a mold very similar to that used for the last pedestal, with the addition of a fruit basket in the child's hands. This mold seems to have seen more wear than the last; notice how much sharper the details appear in the first piece. NP

Impressed WEDGWOOD manufacturer's mark on Wedgwood pedestal base.

The "Grape" bread tray, Wedgwood, appears in 1876 catalog; grape leaf motif with twig handles. 11" x 9". This form was first produced in the 1760s in creamware. In majolica, another version was made in 1879 with a cobalt center and turquoise honeycomb. A similar basket was produced incorporating cauliflower leaves. *Courtesy of Michael G. Strawser, Majolica Auctions.* $815+

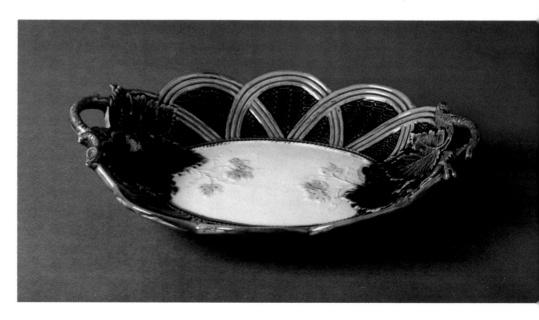

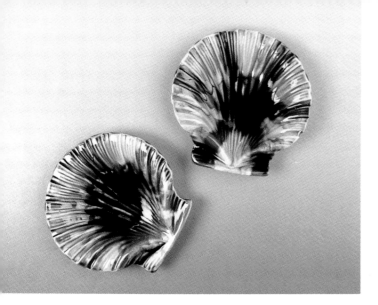

Two small dessert dishes, Wedgwood; seashell shapes. Each 5.5".
Courtesy of Michael G. Strawser, Majolica Auctions. $85-95 each

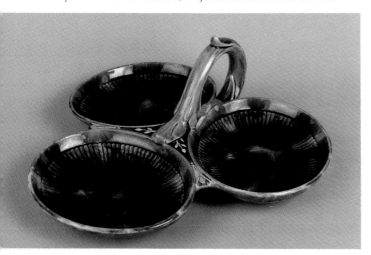

Server, Wedgwood; three-sectioned with handles and mottled glaze.
13" dia. *Courtesy of Michael G. Strawser, Majolica Auctions.* $815+

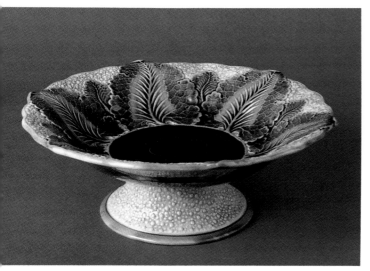

Compote. Wedgwood; cauliflower and leaf pattern with cobalt
center. 11" dia. x 4" high. A similar piece was featured in
Wedgwood's 1876 advertising catalog. *Courtesy of Michael G.
Strawser, Majolica Auctions.* $735+

signs and the sensibilities of the Aesthetic movement
of the late 1870s.

While Wedgwood continued manufacturing majolica in small amounts well into the first quarter of
the twentieth century, production by then had been
sharply curtailed.[18]

Wedgwood Marks

Nearly all Wedgwood wares were marked, in
keeping with company tradition. The familiar impressed WEDGWOOD mark in capital letters is a constant. The name ENGLAND was added in 1892 and
transformed to MADE IN ENGLAND in 1911. Other
marks on Wedgwood majolica included:

pattern numbers from a consecutive design index frequently found with a letter prefix identifying the
ware.

The letter M was used for majolica between 1873
and 1888,

and K until 1920.

From roughly 1884, majolica glaze tiles used the letter Q.

In 1860 Wedgwood also began using a impressed letter code for the potting date. The three letter code
was used until 1929 to indicate the month and year.
The first letter was the month, the second the potters mark and the third the year beginning with the
letter O in 1860.

The alphabet was used in three cycles beginning with
A in 1872 and once again in 1898 when the first
full 26 letter cycle was completed.

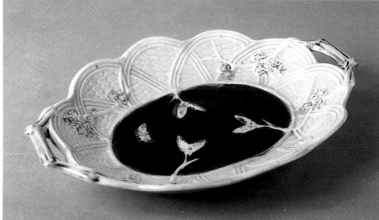

Platter, unmarked; yellow honeycomb pattern on cobalt center,
with prunus blossoms and a butterfly. 11" long x 9" wide. While
it is clear that this piece was created from the same basic pattern as
the Wedgwood "Grape" bread tray (though with different handles
and flowers), its origins are unclear. The inferior quality of the
painting and the loss of some of the imprinted detail suggest that it
may have been potted by a lesser company using a "tired" mold
bought from Wedgwood. *Courtesy of Michael G. Strawser, Majolica Auctions.* $675+

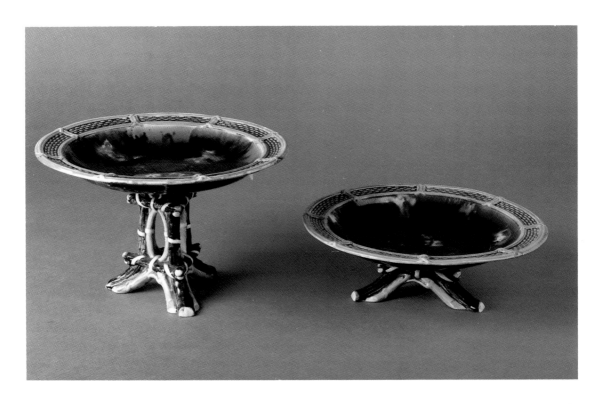

High and low compotes. Wedgwood; mottled pattern. 5.5" high and 2.5" high, both 9" dia. *Courtesy of Michael G. Strawser, Majolica Auctions.* $675-750 each

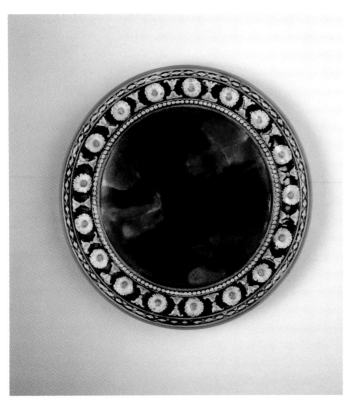

Trivet, Wedgwood; *Stanley* pattern, 1869. 7". *Courtesy of Michael G. Strawser, Majolica Auctions.* $435+

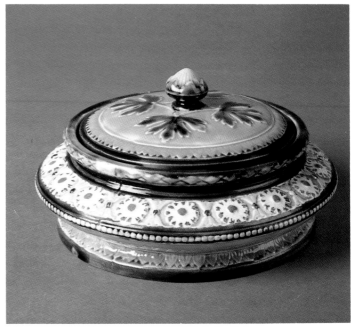

Covered butter, Wedgwood; *Stanley* pattern, 1871. 6.25" wide x 3.25" high. This butter dish was designed by Frederich Bret Russel, the designer of the *Caterer* jug. *Courtesy of Michael G. Strawser, Majolica Auctions.* $735+

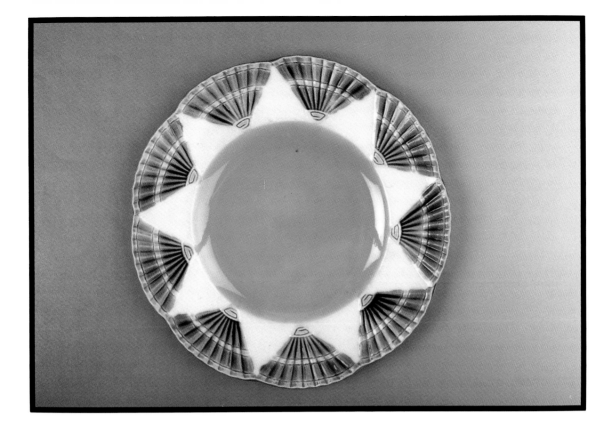

Plate, Wedgwood; border of open fans. 9" dia. Wedgwood's reaction to the influx of Asian influence was to adapt some of the clean, spare aesthetics as well as the typical motifs. *Courtesy of Michael G. Strawser, Majolica Auctions.* $500-550

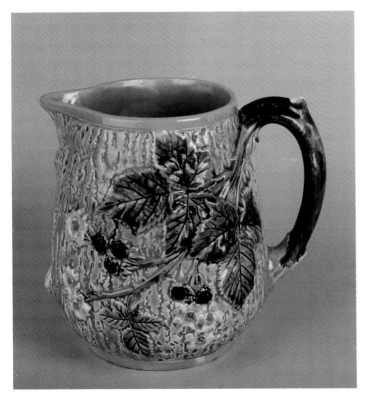

Pitcher, Wedgwood; blackberry pattern with spider in the bottom. 7" high. *Courtesy of Michael G. Strawser, Majolica Auctions.* $625+

James Woodward

James Woodward produced majolica at his factory at Swadlincote, Derbyshire, England from c. 1860 to 1888. Although the factory produced a large amount of lead-glazed pottery, little is known about the firm.[19]

James Woodward Mark

His mark was an anchor fouled with a cable forming the monogram "J.W."

Chapter 5
American Majolica

America discovered majolica on a large scale later than England. Although developing transportation systems extended the global reach of disparate cultures, news of developments in the arts and culture traveled slowly, especially when separated by some three thousand miles of ocean. The major avenue for reaching the masses and making a lasting impact on the consumer market in the nineteenth century, at least in the ceramics industry, appears to have been through the great exhibitions. For America, the first influential ceramics exhibition took place in Philadelphia in 1876 at the Centennial Exhibition.

As the American economy was recovering from recession and the nation was recovering from its civil war, majolica took off in the American market. Through the 1880s, majolica was all the rage. Bright colors would glint from the dark and cluttered recesses of American parlors and dining rooms in the last quarter of the nineteenth century as they had through the third quarter in England.

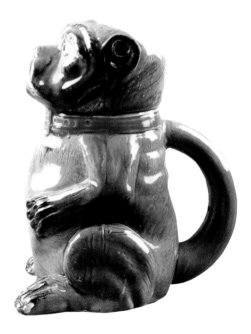

Hand and Pineapple vase, unattributed American, with "Straus, New York" seal. 13" high. Through the 1880s, Americans accepted majolica with open arms. The open hand shown here was a standard Victorian symbol of friendship and the pineapple is a long recognized symbol of hospitality. $275+

Pitcher, unattributed, definitely American; figural pug dog. As America recovered from recession and civil war, majolica took off in the American market. $400-600 depending on the size of the pitcher (several sizes were produced)

A. M. Beck

A. M. Beck, an Englishman in Evansville, Indiana, is most notable for having established a majolica pottery factory farther west than any other in America. Beck worked his three-kiln pottery for two years before his death in 1884. It should be no surprise that Beck, with his small operation, did not mark his majolica. At the time of his death, Beck's factory was purchased by Bennighof, Uhl and Company to manufacture white graniteware. In 1891 the factory was reorganized as the Crown Pottery Company.[1]

The Bennett Pottery

The Bennett brothers - James, Daniel, Edwin and William - were English potters who immigrated to America. James arrived in 1834 and established himself at the Jersey City Pottery in Bergen, New Jersey. After a series of moves, James Bennett opened his own pottery in 1839 in East Liverpool, Ohio where the clays were right for yellow ware production. Meeting with quick success, James sent for his brothers, who arrived in 1841. The foursome became the first American potters to produce Rockingham ware, earthenware with yellow or buff-yellow body and a mottled glaze produced in America from c. 1845-1900, in many original designs including an octagonal spittoon later reintroduced in a majolica design. Significantly, they won a silver medal from Philadelphia's Franklin Institute for their earthenware of superior quality, beating out English entries. This was no mean feat in an era when English wares were still generally considered top quality in America.

In 1848, William and Edwin became established in Baltimore, Maryland and christened their firm E. & W. Bennett. They would remain there together until 1856 when William Bennett fell ill and left the firm.

There are two schools of thought concerning Bennett's first production of majolica. In one view, early Bennett wares designed by Charles Coxon in the 1850s are majolica. These include a bust of George Washington bearing the date 1850, a pair of 2' high vases with raised grapevine designs and lizard handles, and a large octagonal pitcher in blue, brown and olive mottled glazes with molded sea monster handles and a common Chesapeake Bay fish body. If this is true, Bennett enjoyed almost no competition in majolica production for roughly twenty years.

The second school holds that the Washington bust and vases are Rockingham. The large octagonal pitcher, also modeled by Coxon, is considered to be a relief-molded jug, rather than majolica. In this view, Bennett began producing majolica much later, in the 1870s.

After William's departure in 1856, the firm was renamed Edwin Bennett Pottery and after 1890 Edwin Bennett Pottery Company, Inc. Both schools agree that Bennett produced majolica during the height of the wares' popularity in America. The Bennett factory was the largest pottery in the Baltimore area and continued in operation until approximately 1937.[2]

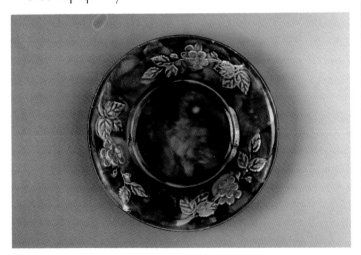

Majolica fruit dish, unattributed; Wild Rose pattern on mottled background. 5" dia. The similarity between mottled Rockingham ware from the first half of the 1800s and similarly glazed majolica from the second half causes some confusion between the two wares. *Courtesy of Michael G. Strawser, Majolica Auctions.* $90+

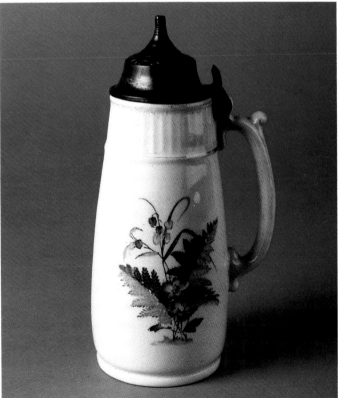

Tankard, Bennett; metal lid, uncharacteristic painting style for majolica lead glazes. 8" high. Bennett's unmottled "majolica" line had a transfer-printed look uncharacteristic of the style. *Courtesy of Michael G. Strawser, Majolica Auctions.* $275+

The Bennett Pottery Marks

During William Bennett's collaboration with Edwin, the pottery had two marks:

E & W
and
E. & W. Bennett
Canton Ave.
Baltimore Maryland

The most common mark found on majolica is BENNETT'S in an arch above a patent date and the word PATENT or COPYRIGHT in an arch below.

The Chesapeake Pottery Company

Between c. 1882 and 1910, The Chesapeake Pottery produced majolica in Baltimore, Maryland. The factory was operated by Donald Francis Haynes, who had been working in the local potting industry for a decade before purchasing this company. During this period, Haynes offered majolica of two different majolica types, each with it's own tradename listed as part of the manufacturer's mark. The first was identified by the tradename "Clifton." Clifton majolica had a cream colored background and a variety of decorative motifs including various berries, fruit, birds and other natural designs. Following Clifton was the second distinctive tradename majolica ware, "Avalon-Faience," which was usually a simple ivory background with a single color for the molded decoration and a gold trim. Other rarer types of Avalon-Faience included as many as five or six colors. Avalon-Faience marks the transition in America between the abundant decorative details of the early Victorian years and the later trend towards sinuous simplicity espoused by the Arts and Crafts movement.

Manufacturer's mark printed on bottom of the Chesapeake Pottery "Clifton" blackberry bowl.

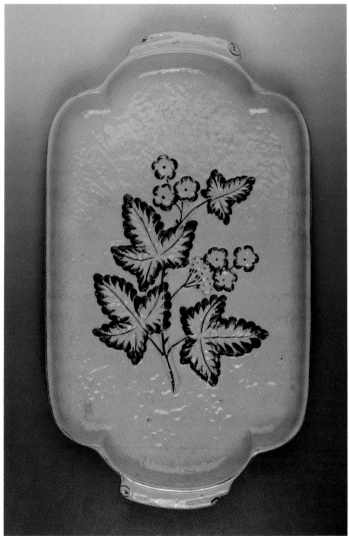

Tray, Chesapeake Pottery Co., marked "Avalon Faience Balt." 16" x 9.25". The usual color scheme for the Avalon line: a single color on an ivory background, with gold trim. *Courtesy of Michael G. Strawser, Majolica Auctions.* $300+

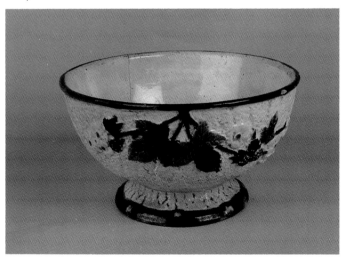

Bowl, Chesapeake Pottery Co., marked "Clifton Decor B;" blackberry pattern, footed. 8.5" dia. Typical of the Clifton line of majolica. *Courtesy of Michael G. Strawser, Majolica Auctions.* $100+

Printed AVALON FAIENCE, BALT, manufacturer's mark on bottom of the Chesapeake Pottery "Avalon" tray.

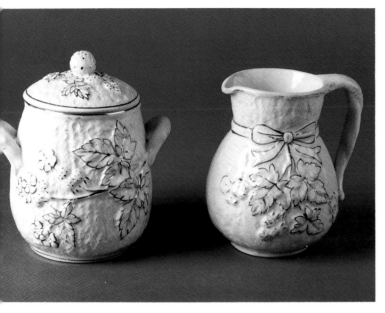

Cream and sugar set, marked "Avalon Faience Balt;" blackberry pattern with gold. 5.75" high. *Courtesy of Michael G. Strawser, Majolica Auctions.* $300+

In 1887, the Chesapeake Pottery Company met with financial difficulties and was sold at auction to Edwin Bennett. The company name was changed to Haynes, Bennett & Company. Edwin Bennett kept this firm as a separate asset from his own successful Edwin Bennett Pottery, which was also located in Baltimore. By 1896, following a series of sales, the company returned to the Haynes family, with its purchase by Frank R. Haynes, Donald F. Haynes' son. The factory continued production until 1914 under the name D.F. Haynes and Son.[3]

The Chesapeake Pottery Company Marks

The marks found on majolica from this company include:

The Clifton mark with two intertwined crescents surrounding the company DFH monogram. Printed within the top crescent is the tradename "CLIFTON" and in the bottom crescent "DECOR B."

The Avalon-Faience mark involves a triangle containing the tradename AVALON/FAIENCE/BALT" with the monogram DFH.

The Faience Manufacturing Company

The Faience Manufacturing Company was established in 1879 in Greenpoint, New York, a section of Brooklyn that had nurtured a potting community since the middle of the century. An accomplished English ceramic artist from Staffordshire, Edward Lycett, joined the firm in 1884 and remained there until 1890. The firm ceased operation in 1892. During their brief operation, The Faience Manufacturing Company produced art pottery and majolica. Majolica was only produced during the early years of operation, when demand was high.[4]

The Faience Manufacturing Company Mark

The Faience Manufacturing Company used an incised monogram "FMCO." on their majolica and art pottery.

Griffen, Smith & Hill

"Much of the finest majolica was made by this firm and most of the pieces will be found stamped with the monogram *G.S.H.* surrounded by the words *Etruscan Majolica* or some just *Etruscan.*" - Druscilla Smith Yarnell, daughter of David Smith

While not the first American majolica manufacturer, Griffen, Smith & Hill of Phoenixville, Pennsylvania has been considered by many to have produced the very best American majolica, and possibly the largest quantities. Beginning with W.A.H. Schreiber in 1867, a series of potters struggled to run the Phoenixville works. Despite the pottery's strategic location near local kaolin deposits and the Schuylkill River, these early aspirants had limited success. However, on January 1, 1879, Henry Griffen, his brother George, David Smith and William Hill leased the property and changed its luck. Under the name "Griffen, Smith & Hill," they and their "GSH" monogram cartouche became well established, producing a number of different types of ware.

Griffen, Smith & Hill first offered majolica among their wares in 1882. By this time, William Hill had left the firm and the pottery had been officially renamed Griffen, Smith and Company. The prominent Griffen, Smith and Hill manufacturer's mark did not change so quickly. Remarking on the disparity, David Smith proclaimed G.S.H. now stood for "Good, Strong and Handsome!" The mark remained.

David Smith, a native of Fenton, England who received his early training in the Staffordshire potteries, was responsible for the brilliant glaze colors produced, and no doubt other immigrant English potters helped create the popular designs the company made so well.

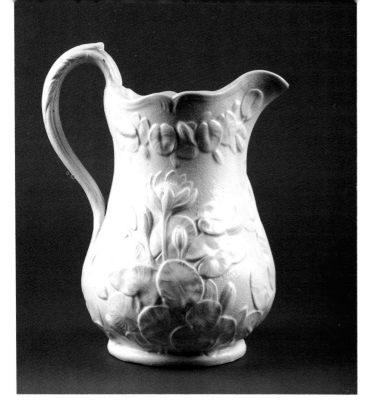

Rare Parian pitcher, marked "Phoenix," between 1867-1878. 8" high x 4" dia. Before the pottery in Phoenixville, PA was leased by Messrs. Griffen, Smith and Hill in 1878, it hosted a series of unsuccessful ventures, none if which is known to have produced any majolica. After 1872, the factory, "Phoenix Pottery," produced Parian ware using molds and models purchased from a defunct New Jersey firm (American Porcelain Manufacturing Co.), closed in 1857. Parian is an unglazed white biscuit first introduced in England in 1846 by Copeland and later produced in England and America. The ware presents the appearance of marble and the name arises from Parian marble. NP

Script "Phoenix Pottery" manufacturer's mark.

Having missed the Centennial Exhibition in Philadelphia in 1876, this firm took advantage of the World's Industrial and Cotton Centennial Exposition in New Orleans in 1884. Here they won critical acclaim and, with the help of a colorful catalog of majolica wares printed for the occasion, they captured the attention of the American public.

The company's output was primarily useful ware in predominantly American motifs, with a small offering of ornamental wares. The company, no doubt aware of an upsurge of public interest in Etruscan revivalist decorative arts christened their majolica "Etruscan." The name harkened back to the potters of ancient Rome in the last seven centuries B.C., grounding Griffen, Smith and Company's increasingly popular modern ware in the romance of centuries past, just as Minton had done over a quarter century earlier.

Cover of the Griffen, Smith & Co.'s catalog printed in time for the 1884 Cotton Centennial Exposition in New Orleans. Its full-color presentation of majolica ware helped the company to capture the country's attention.

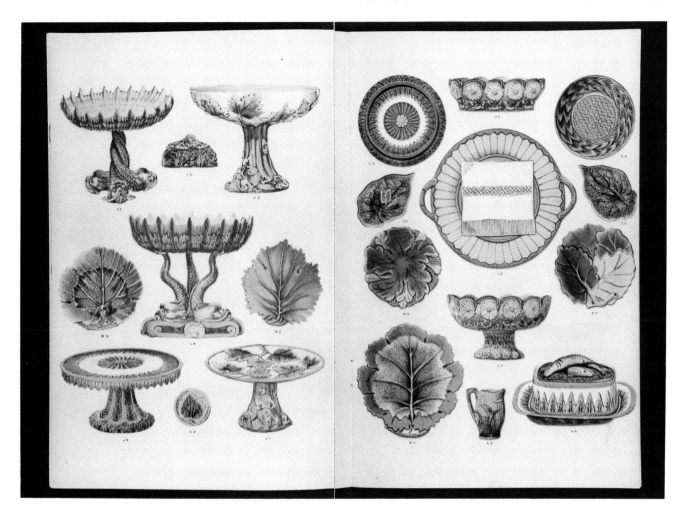

A two-page spread from the Griffen, Smith & Co. catalog showing a broad range of their styles and forms.

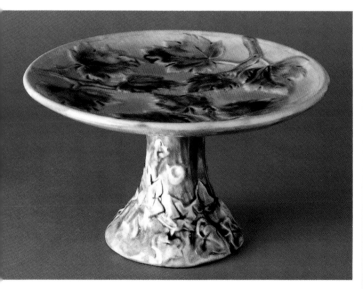

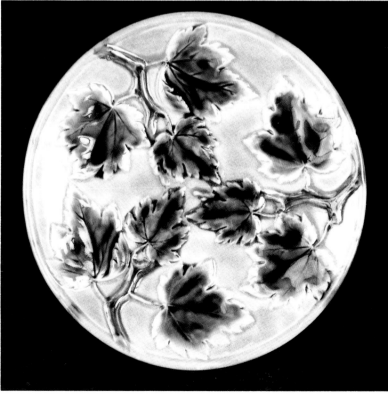

Compote, Griffen, Smith & Co.; maple leaf decoration. 9.5" dia. x 5.5" high. This piece is illustrated in the catalog pages shown above. *Courtesy of Michael G. Strawser, Majolica Auctions.* $250+

Plate, Griffen, Smith & Co., marked ETRUSCAN MA-JOLICA; maple leaf pattern. 9" dia. In same series as compote from the 1884 catalog. *Courtesy of Michael G. Strawser, Majolica Auctions.* $375-425

On the back of the maple leaf plate, Griffen, Smith & Co.'s "Etruscan Majolica" mark. After Hill left the company, David Smith said that Griffen, Smith & Co.'s long-established "GSH" monogram would now stand for "Good, Strong & Handsome."

The bodies of these earthenwares were produced from local gray clays. They tended to be thickly potted and fired at fairly low temperatures, giving their wares a buff color and a lightweight feel. The glazes had a tendency to flow together, a feature seen as an American trait. This produced a soft effect that was striking when applied to the naturalistic patterns such as the popular *"Shell and Seaweed"* wares as well as to those with attractive designs in elaborate low relief. Other successful company majolica wares were left nearly undecorated or had only border colors applied similarly to the popular Wedgwood Argenta wares. These are now commonly referred to as *"Albino"* majolica.

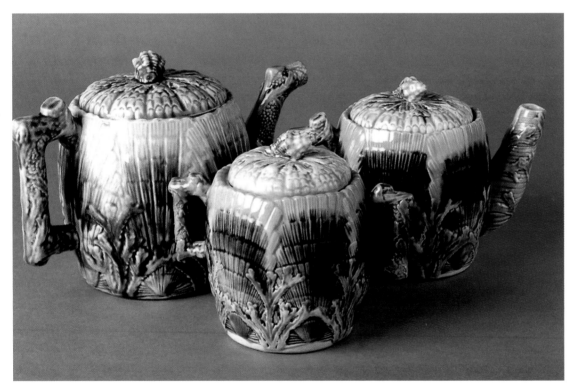

Teapot, coffee pot, and sugar, Griffen, Smith & Co.; Shell-and-Seaweed pattern. Teapot, 7" high; coffee pot, 6" high; sugar, 5.5" high. In America, tea was the stimulant of choice from its introduction; after c. 1830, coffee, with its stronger flavor, was preferred. Courtesy of Michael G. Strawser, Majolica Auctions. Coffee pot: $1800-1980; teapot: $1635-1995; sugar: $570-695

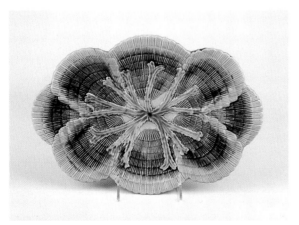

Shell-and-seaweed platter by Griffen, Smith & Co. 9.25" x 14". *Courtesy of Michael G. Strawser, Majolica Auctions.* $1375-1500

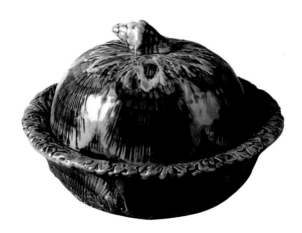

Covered butter, Griffen, Smith & Co., marked ETRUSCAN; *Shell and Seaweed* pattern. 7.5" high. *Courtesy of Michael G. Strawser, Majolica Auctions.* $1125+

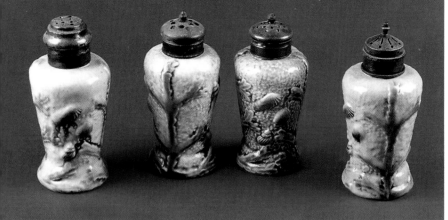

Salt and pepper shakers, Griffen, Smith & Co.; *Coral* pattern. Each 4.5" high. NP

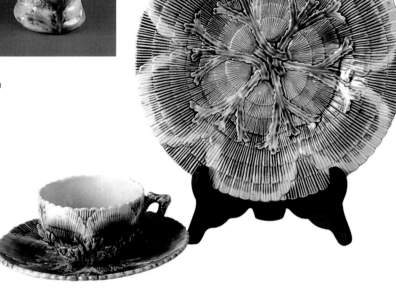

Shell-and-seaweed footed salad bowl by Griffen, Smith & Company. *Courtesy of Michael G. Strawser, Majolica Auctions.* $375+

Tea cup, saucer and plate, Griffen, Smith & Co., *Shell and Seaweed* pattern. 9.5", 6.5" and 3.5" diameters. *Courtesy of Michael G. Strawser, Majolica Auctions.* Cup and saucer: $375-415; plate: $375-425

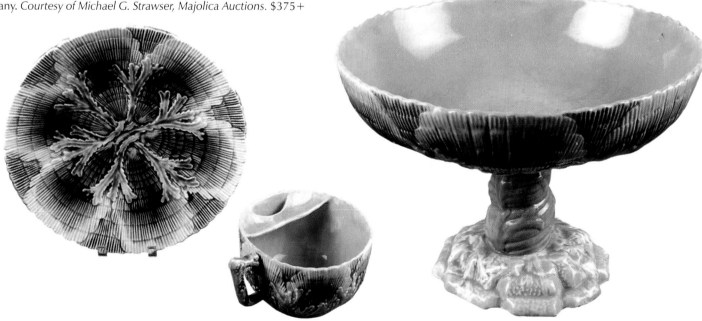

Mustache cup with saucer, Griffen, Smith & Co.; *Shell and Seaweed* pattern. Cup, 3.25" dia. x 2.5" high; saucer, 7" dia. $850-935

Comport, Griffen, Smith & Co., *Shell and Seaweed* pattern. 9.25" dia. x 6.5" high. The rarest pieces in this pattern today are the cake stand and the centerpiece, delicate forms much more vulnerable to breakage. $375-425

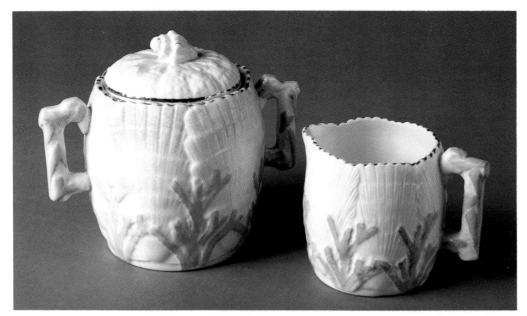

Cream and sugar set, Griffen Smith & Co.; *Shell and Seaweed* Albino pattern. 5" high and 3" high. While more of the colored Shell and Seaweed ware was produced, the Albino line was developed and marketed first. *Courtesy of Michael G. Strawser, Majolica Auctions.* $375-415 set

Tea set, Griffen, Smith & Co.; *Shell and Seaweed* Albino pattern. Teapot, 6.5" high; large sugar bowl, 5.5" high; creamer, 3.25" high; teacup, 2.25" high x 3.25" dia.; saucer, 5.25" dia. Teapot: $1635-1995

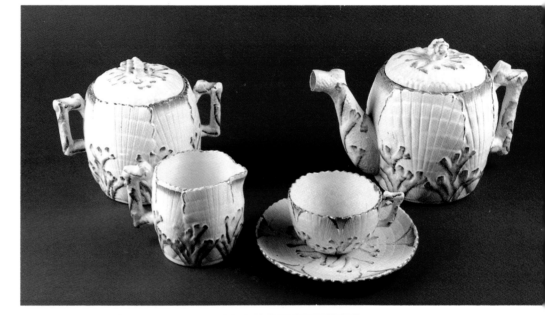

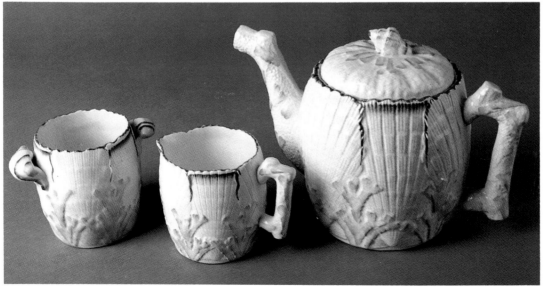

Teapot with open sugar and creamer, Griffen, Smith & Co.; *Shell and Seaweed* Albino pattern. Tea pot is 7" high. Only one in ten of the company's Albino pieces was marked as ETRUSCAN MAJOLICA. *Courtesy of Michael G. Strawser, Majolica Auctions.* Teapot: $1635-1995

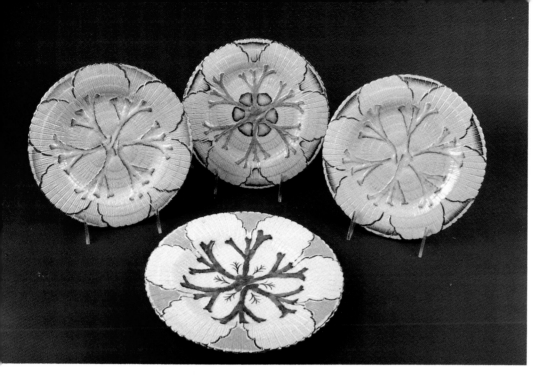

Four dishes, Griffen, Smith & Co.; *Shell and Seaweed* Albino pattern in various color schemes. Standing dishes, 8.25" dia.; flat dish, 9" dia. Griffen, Smith & Co. made some Albino pieces without any color at all, nonetheless called "majolica." $375-445 each

Despite the all-American imagery of sunflowers, vegetables, foliage and boys playing baseball in Griffen, Smith and Company motifs, British and Asian influences may be found. The British influence is easy to understand: popular belief in the superiority of British wares lingered and Griffen, Smith and Hill was trying to beat them at their own game.

Several of the Phoenixville patterns were blatant copies of Wedgwood motifs, including a strawberry dish bearing an 1871 Wedgwood mark date. *The Daily Local News* of nearby West Chester, Pennsylvania in 1882, took great pride in declaring the local Phoenixville copy to be superior to its imported counterpart:

"We have been shown a number of articles of majolica ware just manufactured ... which were equal to any made at Wedgwood, Mintons or other celebrated potteries in Europe. The articles ... consisted of two strawberry dishes with sugar bowl and cream mug attached ... The ones made at the Phoenixville works were similar in form but the details were more carefully worked up while the glazing and coloring, was, we think, superior to the English article."

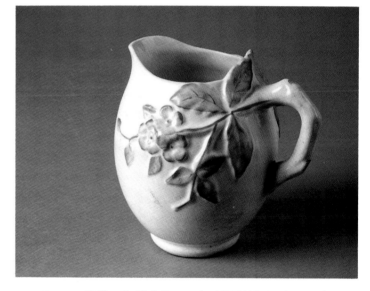

Creamer, Griffen, Smith & Co., marked ETRUSCAN; the Hawthorne pattern in an argenta-type glaze. 4.5" high. *Courtesy of Michael G. Strawser, Majolica Auctions.* $175-195

Several items from the Griffen, Smith & Co. catalog, including a begonia leaf plate and two leaf-form butter pats.

Several butter pats in leaf form, Griffen, Smith & Co., (left to right) maple leaf, pond lily, and begonia on wicker patterns. *Courtesy of Michael G. Strawser, Majolica Auctions.* Left: $135-165; center: $165-185; right: $275+

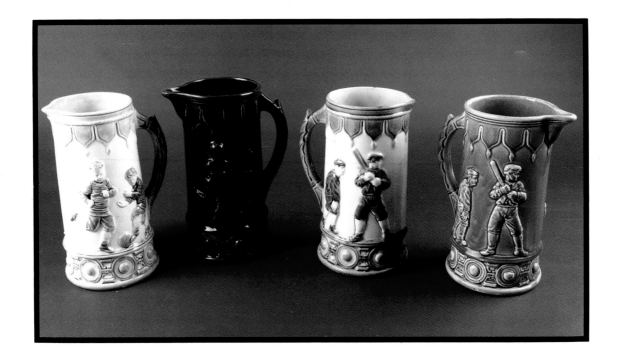

Four pitchers, Griffen, Smith & Co., marked "Phoenixville" (except for red pitcher, unmarked). All 3.5" dia. x 7.75" high. Pitchers on left are turned to show the back, with boys playing soccer; pitchers on right show the front, boys playing baseball. These pitchers are rare, but even more rare are a series of solid-color pitchers produced with the same border pattern but smooth sides, without the molded sporting scenes. NP

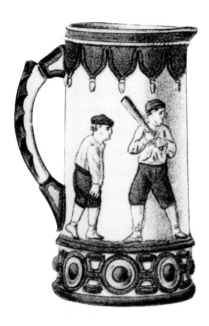

Illustration of the front of the sports pitcher, from Griffen, Smith & Co.'s 1884 catalog.

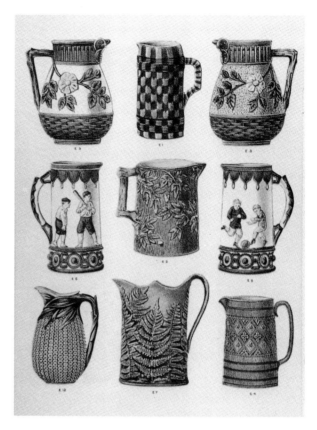

A range of Griffen, Smith & Co. pitchers, from the 1884 catalog.

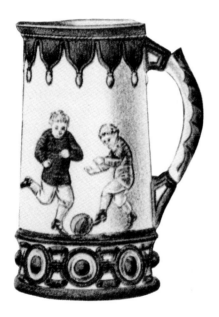

The reverse of the pitcher.

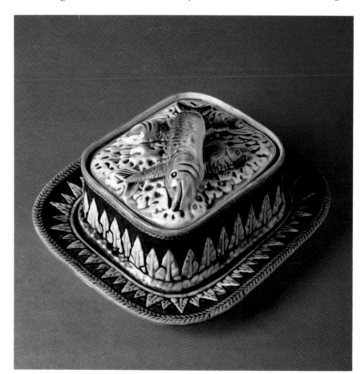

Rare sardine box, Griffen, Smith & Co., marked ETRUSCAN; with attached underplate. 9" long x 7.5" wide. Like most other American potters, Griffen, Smith & Co. felt the need to compete with their British counterparts, and frequently provided U.S. customers with less expensive versions of well-known English wares. This piece was modeled after a popular George Jones sardine box. *Courtesy of Michael G. Strawser, Majolica Auctions.* $1320+

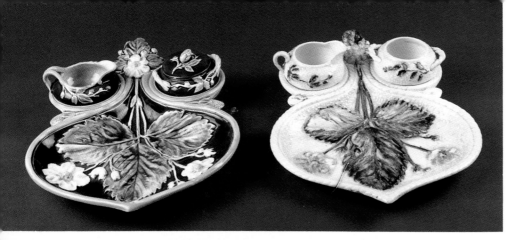

On left, Wedgwood's rare cobalt strawberry server, c. 1871. On right, Griffen, Smith & Co.'s version, c. 1882. Both approx. 10" x 8". $2250+ each

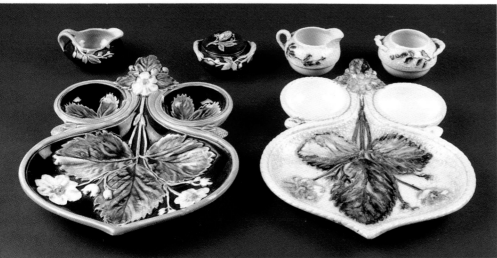

Illustration of the Griffen, Smith & Co. strawberry server modeled after a Wedgwood piece.

The Wedgwood and Griffen, Smith & Co. strawberry servers, cream mugs and sugar bowls removed. "...The glazing and coloring was, we think, superior to the English article" (*The Daily Local News*, West Chester, PA, 1882)

One interesting aspect of the American design copies was the disinterest of the American consumer in the social movements behind the imported designs. They desired simply to own items perceived superior by their English origin. Griffen, Smith and Company were proud to have equaled, or in the eyes of the local press, to have surpassed English manufacturing prowess with their derivative designs. In the end, the goal of the American majolica potter was to reach a level of technical perfection in the manufacturing process, maximize the efforts of their labor force, and to provide fashionable wares appealing to the expanding American market.

Japanese design influences made its appearance in Phoenixville majolica in the forms of birds and bamboo. The birds appeared on creamers, covered sugar bowls and spooners, perched on simply sketched reeds before wicker backgrounds. The bamboo motif was popular in America in the 1880s and many firms used the design. Griffen, Smith & Company produced cream pitchers, sugar bowls, teapots, spooners and bowls in the bamboo motif.

One naturalistic design considered original to the company was the very popular single Begonia leaf. It was most often manufactured as a pickle dish, although it was popular as a pin tray as well. The begonia leaf was glazed in green with a yellow and pink border and brown highlights near the center. Employees spent time combing the countryside nearby for begonia and other leaves to press into clay patterns for the company. As Druscella Smith Yarnell recalled: "Their English modeler (a man by the name of Bourne) made some very original designs, such as procuring a large beautiful Begonia leaf, and making a mold from pressing the leaf in soft clay, and after the dish was made would decorate it in the natural color."

Sea life figured prominently in several Griffen, Smith & Company designs. They offered three types of shell-and-dolphin comports, and a complete line of shell-and-seaweed dining wares including tea sets, bowls, comports, covered dishes, butter pats, plates, platters and even tobacco jars. These shell-and-seaweed patterns harken back to Irish Belleek wares, with an eye towards the English competition's offerings in these patterns from Wedgwood.

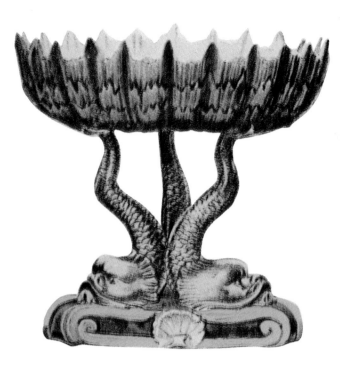

Compote, Griffen, Smith & Co.; *Shell and Dolphin* pattern. 7.5"
high. NP

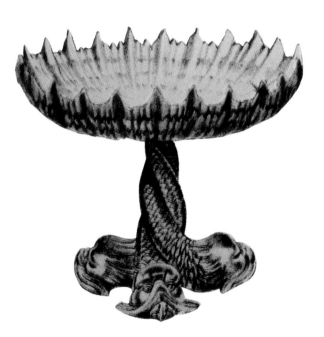

Illustrations of Griffen, Smith & Co.'s three *Shell and Dolphin* com-
ports, from the 1884 catalog.

Compote, Griffen, Smith & Co.; three-dolphin pedestal. 7.25"
high, 10" dia. The artisans dreaded working with this piece. It was
an expensive design and delicate, the tips of the bowl snapped off
easily. $930-1025

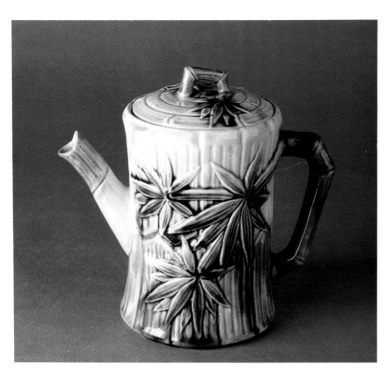

Teapot, Griffen, Smith & Co.; bamboo motif. 5.5" high. *Courtesy of Michael G. Strawser, Majolica Auctions.* $600-660

By 1885, the company works had doubled, and as many as 400 people may have been employed there. The life of the company was short, however. In 1889 David Smith retired in ill health, his shares were sold to J. Stuart Love, Henry Griffen's father-in-law. The name was changed to Griffen, Love & Company, and the pottery's era of majolica production closed.

This decline was a sign of the changing times. By 1890 the demand for majolica in America was waning. Some blame the economic hard times of a rising recession during this period; others see George H. Hartford and his A & P stores as the culprit, by glutting the market with small majolica wares and creating the impression that majolica was just plain cheap. Whatever the cause, Griffen, Smith & Company stopped manufacturing majolica at just the right time. By 1900 most firms in America and elsewhere had ceased production. One collector's father, the owner of a general store, best summed up the new attitude towards majolica the day he discovered she was collecting the colorful ware. "Why are you collecting *this*?! I used to give it away."[5]

The Tea Trade and the Transcontinental Railroad in America

Part of Griffen, Smith and Company's success is coupled with the completion of the transcontinental railroad in 1869 and the subsequent improvements in the tea trade in America. In 1859 George H. Hartford of New York made a name for himself by selling tea cheaper than any of his competitors. Hartford managed this by purchasing tea in shiploads himself and selling his purchase directly to his customers. This cut out two price mark-ups by removing importers' and wholesalers' fees.

While this worked well, Hartford found the completion of the railroad connecting the west coast with the east an opportunity to increase his lead over the competition. Using the transcontinental line, Hartford could have Chinese tea shipped from the west coast to the east in 30 to 40 days instead of the four months necessary by ship to round the tip of South America. Hartford renamed his store The Great Atlantic and Pacific Tea Company and advertised that he could provide the freshest tea anywhere. By 1884 Hartford had over one hundred A & P stores dotting the east and mid-west.

At this point, George Hartford's fortunes merged with those of Griffen, Smith & Company following the New Orleans Exposition. Hartford wanted a premium to draw more customers into his stores and decided on Etruscan majolica. Hartford eventually became Griffen, Smith and Company's biggest customer and small Etruscan pieces thus were distributed far and wide.

Begonia leaf dish, Griffen, Smith & Co. 8.5" x 6". Employees were sent to roam the Pennsylvania landscape, gathering leaves and other plant life for use in modeling popular wares like this one. *Courtesy of Michael G. Strawser, Majolica Auctions.* $280-310

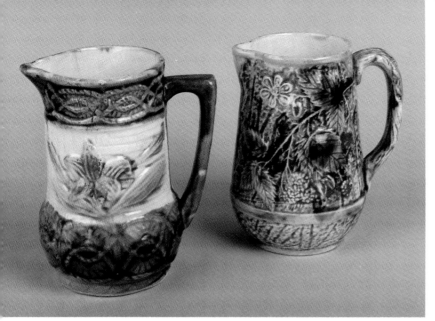

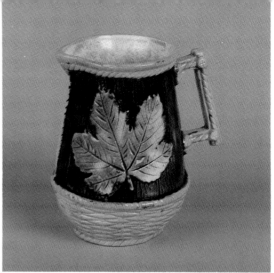

Pitcher, unattributed; maple leaf pattern. *Courtesy of Michael G. Strawser, Majolica Auctions.* $225-250

Two creamers, unattributed; one blackberry pattern, one rope and floral. Both 5" high. Griffen, Smith & Co. was prudent to stop its majolica production when it did; most of the wares produced in the final years of the 19th century were of poor quality, and consumer interest declined. *Courtesy of Michael G. Strawser, Majolica Auctions.* $175-195

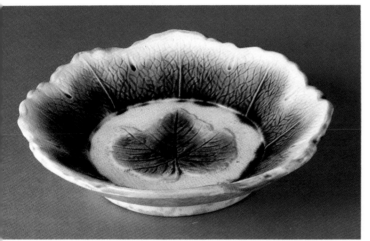

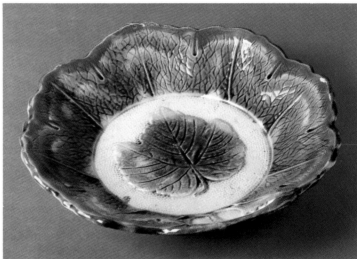

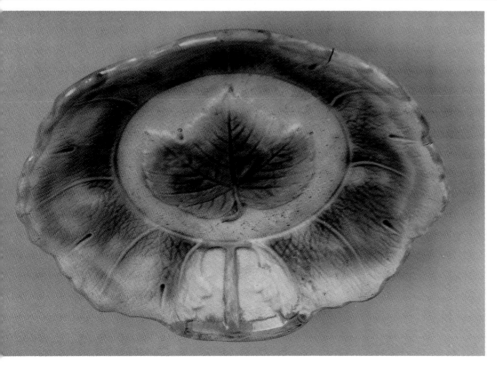

Three bowls, all unattributed; grape leaf motifs. 10" dia. Originality in design and quality decoration had been so badly neglected by later majolica potters that it is perhaps immaterial whether or not these pieces, apparently from the same mold, were manufactured by the same company. *Courtesy of Michael G. Strawser, Majolica Auctions.* $125-140 each

Griffen, Smith & Hill Marks

Griffen, Smith & Hill marked most of their wares. The company used four basic stamped and impressed marks:

a G.S.H. monogram which lingered on years after the company was renamed Griffen, Smith and Company,

the monogram with the word ETRUSCAN found below,

a double circle with ETRUSCAN impressed above and MAJOLICA below,

and the rarest mark is simply the trade name ETRUSCAN impressed in block letters.

Another mark is commonly found on Griffen, Smith & Hill majolica. The mark is a combination code beginning with a letter designation from A to O followed immediately by a number. The **letter** indicates the **vessel form** and the **number** the **style of decoration** to be found on it. This is a useful aid in identifying the company's majolica when their manufacturer's mark is not present. The letter code indicated the following vessel forms:

A ... Individual butter plates, round, leaf or flower shape.

B ... Pickle dishes, usually in an irregular leaf shape.

C ... Cake trays or dishes, leaf or flower shape with irregular or round shape.

D ... Plates in varying patterns, round with conventional leaf or shell shape.

E ... Hollow forms, pitchers, coffee/tea pots, syrup jugs, sugar and slop bowls.

F ... Cuspidors and jardinieres.

G ... Cake baskets.

H ... Bonbon dishes, in a deep oval form.

I ... Covered boxes.

J ... Comports with pedestals or stands.

K ... Paper weights, pin trays or small flower jars, and special forms of cheese dishes and trays.

L ... Celery vases, mugs, pepper and slat shakers, jewel trays and comports with dolphin-shaped feet.

M ... Bowls, covered jars, bonbon dishes and certain plates.

N ... Covered cheese and sardine boxes.

O ... Cups and saucers.

The Hampshire Pottery

In 1871 in Keene, New Hampshire, James Scollay Taft and his uncle fired the kiln in their converted clothespin factory and promptly burned their first works to the ground. The Hampshire Pottery opened for business again by the beginning of the new year. The factory produced ornamental terra cotta and inexpensive domestic earthenware from the native red clays of New Hampshire in the early years of production. In 1879, with the introduction of the English potter Thomas Stanley as superintendent, the Hampshire Pottery began high-glaze majolica production. The earliest examples were coated in brown, yellow, green and blue glazes. One of their most popular majolica patterns was a corn pattern, found on salt and pepper shakers, tea services and pitchers. The factory was in operation until 1914.[6]

The Hampshire Pottery Marks

Very few of The Hampshire Pottery wares were marked. The most common mark found is "James S. Taft & Co., Keene, N.H." Other marks used by the pottery were "J.S.T. & Co., Keene, N.H." and "Hampshire Pottery."

Morley & Company

Between roughly 1879 and 1885, Morley & Company produced majolica in Wellsville and East Liverpool, Ohio. Here, along the banks of the Ohio River, excellent clays were found that attracted many accomplished potters. In fact, East Liverpool was claimed to more closely resemble an English pottery town than any other in America. Between East Liverpool and Wellsville, in 1880, there were nearly ninety potteries.

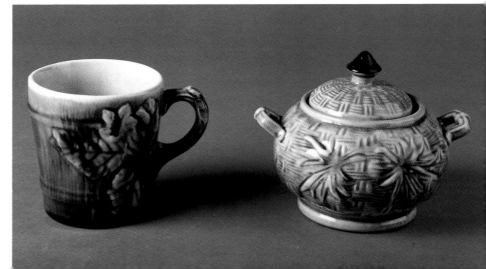

Mug and covered sugar bowl. Morley & Co.; basket and fern motif on bowl, fence and acorn on mug. 4.5" high and 4" high. *Courtesy of Michael G. Strawser, Majolica Auctions.* Mug: $125-135; sugar: $500-550

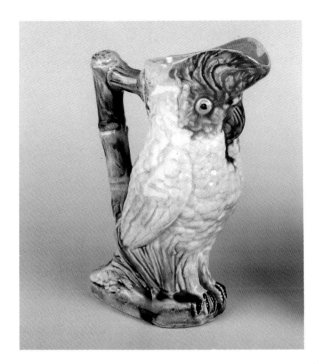

Pitcher, possibly one of Morley's popular parrot pitchers. 8"
high. *Courtesy of Michael G. Strawser, Majolica Auctions.* $525-
550

George Morley, the pottery's founder, had learned
the potting trade at the Staffordshire potteries in En-
gland. He arrived in East Liverpool, Ohio in 1852 and
worked at Woodward, Blakely and Company for 18
years. He began the Salamander Pottery, a three man
partnership between 1855 and 1878, before open-
ing his own firm in about 1879. Morley & Company
produced majolica and ironstone from the start. Of
the East Liverpool potteries, George Morley's made
the most significant contribution; in thirty-eight years,
Morley produced more majolica than any other firm
west of the Pennsylvania line.[7]

The most popular products of this pottery are fig-
ural pitchers in the forms of fish, parrots, and owls. Of
these, the best known are the "gurgling fish" pitchers
which feature a distinctive pouring sound. The fish
pitchers came in graduated sizes from five to eleven
inches tall. Morley & Company also issued a compote
and a plate with a large leaf pattern, potted from molds
purchased from Griffen, Smith & Hill. The bodies of this
firm's wares were generally denser than most majolica;
indeed, some was ironstone with a majolica glaze.

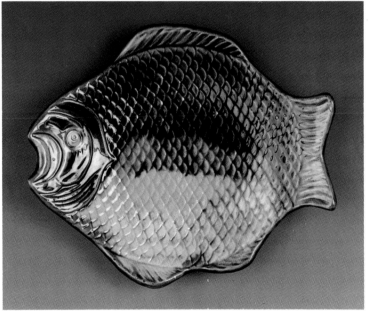

Platter, American, probably from one of the Ohio potteries; very
realistic fish design. 12.5" long x 6.5" wide. *Courtesy of Michael G.
Strawser, Majolica Auctions.* $225-250

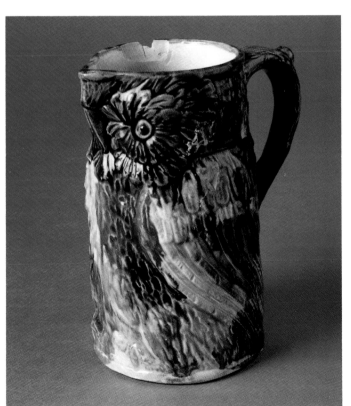

Pitcher, possibly Morley; figural owl. 6.25" high. *Courtesy of Michael
G. Strawser, Majolica Auctions.* $670-770

Morley & Company Marks

George Morley had large quantities of his majolica wares marked. His marks included:

MORLEY & CO.
MAJOLICA
WELLSVILLE, O.
from 1879 to 1884, and
GEORGE MORLEY'S
MAJOLICA
EAST LIVERPOOL, O.

upon his return to East Liverpool. At times the word majolica was spelled with two Ls in the 1879-1884 mark.

The New Milford Pottery Company and the Wannopee Pottery Company

This pottery was established in New Milford, Connecticut in 1887. The New Milford Pottery Company was the last major American firm to produce majolica before the demand dropped off. The factory was created with the combined efforts of thirty-four citizens led by Lewis F. Curtis and William Diamond Black. Majolica production began in 1888. The lines were simple and glazes were applied in streaks, drips and mottled patterns. In 1889 the pottery was reorganized after suffering financial setbacks and once again produced majolica including umbrella stands, wash bowl and pitcher sets, and a variety of small utilitarian dinner wares.

The firm was liquidated in 1892 following William Black's death and became the Wannopee Pottery Company, specializing in majolica *Lettuce Leaf* wares in an eighteenth century style until about 1904. Twenty five patterns were produced in the *Lettuce Leaf* pattern, including dinner services. They also produced a range of more conventional majolica and Rockingham wares including pitchers, candlesticks, umbrella stands, cuspidors, clock cases, jardinieres and table wares from the New Milford Pottery Company's molds.[8]

New Milford Pottery Company and Wannopee Pottery Company Marks

The New Milford Pottery Company mark on majolica was "N.M.P.CO." in a diamond shaped mark.

The Wannopee mark was an incised "W" in a sunburst. At times "NEW MILFORD" accompanied the sunburst. The mark "WANNOPEE POTTERY CO." was used as well.

One method patterns are perpetuated after the original firm has ceased production was illustrated when the Wannopee Pottery Company closed in 1904. The *Lettuce Leaf* molds were purchased by the George Bowman Company of Trenton, New Jersey. There the molds were used to resurrect the pattern. The later Bowman Company *Lettuce Leaf* majolica was heavier than the Wannopee examples and the George Bowman Company wares were also stamped "LETTUCE LEAF, TRADE MARK" in black.

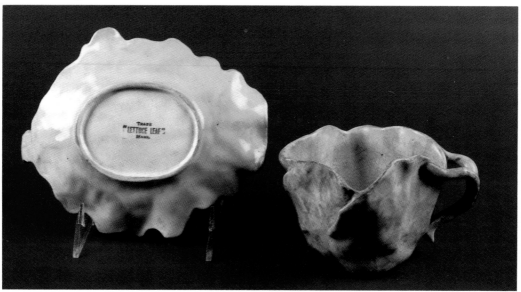

Gravy boat pitcher and platter, Wannopee Pottery Co., marked TRADEMARK "LETTUCE LEAF" on bottom of platter. Pitcher 3.5" high; platter, 9" long. The inspiration for Lettuce Leaf wares came from French 18th century faience. NP

The New York City Pottery

James Carr, an English potter who worked for James Clew and John Ridgway in Britain before arriving on American shores in 1844, established his impressive New York City Pottery at 442 West 13th St., Manhattan in 1853. This was one of the most advanced works in North America and produced wares of high quality and exacting standards for more than twenty years. The first products of the factory were Rockingham wares and yellow glazed earthenwares.

Majolica was added to the factory's repertoire by the mid-1860s. They produced game dishes, sardine boxes, comports, centerpieces, pitchers, match strikers, garden seats and vases reflecting English designs and techniques. A cauliflower pattern, reminiscent of Wedgwood's work, is among the best known of Carr's majolica wares.

James Carr displayed his majolica wares at the 1876 Centennial Exhibition in Philadelphia. His majolica won a gold medal there and received high critical acclaim. As with most successful firms, Carr made good use of additional exhibitions during the life of his factory. He enjoyed great success at the international Paris Exposition in 1878 where, against stiff English and Continental competition, James Carr was honored for the quality of his work.

The New York City Pottery continued production of majolica and other wares until 1888. Before the firm closed, James Carr had established a legacy as one of the most significant potters in America. By virtue of Carr's early majolica production, his firm trained many of the American artists active during majolica's American height in the 1880s, including J. E. Jeffords of Philadelphia.[9]

The New York City Pottery Marks

Unfortunately, Carr's majolica was not frequently marked, particularly in the early years. One school of thought argues that no marked James Carr majolica from the New York City Pottery survives today, leaving positive identification of his majolica wares in doubt at this time. Another argues that his majolica may be found today with at least one known mark, an impressed "JC" monogram, looking a great deal like the George Jones "JG" monogram. If the second school of thought is correct, this similarity in monograms with a well known and appreciated English firm may have been a conscious choice on James Carr's part, at least during his early years of production. Obscuring the country of origins for Carr's wares would have allowed him to side-step the American prejudice against local

Odell and Booth Brothers

Odell and Booth Brothers began operations in 1878 in Tarrytown, New York. The company produced majolica and faience. By 1890, the company ceased its production of majolica, closed its doors and transformed itself into the Owen Tile Company, manufacturers of decorative tiles.[10]

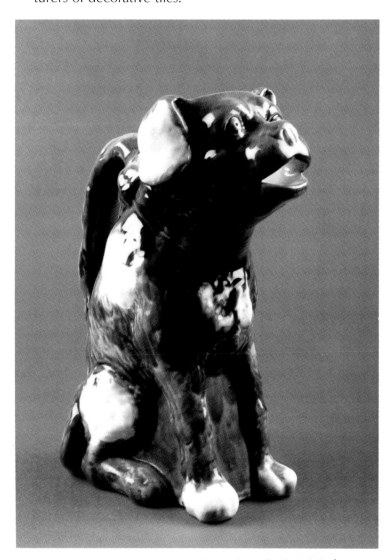

Pitcher, Odell & Booth Brothers; figural dog. The O.& B.B. dog pitcher is one of the few forms the company deigned to mark. $275+

O.& B.B. manufacturer's mark on bottom of dog pitcher.

Odell and Booth Brothers Mark

Not much of this firm's majolica was marked. One of the infrequently marked pieces is a dog-shaped pitcher which pours from the mouth and is glazed brown and white. It is marked with an impressed "O & BB"

The Peekskill Pottery Company (Harrison's Pottery Works)

In Peekskill, New York, Richard Harrison began a small pottery works in c. 1882. The idea was to diversify his established interests as a pottery and glass merchant. Majolica was possibly the only product of the factory. Several marked examples have survived. These include bread trays, toby mugs, and pitchers. The factory is believed to have closed around the down-turn of public interest in majolica in c. 1890.[11]

The Philadelphia City Pottery (Jeffords and Company)

In 1868 J.E. Jeffords established the Philadelphia City Pottery, also known as the Port Richmond Pottery Company, in Philadelphia. Jeffords had trained with James Carr at the New York City Pottery and, like Carr, exhibited majolica at the Philadelphia Centennial Exhibition in 1876. This factory was in operation until 1890.

The Philadelphia City Pottery produced Rockingham ware, yellow ware and ironstone along with its majolica. The factory was capable of some extraordinary large-scale castings. One of the most striking was a massive twenty gallon teapot held aloft on a four foot high majolica pedestal, relief decorated with images of immense vases bearing classical medallions and gilded lion's-head handles. This piece drew attention at the Centennial Exhibition.[12]

The Philadelphia City Pottery Marks

Jeffords was not in the habit of marking his majolica.

Tenuous Majolica

There are exceptions in every rule. Most small potting firms did not identify their wares as they had no name recognition and therefore no use for a maufacturers' mark. One of these lesser firms, however, identified their wares regularly, using the impressed mark "Tenuous Majolica." The name is appropriate; to date, next to nothing is known about this anonymous American potter beyond the evidence of his well potted and glazed wares.

Tenuous produced designs similar to those of Griffen, Smith & Company, including simplified versions of the Etruscan *Shell and Seaweed* pattern and stylized leaf designs. Tenuous produced a range of wares from butter pats and trays to creamers and syrup jugs.[13]

Tenuous Manufacturers' Mark

The firm used an impressed circular mark bearing the word "TENUOUS" along the upper half of the circle, "MAJOLICA" on the lower half and the letter "H" in the center of the circle.

The Trenton Potteries

For potters, Trenton, New Jersey had it all: fine natural resources, accessible shipping routes through the Delaware and Chesapeake canal systems, and docking facilities on the Delaware River. By 1875, nineteen different potteries were taking advantage of Trenton's resources and several are notable for their majolica production.

Arsenal Pottery

The founding date for the Arsenal Pottery is unclear. The company, owned by Joseph Mayer, is known to have been in operation in Trenton as early as 1877. The Arsenal Pottery produced well-modeled majolica wares including jugs and Toby pitchers. The company also exhibited their majolica at the Chicago World's Fair in 1893. The Arsenal Pottery did not mark their majolica.[14]

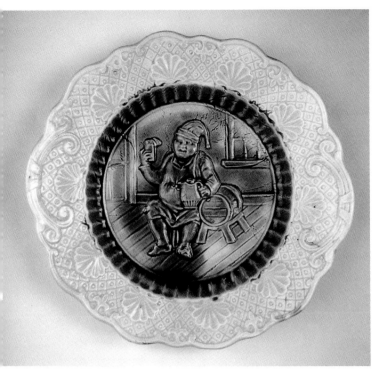

Toby plate, unattributed, beer hall scene in center. 10.5" dia. The Arsenal Pottery was known to make Toby pitchers, featuring similarly jovial vignettes. The inspiration for this plate was the Toby jug, a popular pottery drinking jug molded as a seated man holding a mug and pipe, wearing a tri-corner hat. The original creation of these mugs (some 25 forms) has been attributed to Ralph Wood I and his son in England from 1748-1795. *Courtesy of Michael G. Strawser, Majolica Auctions.* $280-310

Eureka Pottery

Leon Weil founded the Eureka Pottery in Trenton in 1883. The pottery had a short life, closing forever when it burned down in 1887. This firm produced what may have been the most attractive majolica to come out of Trenton. Their majolica was quality ware fashioned after English patterns. Two marked Eureka patterns were adaptations of Asian designs produced earlier in the century in English majolica. The first was a bird and fan on a pebbly white or blue background. The second was an owl and fan design on a white, brown or pebbly gray background.

George Jones' and Minton's stork patterns were also reflected in Eureka designs. Eureka produced stork pitchers with a single large white bird standing among cattails and other marsh plants.[15]

Side dish, Eureka, 1885; dragonfly and fan pattern. 9.5" x 10.5". This is one part of a ice cream service featuring a central platter and side dishes. *Courtesy of Michael G. Strawser, Majolica Auctions.* With six side dishes, the ice cream set is valued at $2000+.

Cake stand, Eureka; bird on branch. *Courtesy of Michael G. Strawser, Majolica Auctions.* $425+

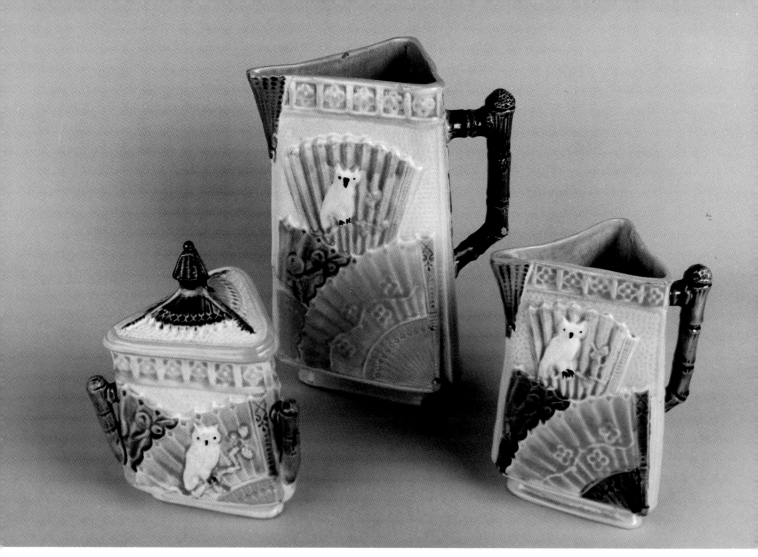

A triangular sugar bowl, a pitcher, and a creamer, Eureka; triangular, fan and owl motif. Pitcher, 9″ high; creamer, 6″ high; sugar bowl, 6.5″ high. *Courtesy of Michael G. Strawser, Majolica Auctions.* Sugar: $375-415; 9″ high pitcher: $525-575; creamer: $240-265

Eureka Pottery Marks

Eureka Pottery marked much of their majolica wares. They used an impressed mark with the company name "EUREKA POTTERY" arching over the "TRENTON" town name.

Glassgow Pottery

In 1863 John Moses founded the Glasgow Pottery to produce yellow ware, Rockingham, cream-colored wares, and white granite; majolica came later. Most of the Glasgow Pottery's products were utilitarian. It is most notable as one of only three American firms (along with The New York City Pottery and The Philadelphia City Pottery) to display majolica at the Philadelphia Centennial Exhibition. Unfortunately the pottery apparently marked none of its majolica. The plant ceased production around 1900.[16]

Willets Manufacturing Company

Willets opened in Trenton, New Jersey in 1879, touted as one of the largest pottery firms in America. It is unclear how much majolica this pottery produced or for how long, but among its wares was at least one improbable item, a majolica doorknob. While Willets Manufacturing Company produced many marks for its other wares (including white granite, semi-porcelain and Belleek) no marked majolica wares have been found to date.[17]

Continental Majolica

By the third quarter of the nineteenth century, pottery firms in Europe had joined in the production of majolica. As English potters had been inspired by Minton's majolica display in 1851, so European potters were motivated into majolica production by dis-

plays of the English product during the Paris Exhibition of 1855 and the London Exhibition of 1862. Once again, international exhibitions proved pivotal to the dissemination of majolica.

Berry set (pitcher missing), Julius Dressler, marked "Austria" with a heraldic crest; seashell form. 13" x 10". Potteries throughout the European continent produced some lovely pieces, many unattributable. *Courtesy of Michael G. Strawser, Majolica Auctions.* Berry platter: $475-525; berry pitcher: $325-360.

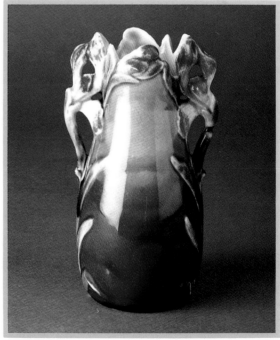

Late mark from Julius Dressler printed on the base of the berry set.

Vase, from the Continent; iris motif. 5.5" high. *Courtesy of Michael G. Strawser, Majolica Auctions.* $150-165

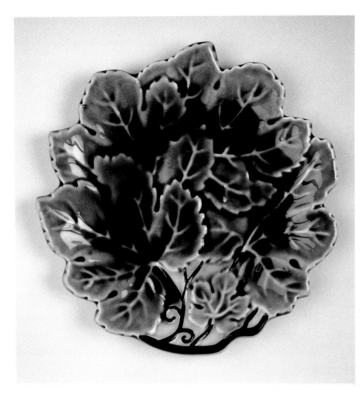

Plate, unattributed, marked "Czechoslo-vakia" on back; grape leaf motif. 7" dia. *Courtesy of Michael G. Strawser, Majolica Auctions.* $50+

Mark on back of grape leaf plate.

Pitcher, unattributed, marked "From Paris;" figural dog. 8" high. $475-525

Plate, unattributed French; Joan of Arc under the motto "Glorie, Honneur, Patrie, Liberte." 8.5" dia. French potters did not stop at pottery tradition for their inspiration; they drew upon the history of the entire nation. *Courtesy of Michael G. Strawser, Majolica Auctions.* $155-175

France, Germany, Austria, the Scandinavian countries, Portugal and Italy added their visions of majolica to the international marketplace. Continental potters looked both to their British competition and to their own Renaissance antiquities for inspiration and designs. The French, Germans and Austrians were most inclined to produce majolica based on established English designs, and the largest quantities emanated from the Sarreguemines factory in Lorraine, France. Wedgwood's designs were particularly popular sources of design inspiration among these firms.[1]

Deliberately avoiding the designs of the British competition were the older and more established factories. These turned to producing modern interpretations of their own Renaissance heritage. Much of this more original and interesting majolica was derived from the same remarkable sixteenth century wares that Léon Arnoux and Herbert Minton admired, those of the famed French naturalist and potter Bernard Palissy. The popularity of Palissy's work, large dishes extraordinarily encrusted with intricately detailed flora and fauna, was attested to by the many copies, "Palissy wares", produced by ardent followers ever since. The most successful reproductions of Palissy's work in the nineteenth century were accomplished by Charles Jean Avisseau in Tours, France.[2]

In the 1870s, while majolica production diminished in England, a number of potters in France, Germany and Austria turned their efforts towards the production of novelty majolica items. These were to be sold cheaply as foreign exports, primarily to the United States and, ironically, Great Britain. The firms that had been most interested in imitating English majolica wares were now sending the imitations home to England. Production of these inexpensive exports continued well into the twentieth century and are readily available today.[3]

Arabia Pottery

This Finnish firm was founded in 1874 on the outskirts of Helsinki as a subsidiary of the prestigious Rörstrand Pottery of Sweden. Arabia's primary decorative product was art pottery. Much of the majolica this company produced was large and functional, including jardinieres and plant stands in an Art Nouveau style. These tended to be impressed with the "ARABIA" mark which was in use from 1874 to 1930.[4]

Avisseau (and other French proponents of Bernard Palissy's wares)

Charles Jean Avisseau was a Victorian man with a mission. Renaissance Revivalism was sweeping France, and Charles Avisseau swiftly pounced upon this passion for all things Renaissance. In 1829 he founded a small pottery in Tours, France with the sole intent of authentically reproducing earthenwares in Bernard Palissy's inimitable Renaissance style.

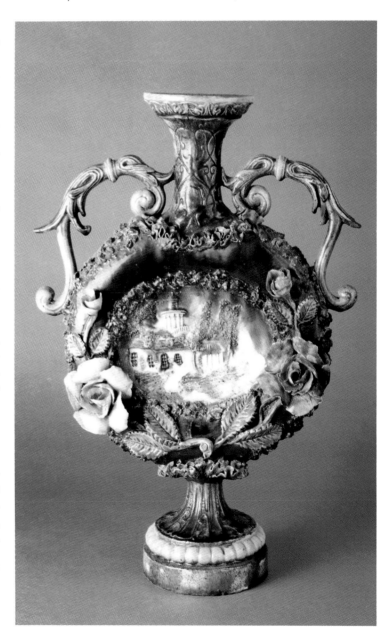

Extremely unusual humidifier, French, signed Francois Maurice. Palissy's work was a popular inspiration to 19th century French designers. 18" high x 12" wide x 2" thick. *Courtesy of Michael G. Strawser, Majolica Auctions.* $275-375

143

Avisseau succeeded in his efforts. These detailed Palissy-style ceramics are often considered part of what is broadly interpreted as majolica today, although much of Avisseau's work predates the introduction of the majolica trade name by several decades. Moreover, they differ in several technical aspects. Avisseau's work, and those of French potters he inspired, was decorated differently from the majority of Victorian majolica. His wares were painted with metallic enamel colors applied to the surface of a vessel and then protected with a coat of glaze, instead of following the standard majolica pattern of achieving colors by using opaque or semi-opaque glazes that are themselves colored.

Also unlike the majority of Victorian majolica, which was pressed and slip-cast using mass production techniques, Avisseau's wares and those of his adherents were hand-made, using precise hand modeling and potting techniques in Palissy's sixteenth century tradition. Such labor-intensive wares were made in small quantities and are rare today.

Beginning in 1843, Avisseau's designs were created by his brother-in-law, Joseph Landis. Landis would be succeeded by his son Alexandre. In 1850 Charles Avisseau's son Edward and daughter Caroline joined their father's efforts. In 1855 the Avisseau's displayed their wares at the Paris Exhibition, and as it had done for Minton in 1851, the exhibition exposure created a demand for Avisseau's Palissy ware, most strongly in his native country.[5]

As often happens with a popular product, after Charles Avisseau died others took up the production of the popular Palissy wares. These manufacturers produced Palissy wares in more contemporary forms to gain a wider commercial market. Members of Avisseau's family and other French manufacturers, including Leon Brard, Auguste Chauvigne, Thomas Sergent, Victor Barbizet, and George Pull produced these later wares in France. However, the primary source for later Palissy wares would be in Caldas da Rainha, Portugal.

Manufacturer's Marks

Most of the Victorian French potters used painted or incised monograms on their wares. Unfortunately many of their wares are also found unmarked.

Ulisse Cantagalli

This firm was established in Florence in 1878 and remained in production until 1901. Their majolica tended to reflect the Italian Renaissance maiolica in form and design. Here they have used an impressed mark, "CANTAGAL FIRENZE".[6]

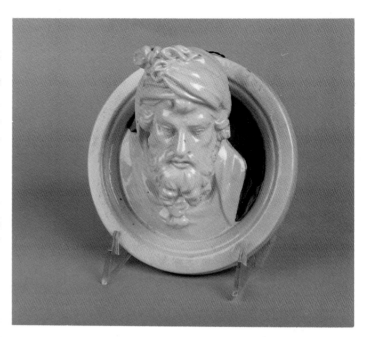

Tavern wall hanging, Ulisse Cantagalli, marked on back "Cantagalli, Firenze, Marca Ditta," with an encircled rooster seal. Approx. 8" dia. *Courtesy of Michael G. Strawser, Majolica Auctions.* $100+

Cantagalli manufacturer's mark on tavern wall hanging.

Choisy-le-Roi

Taking advantage of the interest in Chinese export porcelain being pedaled by the East India companies, Valentin Paillart built a faience pottery in Choisy-le-Roi in 1804. Louis Boulanger became manager in 1836 and his son Hippolyte Boulanger succeeded him in 1863. True to its roots, the company added majolica to its repertoire in the early 1860s, as demand for this ware grew following the Paris Exhibition. Majolica would continue to be produced there until 1910.

The Franco-Prussian War assisted the company in 1870 by annexing its prime competitor, Sarreguemines, into another nation and out of the

favor of French consumers. The annexation of Alsace-Lorraine by Bismark left Choisy-le-Roi as the favorite French majolica manufacturer. To further improve matters, some of the Sarreguemines workers came back to France and to Choisy, bringing with them a wealth of information and technical expertise from what had been France's preferred pottery.

While the fascination with Renaissance wares held sway in the early 1860s, Choisy artists were enraptured by the Japanese ceramics exhibited at the Paris exhibitions of 1867 and 1878; spare and asymmetrical oriental designs became a dominant decorative influence. Other motifs used during the last quarter of the nineteenth century included leaf plates and a variation on the shell-and-seaweed pattern.[7]

Choisy-le-Roi Marks

The firm's majolica was not always marked. The marks which were used included:

"Choisy-le-Roi,"
and
"Choisy,"

sometimes followed with the initials "HB" for Hippolyte Boulanger.

José A. Cunha

One accomplished Portugese potter following Palissy's inspiration was José A. Cunha, also of Caldas da Rainha, Portugal. Examples of Cunha's wares dating from around 1900 were leaf molded table wares with imaginative designs, some of which were inspired by eighteenth century tin-glazed earthenware as well.[8]

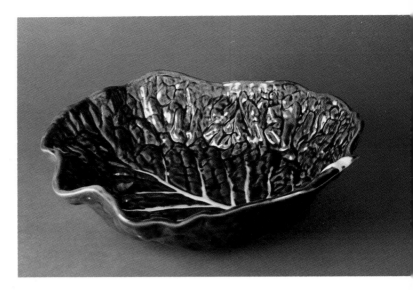

Bowl from salad set, Portuguese; lettuce leaf motif. Bowl, 13" dia.; four plates are 7.5" dia. *Courtesy of Michael G. Strawser, Majolica Auctions.* $150-165

José A. Cunha Mark

Pieces of Cunha's work may bear an impressed manufacturer's mark.

Gien

La Faïencerie de Gien was an established firm which began producing majolica in 1864. By 1866 the firm employed over a thousand employees and could produce roughly 50,000 plates daily. The company's majolica wares included vases, plaques (round and square), and green-glazed dessert plates which were exhibited at the Paris exhibition of 1878.[9]

Plate, unattributed, Portuguese; leaf-molded form. 7.5" dia. *Courtesy of Michael G. Strawser, Majolica Auctions.* $115-125

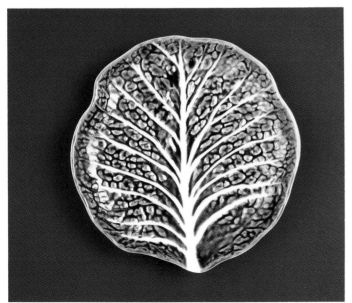

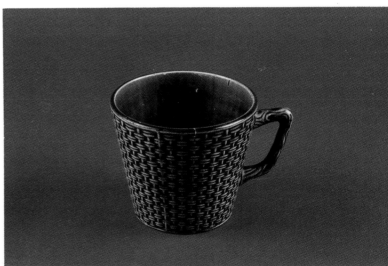

Mug, marked "Faiance, GIEN, Medalles D'Or Diplumes S'Monneor" on bottom; basketweave texture. 3.25" high. NP

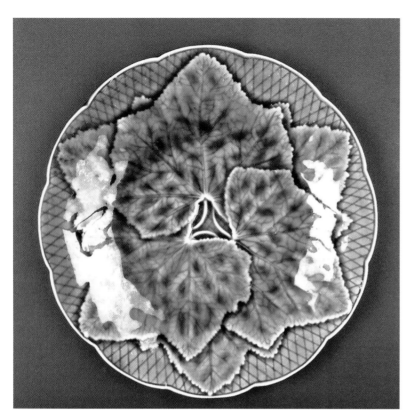

Plate, La Faïencerie de Gien, overlapping grape leaves. *Courtesy of Michael G. Strawser, Majolica Auctions.* $100-110

Printed manufacturer's mark, GIEN FRANCE.

Gien Marks

Two marks used on majolica wares were a turreted castle with "GIEN" printed above and "FRANCE" below the castle and an oval mark with the words "La Faïencerie de Gien."

Luneville and Saint Clément

Luneville and Saint Clément were both located in a portion of the contested province of Lorraine that was not ceded to Germany following the Franco-Prussian War. Both were established in the eighteenth century, in 1731 for Luneville and in 1758 for Saint Clement. Both produced faience first and then, in the second half of the nineteenth century, majolica.

The firm of Keller et Guerin produced a small amount of majolica at the historic Luneville works. Their majolica used brilliant colors, heavy in blues and greens. Tea and coffee services, asparagus services and accessory pieces were a specialty at Luneville. Majolica production ceased when the factory doors closed in 1914.

Majolica production at Saint Clément began in the 1860s and continued for more than forty years.

Majolica produced there included table and dessert services, asparagus-artichoke services, pitchers, and ornamental vases. Their majolica was by-in-large delicate in relief and subtle in shading. Outside of their usual line of majolica, Saint Clément also produced jardinieres featuring Palissy style decorations.[10]

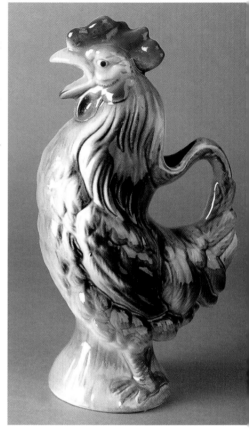

Pitcher, Saint Clément, France; rooster figural design. 11" high. Saint Clément was known for its subtlety in glazing. *Courtesy of Michael G. Strawser, Majolica Auctions.* $350-515

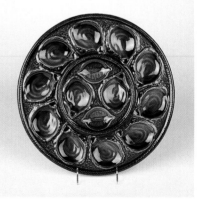

St. Clément brown oyster platter. The St. Clément pottery was established in the town of the same name in France in 1758. By 1892, the factory was purchased by Keller and Guérin (owners of Lunéville—known for its production of majolica asparagus plates and coffee services). St. Clément was known for the production of fine majolica figures with soft, blended glaze colors. St. Clément was purchased in 1922 by the Fenal family. Most were marked either KG (for the owners) or SC (for the company) on the base. 14.5" d. *Courtesy of Michael G. Strawser, Majolica Auctions.* $175-195

Luneville and Saint Clément Marks

The Luneville manufacturer's mark was the impressed company name "LUNEVILLE," at times with the letters "KG" (for Keller et Guerin) and the word "DEPOSE."

Saint Clément tended to mark their wares. Most common was an impressed "SAINT CLEMENT" mark.

The Manufacture Royale de Rato

The Manufacture Royale de Rato in Lisbon, Spain, roughly 100 kilometers south of Caldas da Rainha, was also a significant manufacturer of Portugese majolica. The firm also produced and exhibited Palissy ware at the 1867 Paris Exhibition.[11]

Marfra and Son

Much of the Victorian Palissy ware produced during the second half of the nineteenth century emanated from Portugal. Manuel Cyprianio Gomez Marfra's firm Marfra and Son at Caldas da Rainha produced the lion's share of the Portugese Palissy ware beginning in 1853. Caldas da Rainha is a town with a long potting tradition where Palissy wares and reproduction majolica wares are still produced today.[12]

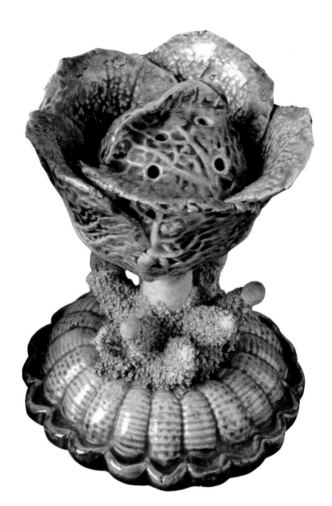

Salt shaker, unattributed, Portuguese; Palissy-inspired naturalistic detail. $375-415

Platter, unattributed, Portuguese; corn and ribbon pattern. 13.5" x 11", Portugal. *Courtesy of Michael G. Strawser, Majolica Auctions.* $250-275

Manuel Mafra's son Eduardo introduced his father to Bernard Palissy's work and directed Palissy ware production at the family factory until 1897. While the nineteenth century copies of Palissy plates and large platters are sometimes difficult to distinguish from the sixteenth century originals, they tend to be more densely packed with sea-life motifs than the originals. The Portuguese, like Palissy, also found their inspiration in local flora and fauna which was a little different from that found around Sainte, France. The Portuguese Palissy wares are not quite as impressive as their French counterparts produced by Charles Jean Avisseau. One tea and coffee service in the shape of small lettuce or cabbage leaves is very similar to the American New Milford "Lettuce Leaf" pattern.

In 1897, operation of the factory transferred to Cyprianio Gomez Mafra, another family member.

Marfra and Son Marks

During their years of production, the firm used an impressed manufacturer's mark "M. MAFRA" in an arc above an anchor with the words "CALDAS PORTUGAL" below.

Onnaing

La Faïencerie d'Onnaing produced a tremendous amount of majolica from 1870 to 1900 in northern France. They had produced faience in a rustic style from 1821 to 1838. The firm imported clays from England, Germany and Belgium to supplement their local supply. Their generally muddy-colored glazes were applied without much attention to detail. No great attempts at skillful work were made.

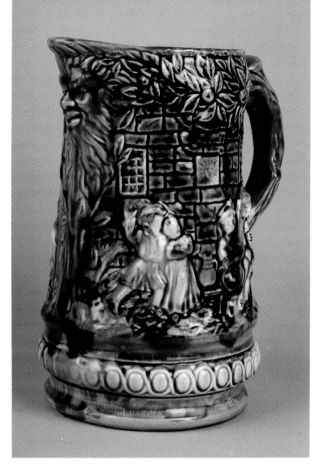

Spout of Frie Onnaing pitcher, with gargoyle.

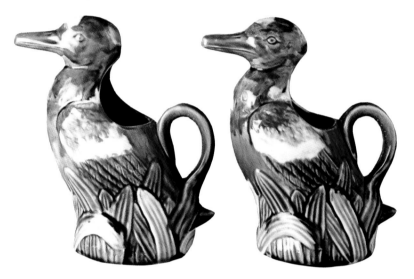

Pitchers, marked "#712, Frie Onnaing;" figural ducks. 9.5" high and 8" high. *Courtesy of Michael G. Strawser, Majolica Auctions.* $385-425 each

Pitcher, marked on bottom "Frie Onnaing" and "Made in France," decorated with relief illustrations. 8.5" high. *Courtesy of Michael G. Strawser, Majolica Auctions.* $425-465

Small pitcher, Frie Onnaing, France; heraldic lion motif. 4.5" high. *Courtesy of Michael G. Strawser, Majolica Auctions.* $375-415

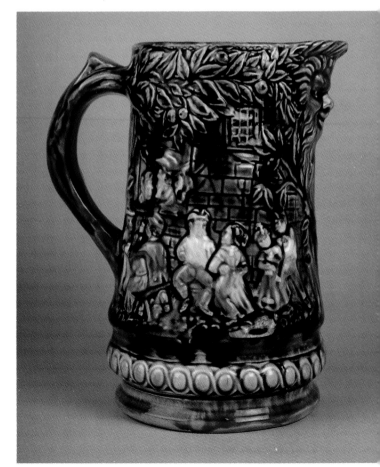

Manufacturer's marks on bottom of Frie Onnaing pitcher.

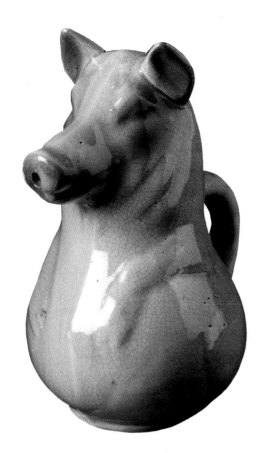

Pitcher, Sarreguemines; figural pig. 8.25" high. *Courtesy of Michael G. Strawser, Majolica Auctions.* $425-470

Pitcher, Frie Onnaing, France, marked #712; figural duck. 9.25" high. *Courtesy of Michael G. Strawser, Majolica Auctions.* $385-425

Majolica from Onnaing included dinner wares, pitchers, flowerpots, vases, umbrella holders, small clocks and children's toys. Here was a firm with an eye on the novelty export market and a mind centered on whimsy. Smoking accessories included match strikers and ashtrays molded in a variety of odd forms including vultures, and tobacco jars in the forms of frogs, dragons, bears and devils. Candlestick holders were fashioned as elephants and characters in period dress, and many other imaginative, lively forms were produced. The work was cheap, made for fairs late in the nineteenth century through 1914.

Onnaing also potted more expensive majolica in a whimsical vein. These included pitchers in animal shapes (pig chefs, frog waiters, and an entire barnyard menagerie) and human figures lampooning government officials and foreigners (particularly the British). Though tongue-in-cheek productions, Onnaing introduced five new pitcher models each and every year which are still being reproduced.[13]

Onnaing Marks

The manufacturer's mark on the expensive ware was a sun and crown above a shield bracketed with the letters "Frie" to the left and "O" to the right as an abbreviation of the firm name.

While none of the inexpensive wares bear the company name, they do provide a three or four digit number code impressed on a white base, a clue to their identity.

Rafael Bordalo Pinheiro

Rafael Bordalo Pinheiro established a large factory of his own in Caldas da Rainha, Portugal in 1883. Pinheiro was inspired by both Palissy and Mafra. He designed and produced a wide range of majolica wares including tiles and Palissy wares. Examples of his wares were on display at the 1889 Paris Exposition. His factory is still in business today.[14]

Sarreguemines

In 1770, Paul Utzschneider established Sarreguemines as a large pottery works at Dijon and Limoges in the Lorraine region of France and following the Franco-Prussian War of 1870 in Prussia. Despite shifting nationalities, the firm continued production until the early twentieth century. In the 1850s, the company's principle product was faience, a French tin-glazed earthenware. Expansion in the 1860s, and Europe's increasing interest in majolica following the exhibitions of 1855 and 1862, led the company to produce majolica. With kilns designed by Léon Arnoux (ordered from Mintons and installed in the new works at the Dijoin plant) Sarreguemines began producing majolica following English designs.

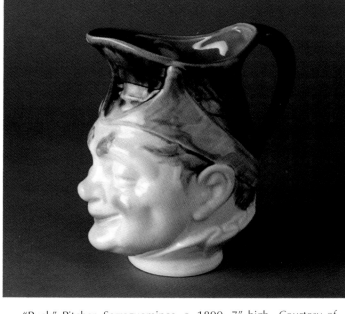

"Puck" Pitcher, Sarreguemines, c. 1890. 7" high. *Courtesy of Michael G. Strawser, Majolica Auctions.* $275-350

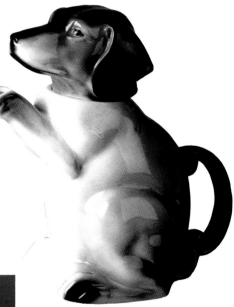

Pitchers, Sarreguemines. Each 8.5" high. *Courtesy of Michael G. Strawser, Majolica Auctions.* $300-400

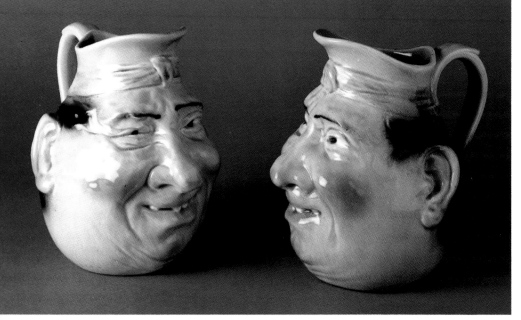

Teapot, Sarreguemines; model of a begging dog. 8.5" high. *Courtesy of Michael G. Strawser, Majolica Auctions.* $195-225

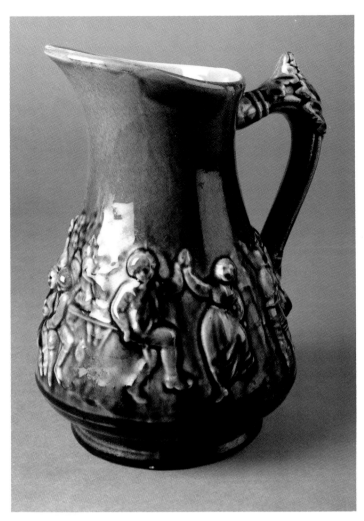

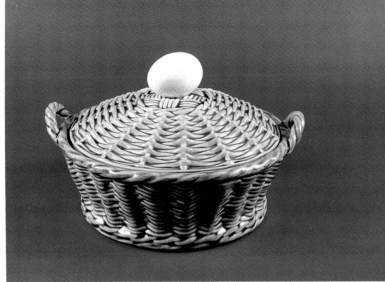

Egg basket, marked "Sarreguemines". 8" dia. x 6" high. $250-275

Pitcher, Sarreguemines; decorated with village scenes in relief. 8.25" high. *Courtesy of Michael G. Strawser, Majolica Auctions.* NP

Covered tureen, Sarreguemines; beautifully glazed duck 11" x 7" x 8.5" high. $250-275

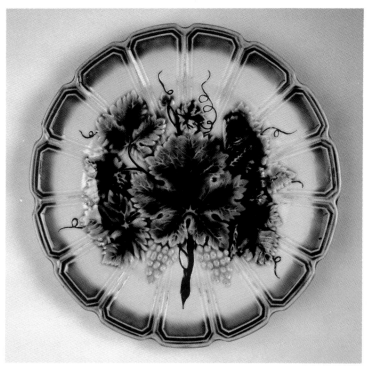

Small plate, Sarreguemines; grape and leaf pattern. 7.75" dia. *Courtesy of Michael G. Strawser, Majolica Auctions.* $125-135

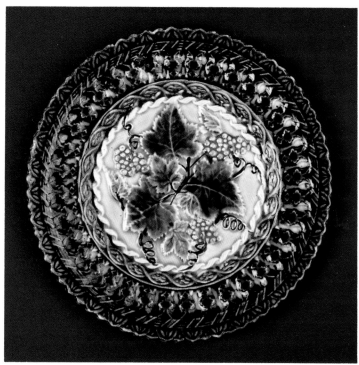

Plate, Sarreguemines, marked U. & C.S. (Utzschneider et Compagnie, Sarreguemines) on back; cobalt with grape decoration. *Courtesy of Michael G. Strawser, Majolica Auctions.* $135-150

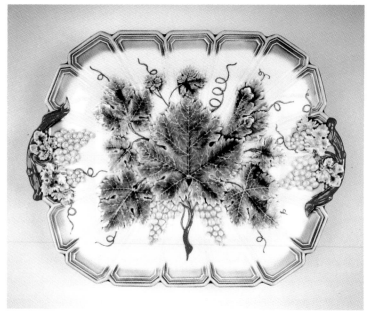

Platter with handles, marked "Sarreguemines;" grape and leaf pattern. 12.5" x 10". *Courtesy of Michael G. Strawser, Majolica Auctions.* $525-575

Manufacturer's mark impressed on back of Sarreguemines grape and leaf platter.

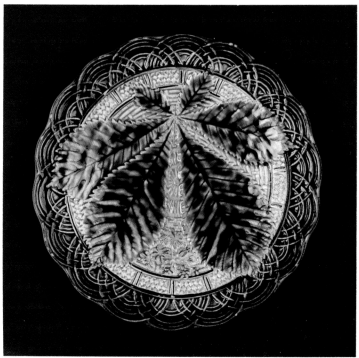

Plate, Sarreguemines, marked U. & C.S.; fern motif with scalloped border. 8" dia. *Courtesy of Michael G. Strawser, Majolica Auctions.* $135-150

Manufacturer's mark on reverse of U.C. & S. fern plate.

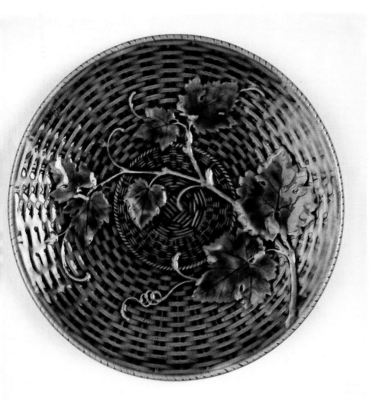

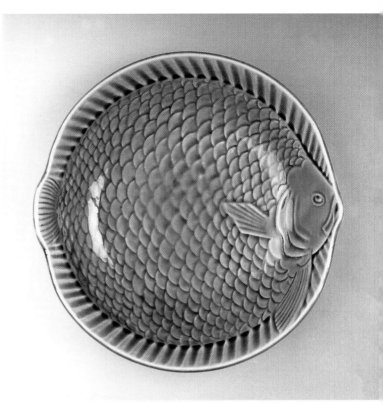

Plate, Sarreguemines, marked "MAJOLICA DEPOSE;" wicker and leaf pattern in monochrome green glaze. 8.25" dia. Also appears naturalistically colored in greens and browns, on a yellow wicker background. *Courtesy of Michael G. Strawser, Majolica Auctions.* $125-135

Bowl, Sarreguemines; fish with a raised pattern. 8" dia. *Courtesy of Michael G. Strawser, Majolica Auctions.* $125-135

Back of Sarreguemines wicker and leaf plate. "DEPOSE" indicates French origin, and can also be impressed merely as "DEPO."

Script manufacturer's mark (unfortunately upside-down) on back of Sarreguemines fish bowl.

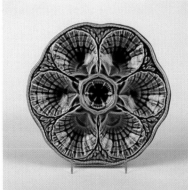

Oyster plate in green by Sarreguemines. 10" d. *Courtesy of Michael G. Strawser, Majolica Auctions.* $225+

The Dijon factory became the largest of its type in France, supporting over 2000 workers and creating majolica of a quality rivaling Minton's. Sarreguemines manufactured majolica into the early twentieth century, maintaining a high standard of quality to the end.

Among Sarreguemines majolica wares were ornamental, figural and novelty items, architectural forms and useful wares emphasizing dessert services. The body of these wares was heavily potted, creating durable majolica forms. The designs were predominantly English inspirations. There were, however, some examples with a distinctly French style, especially those items reflecting the influence of the Art Nouveau movement which were produced around 1900.[15]

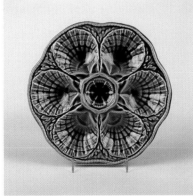

Sarreguemines oyster platter, shell, seaweed and rope motif. 15" l. *Courtesy of Michael G. Strawser, Majolica Auctions.* $250+

Sarreguemines Marks

Most of the majolica this company produced was well marked. "SARREGUEMINES" was the most common mark, impressed or printed with the monogram letters "U" and "C," for Utzschneider et Compagnie, surrounded by an octagon.

Wilhelm Schiller and Sons

In 1829, this company was founded in Bodenbach, Bohemia in Czechoslovakia to produce porcelain and earthenware. The quality was considered very high, striking in modeling and glaze.

The plant closed in 1895.[16]

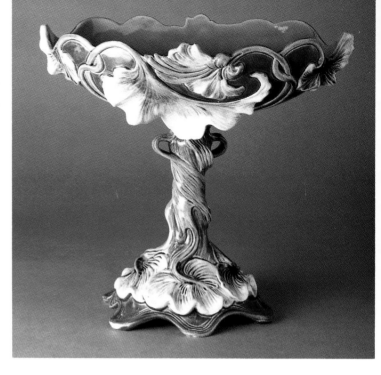

Compote, Wilhelm Schiller & Sons, signed "W.S. & S., No. 11562;" Art Nouveau style. A post through the center allows rotation of the top dish. 12" dia. x 10.5" high. *Courtesy of Michael G. Strawser, Majolica Auctions.* $275-300

Wilhelm Schiller and Sons Marks

Wilhelm Schiller and Sons used an impressed "W.S. & S." manufacturer's mark on their majolica.

Georg Schneider

Schneider produced useful rather than ornamental majolica in Germany and a line of souvenir wares in an English style. The most common wares were dessert plates. Majolica wares were manufactured at the Zell Pottery in Baden from c. 1890 to 1920.[17]

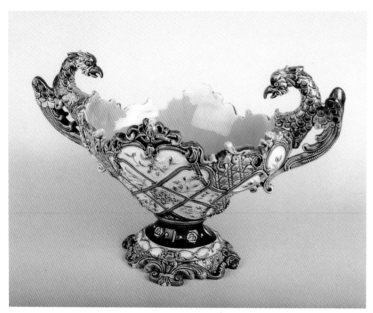

Console bowl, Wilhelm Schiller & Sons; eagle motif, turquoise interior. 16.5" x 11". *Courtesy of Michael G. Strawser, Majolica Auctions.* $850-935

Plate, Zell; water lily design. 7.5" dia. $65-75

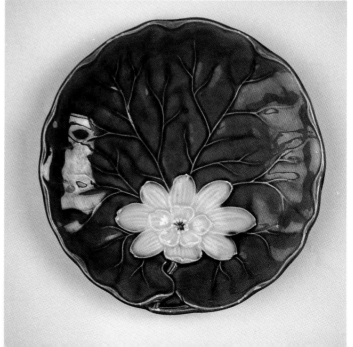

Back of Zell water lily plate. Printed teacup manufacturer's mark includes the company name and the initials G.S., Georg Schneidor. Also marked "GERMANY."

Georg Schneider Mark

Some of Schneiders majolica was marked with a printed up surrounding the monogram "GZS."

Two plates, Zell, Baden, Germany; stylized dandelion design. *Courtesy of Michael G. Strawser, Majolica Auctions.* 11" dia.: $160-180; 7.5" dia.: $55-65

Platter, unattributed, marked "Made in Germany;" two birds eating grapes. 11" dia. A good amount of majolica was produced in Germany, some echoing English motifs and others thoroughly original. *Courtesy of Michael G. Strawser, Majolica Auctions.* $160-180

Impressed teacup mark on back of Zell dandelion plates; with origin, "BADEN," indicated below.

Mark from back of birds and grapes platter.

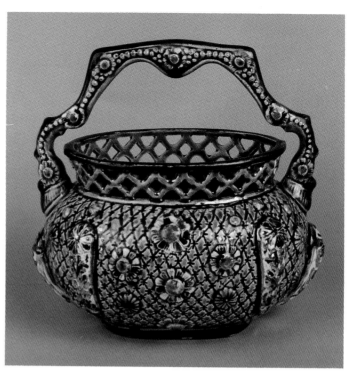

Basket, unattributed, German. 8" high. *Courtesy of Michael G. Strawser, Majolica Auctions.* $150+

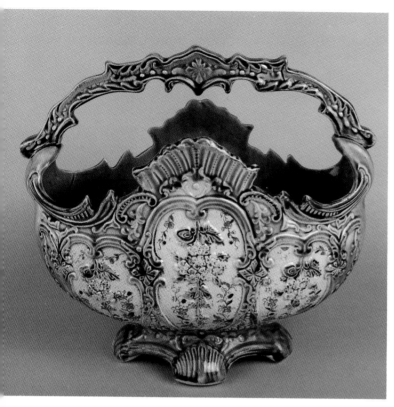

Basket, unattributed, German; very ornate. 12" long x 10.5" high. *Courtesy of Michael G. Strawser, Majolica Auctions.* $165+

Butter tub, unattributed but numbered #2837, German; bucket and fruit motif. 4.5" dia. x 2.5" high. *Courtesy of Michael G. Strawser, Majolica Auctions.* $250-275

Flowerpot, unattributed, German. 5.5" high. *Courtesy of Michael G. Strawser, Majolica Auctions.* $175-195

Platter, Wechtersbach, W. Germany; fish design. 11" x 10". *Courtesy of Michael G. Strawser, Majolica Auctions.* $215-235

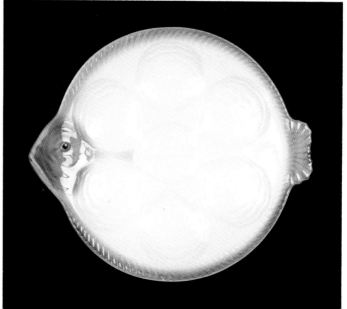

Mark on back of German fish platter.

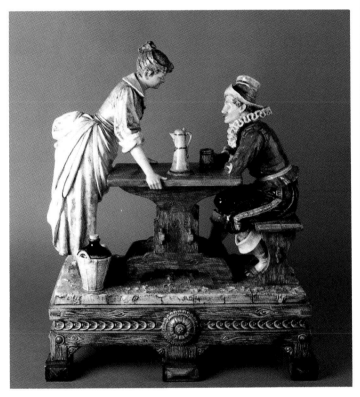

Tavern statue, German, "Gesetz gescnulzt Varviefaltigung verbehalten #12227;" museum quality. 21" high x 17.5" long x 9.5" wide. *Courtesy of Michael G. Strawser, Majolica Auctions.* $2425+

Plate, marked "Imperial Bonn, Germany;" floral pattern. 9.5" dia. *Courtesy of Michael G. Strawser, Majolica Auctions.* $140+

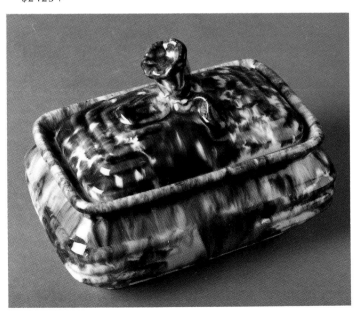

Mark on back of Imperial Bonn plate.

Covered box, signed "Germany;" mottled with flower finial handle. 7.5" long x 4.5" wide x 6" high. *Courtesy of Michael G. Strawser, Majolica Auctions.* $185-205

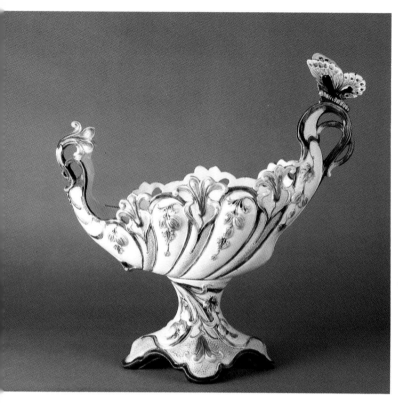

Centerpiece bowl, B. Bloch & Co., Eichwald, Bohemia [Czecho-slovakia], 2378; with butterfly perched on the handle. 18" high x 17.5" long x 6" wide. *Courtesy of Michael G. Strawser, Majolica Auctions.* $900+

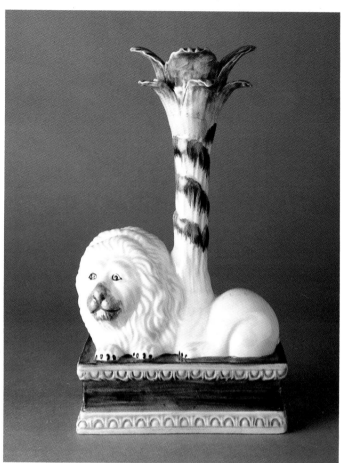

Candle holder, unattributed, Italian; figural lion and palm tree. 10" high. *Courtesy of Michael G. Strawser, Majolica Auctions.* $185-205

The Società Ceramica Richard

This company, located in Milan, Italy produced majolica from 1842 (without Minton's tradename) to 1860. Their majolica reflected the Renaissance Italian maiolica in form and design. The colors were not as rich or the designs as striking but the influence was undeniable.[18]

Società Ceramica Richard Marks

The company employed many marks over the years. The one most commonly associated with majolica, however, was a crown above the word "GINORI".

Table lamp base, unattributed, from Italy. 16.5" high. *Courtesy of Michael G. Strawser, Majolica Auctions.* $185-205

Villeroy and Boch

This company, the dominant German majolica manufacturer, had been established in 1748 by François Boch. It merged with the Villeroy family works in 1836, creating the single largest manufacturer of its sort in Europe. Between about 1860 and 1900, large quantities of majolica poured forth from Mettlach in the Rhineland, courtesy of Villeroy and Boch, much of it bound for the United States. Common products of the firm included leaf plates and other table wares reminiscent of English designs, a wise choice for the American marketplace.

The body of Villeroy and Boch majolica was stoneware, the same as is used in their popular steins today. Their glazes tended to be semi-translucent and flowing. During the early twentieth century, the company produced a line of souvenir majolica.[19]

Plate, Villeroy & Boch, Schromberg, Germany, marked "VBS;" fern imprints, scenic center. 7.5" dia. *Courtesy of Michael G. Strawser, Majolica Auctions.* $165-185

Compote, Villeroy & Boch, marked VBS; butterfly and floral theme. 9.5" dia. x 3.75" high. *Courtesy of Michael G. Strawser, Majolica Auctions.* $235-260

Bowl, Villeroy & Boch; hunt scene. 9" dia. *Courtesy of Michael G. Strawser, Majolica Auctions.* $300-330

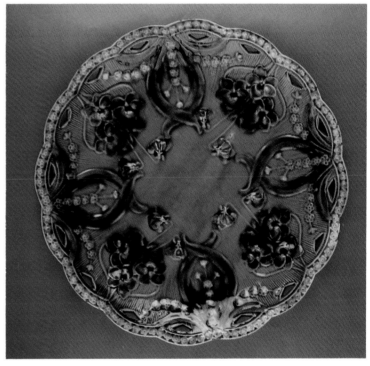

Platter, Villeroy & Boch, Schromberg, marked "VBS;" "Made in Germany" and "1313/2;" Aesthetic period violets and a pierced border. 12" dia. *Courtesy of Michael G. Strawser, Majolica Auctions.* $100-110

Mark on back of violet plate.

Villeroy and Boch Mark

All of their wares were marked. Most were impressed or printed with the letters "VBM" for Villeroy and Boch, Mettlach.

Chapter 7
Unattributed Majolica

Because majolica was such a craze for such a long time, it was inevitable that potters of less than the highest quality would "cash in" on its popularity. A tremendous quantity of low-quality wares was produced, satisfying those customers who could not afford the top pieces manufactured by potteries like Minton or Wedgwood. Not surprisingly, many of the lesser makers saw no reason to mark their wares; while their names could do nothing to attract customers, they might lead angry claimants to their doorstep when blatant copies of top-of-the-line ware appeared on the market. Of course, not all of the now-unattributable pieces have such sordid backgrounds, but for many companies it was undeniably best to remain anonymous!

Marked or unmarked, of high or of low descent, no piece of majolica is without its appeal. Some collectors enjoy the satisfactions of owning famous pieces by top potters; other collectors enjoy the intrigue of charming but unidentified pieces that capture their imagination. The pieces in this section remain mysteries to us, but perhaps in some archive, some long-lost diary, the crumbled ruin of a long-forgotten pottery, or even in the back of your own cabinet, all of the answers may lay in wait.

Geranium plate, unattributed, 7.5" dia. *Courtesy of Michael G. Strawser, Majolica Auctions.* $135-150

Plate, unattributed French; Joan of Arc under the motto "Glorie, Honneur, Patrie, Liberte." 8.5" dia. *Courtesy of Michael G. Strawser, Majolica Auctions.* $155-175

Grape and wicker plate, unattributed, 9" dia. *Courtesy of Michael G. Strawser, Majolica Auctions.* $100-110

Begonia leaf dish, unattributed, 7.5" long. *Courtesy of Michael G. Strawser, Majolica Auctions.* $135-150

Plate with oval leaves, unattributed, 8" dia. *Courtesy of Michael G. Strawser, Majolica Auctions.* $200-220

Morning Glory on napkin plate, unattributed, 9.5" dia. *Courtesy of Michael G. Strawser, Majolica Auctions.* $205+

Cake stand, Tazza; floral. 9" dia. x 2.5" high. *Courtesy of Michael G. Strawser, Majolica Auctions.* $275-300

Leaf plate with brown rim, unattributed, 8.5" dia. *Courtesy of Michael G. Strawser, Majolica Auctions.* $135-150

Shallow bowl, unattributed, 8" dia. *Courtesy of Michael G. Strawser, Majolica Auctions.* $135-150

Plate, unattributed; grapes and leaves motif. 6.5" dia. *Courtesy of Michael G. Strawser, Majolica Auctions.* $150+

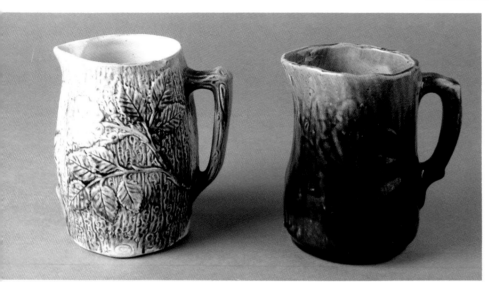

Two pitchers, unattributed; one mottled and one Wild Rose pattern. Mottled, 6" high and Wild Rose, 6.5" high. *Courtesy of Michael G. Strawser, Majolica Auctions.* $165-185 each

Two pitchers, unattributed; six-sided fern and floral designs. 7.5" high. *Courtesy of Michael G. Strawser, Majolica Auctions.* $200+ each

Two pitchers, unattributed. 6.25" high and 8" high (a reader informs me that the Ceramic Museum in East Liverpool, Ohio, had an example of this 8" high white pitcher with floral decoration and attributed it to William Brunt). *Courtesy of Michael G. Strawser, Majolica Auctions.* Left: $200+; right: $165-185

Sugar bowl, unattributed. 5.25" high. *Courtesy of Michael G. Strawser, Majolica Auctions.* $135-150

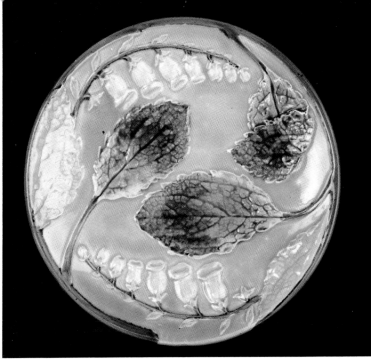

Plate, unattributed; bluebell design. 7.5" dia. $135-150

Open-handled platter, unattributed; begonia and floral design on a cobalt background. 7.5" dia. x 1.25" high. *Courtesy of Michael G. Strawser, Majolica Auctions.* $600+

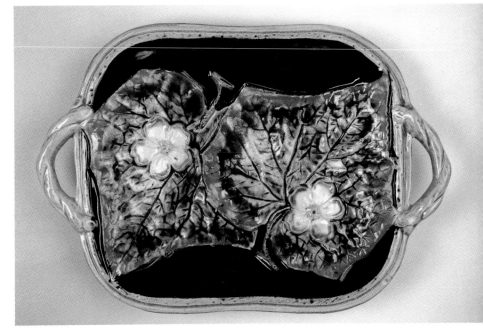

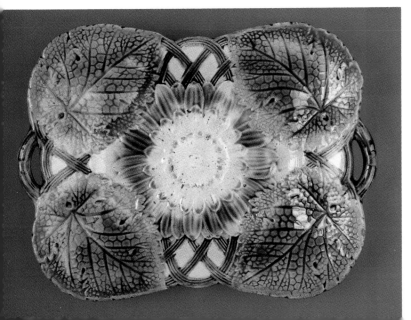

Open server. 13" long. *Courtesy of Michael G. Strawser, Majolica Auctions.* NP

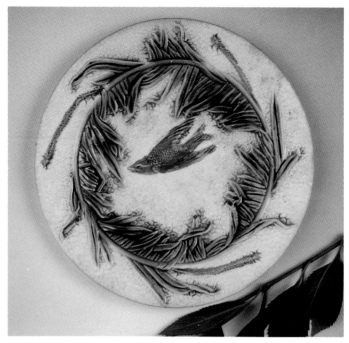

Plate, unattributed; flying bird illustration, 8.5" dia. *Courtesy of Michael G. Strawser, Majolica Auctions.* $135-150

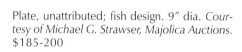

Plate, unattributed; fish design. 9" dia. *Courtesy of Michael G. Strawser, Majolica Auctions.* $185-200

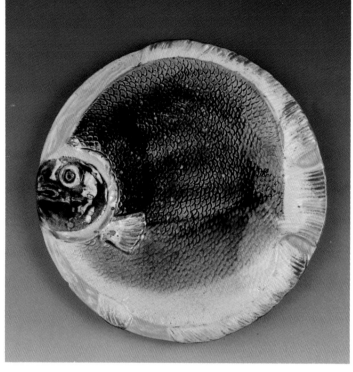

Tray/platter, unattributed; fish design. 9" x 8". *Courtesy of Michael G. Strawser, Majolica Auctions.* $425-465

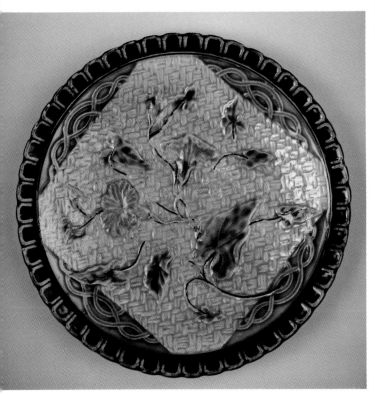

Pitcher, unattributed; basketweave and floral motif. 5" high. *Courtesy of Michael G. Strawser, Majolica Auctions.* $135-150

Napkin plate with morning glories, unattributed but marked with a sunburst on the back; decorated with morning glories. 8" dia. *Courtesy of Michael G. Strawser, Majolica Auctions.* $205+

Sunburst mark on napkin plate.

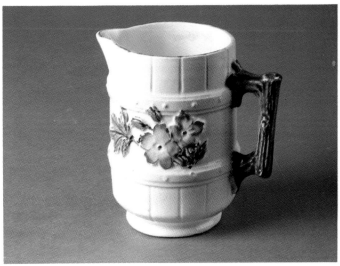

Small pitcher, unattributed; fence and floral motif. 5" high. *Courtesy of Michael G. Strawser, Majolica Auctions.* $135-150

Pitcher, unattributed; with flying crane. 7.25" high. *Courtesy of Michael G. Strawser, Majolica Auctions.* $215-235

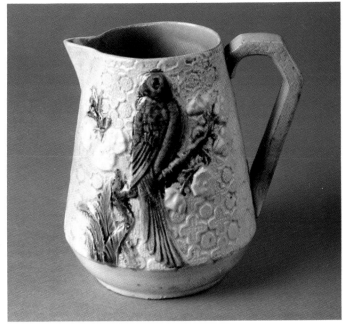

Small pitcher, unattributed; embossed cockatoo on a branch. 5.5" high. *Courtesy of Michael G. Strawser, Majolica Auctions.* $185-200

Plate, unattributed; fern decoration. Also appears with a brown border around a turquoise center. 7" x 8". *Courtesy of Michael G. Strawser, Majolica Auctions.* $135-150

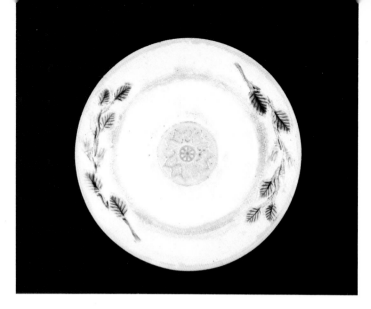

Plate, unattributed; delicate floral pattern. 8.5" dia. *Courtesy of Michael G. Strawser, Majolica Auctions.* $135-150

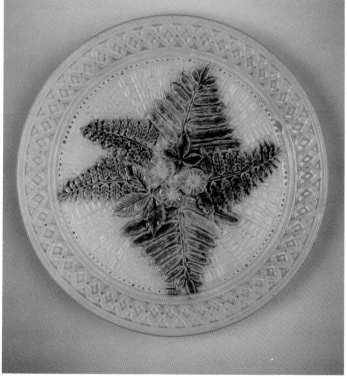

Plate, unattributed; fern and palm motif. 9.25" dia. *Courtesy of Michael G. Strawser, Majolica Auctions.* $135-150

Tray, unattributed; leaf pattern. 12" x 9.5".
Courtesy of Michael G. Strawser, Majolica Auctions. $225-250

Cheese dome, unattributed; basketweave
and floral decoration, pink interior. 8" dia.
x 6.5" high. *Courtesy of Michael G.
Strawser, Majolica Auctions.* $900+

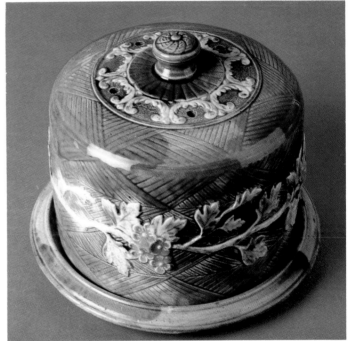

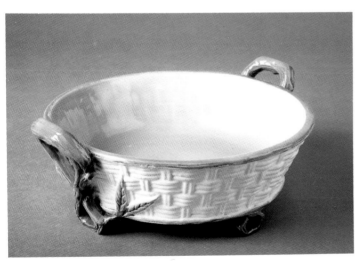

A basketweave dish, unattributed, 9" dia. *Courtesy of Michael G.
Strawser, Majolica Auctions.* $750+

Two pitchers, unattributed; metal lids.
5" tall. *Courtesy of Michael G. Strawser,
Majolica Auctions.* $300+ each

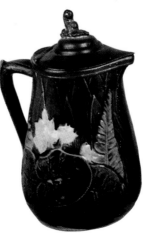

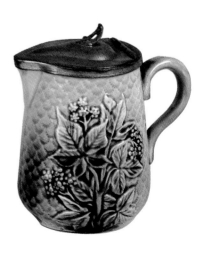

Centerpiece bowl, unattributed but numbered #1285; tropical leaf motif, blue underside. 16" dia. x 9" high. *Courtesy of Michael G. Strawser, Majolica Auctions.* $75-85

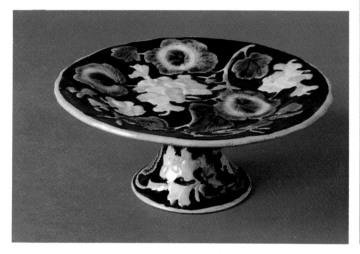

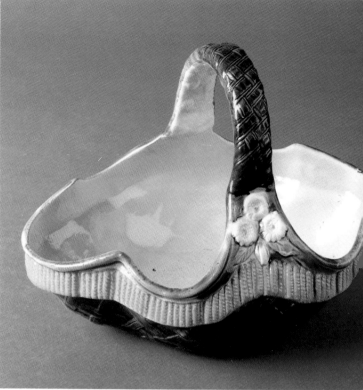

Pedestal dish, unattributed; cobalt with geranium pattern, mottled back. 8.25" dia. x 3.25" high. *Courtesy of Michael G. Strawser, Majolica Auctions.* $685-755

Basket, unattributed; floral with lavender interior. 9.5" long x 7" wide x 7.5" high. *Courtesy of Michael G. Strawser, Majolica Auctions.* $525-575

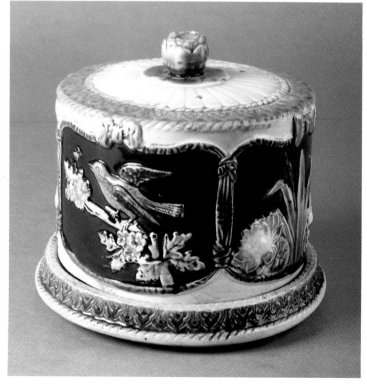

Frog, unattributed; cobalt with leaf and floral pattern. 4" high. *Courtesy of Michael G. Strawser, Majolica Auctions.* $375-410

Cheese dome, unattributed; cobalt. 8.25" dia. x 7.5" high. *Courtesy of Michael G. Strawser, Majolica Auctions.* $1600+

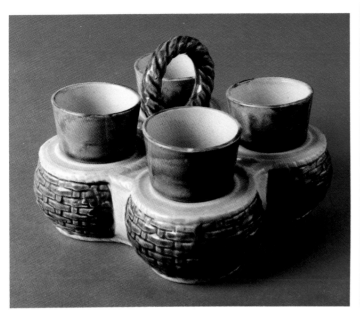

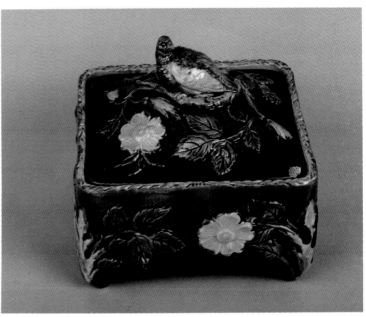

Egg basket, unattributed; four mottled cups. 6" long x 4.5" high. *Courtesy of Michael G. Strawser, Majolica Auctions.* $450+

Covered box, unattributed; footed, with quail handle. 5.5" sq. *Courtesy of Michael G. Strawser, Majolica Auctions.* $1600+

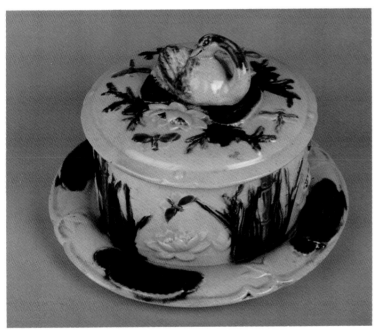

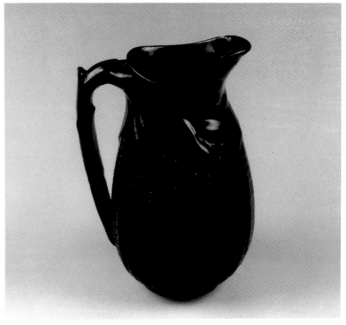

Covered butter, unattributed; swan and water lily motif, pink interior. *Courtesy of Michael G. Strawser, Majolica Auctions.* $925+

Pitcher, unattributed; corn in cobalt glaze. 6.75" high. $160-180

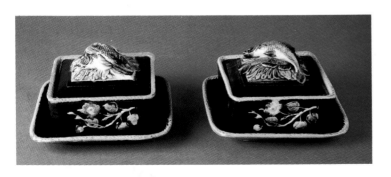

Sardine boxes, unattributed, cobalt, with attached underplates. *Courtesy of Michael G. Strawser, Majolica Auctions.* $1550-1700 each

Shallow bowl, unattributed, 8" dia. *Courtesy of Michael G. Strawser, Majolica Auctions.* $135-150

Egg warmer with four egg cups, unattributed; basket is filled with hot water. Cups, 2.25" high; basket, 6" high. $450+

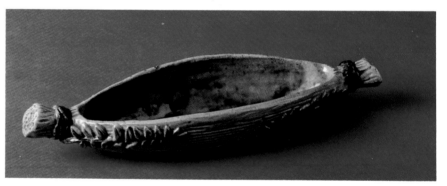

Portuguese server, 10" long. *Courtesy of Michael G. Strawser, Majolica Auctions.* $150-165

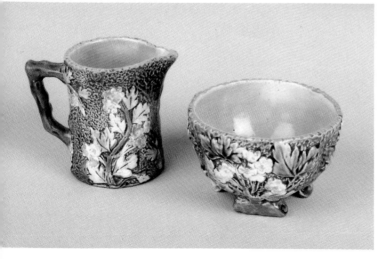

Creamer and lidless sugar bowl, unattributed. $375-410 set

Endnotes

Chapter I

1. Russel Blaine Nye, *Society and Culture in America, 1830- 1860* (New York: Harper Torchbooks, Harper & Row, Publishers, 1974), 175.
2. Marilyn G. Karmason with Joan B. Stacke, *Majolica. A Complete History and Illustrated Survey* (New York: Harry N. Abrams, Inc., Publisher, 1989), 13.
3. Karmason with Stacke, *Majolica*, 13.
4. Ivor Noël Hume, *A Guide to Artifacts of Colonial America* (New York: Alfred A. Knopf, 1985), 105-106.
5. Victoria Bergensen, *Majolica. British, Continental and American Wares, 1851-1915* (London, Barrie & Jenkins, 1989), 26; Jeffrey B. Snyder, *Flow Blue. A Collector's Guide to Pattern, History, and Values* (West Chester, PA: Schiffer Publishing Ltd., 1992), 9.
6. Bergensen, *Majolica*, 26.
7. ibid, 26.
8. ibid, 26.
9. ibid, 26.
10. Nicholas M. Dawes, *Majolica* (New York: Crown Publishers, Inc., 1990), 73.
11. Dawes, *Majolica*, 73.
12. Bergensen, *Majolica*, 24-25; Karmason with Stacke, *Majolica*, 9.
13. Mike Schneider, *Majolica* (West Chester, PA: Schiffer Publishing Ltd., 1990), 31; Snyder, *Flow Blue*, 17.
14. Victoria Cecil, *Minton 'Majolica.' An Historical Survey and Exhibition Catalogue* (London: Jeremy Cooper Ltd., 1982), 20-21; Karmason with Stacke, *Majolica*, 9.
15. Cecil, *Minton 'Majolica,'* 21.
16. ibid, 21.
17. ibid, 22.
18. ibid, 22.

Chapter II

1. Marilyn G. Karmason with Joan B. Stacke, *Majolica. A Complete History and Illustrated Survey* (New York: Harry N. Abrams, Inc., Publisher, 1989), 113; Nicholas M. Dawes, *Majolica* (New York: Crown Publishers, Inc., 1990), 9.
2. Jeffrey B. Snyder, *Flow Blue. A Collector's Guide to Pattern, History, and Values* (West Chester, PA: Schiffer Publishing Ltd., 1992), 11.
3. Dawes, *Majolica*, 18.
4. ibid, 3.
5. Karmason with Stacke, *Majolica*, 11.
6. Victoria Bergensen, *Majolica. British, Continental and American Wares, 1851-1915* (London, Barrie & Jenkins, 1989), 10.
7. Dawes, *Majolica*, 144.
8. Diana Di Zerega Wall, "Sacred Dinners and Secular Teas: Constructing Domesticity in Mid-19th-Century New York," *Historical Archaeology* 25(4)(1991): 70.
9. Mary Cable and the Editors of American Heritage, *American Manners & Morals* (New York: American Heritage Publishing Company, 1969), 213.
10. Terry H. Klien, "Nineteenth-Century Ceramics and Models of Consumer Behavior," *Historical Archaeology* 25(2)(1991): 78-79.
11. Bergensen, *Majolica*, 11; Dawes, *Majolica*, 144.
12. Dawes, *Majolica*, 144.
13. ibid, 154.

14. ibid, 154-155.
15. ibid, 155; Mike Schneider, *Majolica* (West Chester, PA: Schiffer Publishing Ltd., 1990), 25; Karmason with Stacke, *Majolica*, 142.
16. Dawes, *Majolica*, 157; Karmason with Stacke, *Majolica*, 141.
17. Karmason with Stacke, *Majolica*, 14.
18. Bergensen, *Majolica*, 22-23; Daniel Pool, *What Jane Austen Ate and Charles Dickens Knew. From Fox Hunting to Whist-the Facts of Daily Life in 19th-Century England* (New York: Simon & Schuster, 1993), 75.
19. Bergensen, *Majolica*, 22; Pool, *What Jane Austen Ate and Charles Dickens Knew*, 75-76.
20. Pool, *What Jane Austen Ate and Charles Dickens Knew*, 175- 176; Bergensen, *Majolica*, 23.
21. Pool, *What Jane Austen Ate and Charles Dickens Knew*, 175- 176.
22. Bergensen, *Majolica*, 24.
23. Pool, *What Jane Austen Ate and Charles Dickens Knew*, 66- 69.
24. Anne M.P. Stern, "Colorful Majolica," *Majolica Matters* (Summer, 1992), 5.
25. Elizabeth L. Newhouse (ed.), *The Story of America* (Washington, D.C.: National Geographic Society, 1992), 237-239.
26. Schneider, *Majolica*, 34.
27. Stern, "Colorful Majolica," 5.
28. Karmason with Stacke, *Majolica*, 14.
29. Russel Blaine Nye, *Society and Culture in America, 1830- 1860* (New York: Harper & Row, Publishers, 1974), 160.
30. Bergensen, *Majolica*, 14.
31. ibid, 19.
32. ibid, 19.
33. ibid, 17.
34. ibid, 17.
35. Ruth Irwin Weidner, "The Majolica Wares of Griffen, Smith, & Company. Part II: The Designs and Their Sources," *Spinning Wheel* (March/April, 1980), 20.
36. ibid, 20.

Chapter III

1. Geoffrey A. Godden, *British Porcelain. An Illustrated Guide* (New York: Clarkson N. Potter, Inc./Publisher, 1974), 441-443.
2. Jeffrey B. Snyder, *Flow Blue. A Collector's Guide to Pattern, History, and Values* (West Chester, PA: Schiffer Publishing Ltd., 1992), 27.
3. ibid, 27.
4. ibid, 27.
5. ibid, 28.

Chapter IV

1. In Chapters IV, V, and VI, endnote citations have been placed only at the beginning of the discussion of each potter. Mike Schneider, *Majolica* (West Chester, PA: Schiffer Publishing Ltd., 1990), 113.
2. ibid, 113-114.
3. ibid, 115-116; Nicholas M. Dawes, *Majolica* (New York: Crown Publishers, Inc., 1990), 131.
4. Marilyn G. Karmason with Joan B. Stacke, *Majolica. A Complete History and Illustrated Survey* (New York: Harry N. Abrams, Inc., Publisher, 1989), 121.
5. Dawes, *Majolica*, 123; Schneider, *Majolica*, 118-119.
6. Schneider, *Majolica*, 119.

7. Dawes, *Majolica,* 130; Schneider, *Majolica,* 120.

8. ibid, 125-126; ibid, 123.

9. ibid, 112-115; ibid, 123-124.

10. Karmason with Stacke, *Majolica,* 112; Schneider, *Majolica,* 124.

11. Bernard and Therle Hughes, *The Collector's Encyclopaedia of English Ceramics* (London: Abbey Library, 1968), 112; Dawes, *Majolica,* 80-86; Schneider, *Majolica,* 124-125; Karmason with Stacke, *Majolica,* 32.

12. Schneider, *Majolica,* 125.

13. Dawes, *Majolica,* 133.

14. Karmason with Stacke, *Majolica,* 126; Victoria Bergensen, *Majolica. British, Continental and American Wares, 1851-1915* (London, Barrie & Jenkins, 1989), 159.

15. Karmason with Stacke, *Majolica,* 128; Schneider, *Majolica,* 129.

16. ibid, 137; ibid, 129.

17. ibid, 125-126; ibid, 131.

18. Dawes, *Majolica,* 93-96, 108; ibid, 131.

19. Schneider, *Majolica,* 132.

Chapter V

1. Marilyn G. Karmason with Joan B. Stacke, *Majolica. A Complete History and Illustrated Survey* (New York: Harry N. Abrams, Inc., Publisher, 1989), 174; Mike Schneider, *Majolica* (Atglen, PA: Schiffer Publishing Ltd., 1990), 114.

2. Karmason with Stacke, *Majolica,* 142-144; Nicholas M. Dawes, *Majolica* (New York: Crown Publishers, Inc., 1990), 165; Edwin Atlee Barber, *Marks of American Potters* (Philadelphia, PA: Patterson & White Company, 1904), 143-146; Victoria Bergensen, *Majolica. British, Continental and American Wares, 1851-1915* (London, Barrie & Jenkins, 1989), 96; Schneider, *Majolica,* 114-115.

3. Dawes, *Majolica,* 165; Karmason with Stacke, *Majolica,* 166- 167; Schneider, *Majolica,* 117-118.

4. Dawes, *Majolica,* 170; Schneider, *Majolica,* 119-120.

5. Arthur E. James, *The Potters and Potteries of Chester County* (Exton, PA: Schiffer Publishing Ltd., 1978), 114-120; Anne M.P. Stern, "Colorful Majolica," *Majolica Matters* (Summer, 1992): 4-5; Edwin Atlee Barber, "Etruscan Majolica," *Bulletin of the Pennsylvania Museum* (July, 1907): 47; Druscilla Smith Yarnell, penned history of her father's association with local pottery which produced majolica; Miriam Clegg (ed.), "The Phoenix Pottery," *Historical Society of the Phoenixville Area,* 8(2)(December, 1984): 2-3; Ruth Irwin Weidner, "The Majolica Wares of Griffen, Smith, & Hill Company. Part II: The Designs and Their Sources," *Spinning Wheel* (March/April, 1980): 14-21; Schneider, *Majolica,* 121-122; Dawes, *Majolica,* 161.

6. Karmason with Stacke, *Majolica,* 170-171.

7. ibid, 165-166; Schneider, *Majolica,* 125-126.

8. ibid, 172-174; ibid, 126-127.

9. Dawes, *Majolica,* 172; Schneider, *Majolica,* 116.

10. Karmason with Stacke, *Majolica,* 174; Schneider, *Majolica,* 127-128.

11. Dawes, *Majolica,* 170.

12. Karmason with Stacke, *Majolica,* 170; Schneider, *Majolica,* 128.

13. M. Charles Rebert, *American Majolica 1850-1900* (Des Moines, Iowa: Wallace-Homestead Book Company, 1981), 71; Karmason with Stacke, *Majolica,* 161.

13. Karmason with Stacke, *Majolica,* 168; Schneider, *Majolica,* 113.

14. ibid, 168-170; ibid, 119.

15. ibid, 167-168; ibid, 120-121.

16. ibid, 170; ibid, 132.

Chapter VI

1. Nicholas M. Dawes, *Majolica* (New York: Crown Publishers, Inc., 1990), 140-141; Marilyn G. Karmason with Joan B. Stacke, *Majolica. A Complete History and Illustrated Survey* (New York: Harry N. Abrams, Inc., Publisher, 1989), 196.

2. Dawes, *Majolica,* 140-141.

3. ibid, 140-141.

4. ibid, 152.

5. ibid, 145; Karmason with Stacke, *Majolica,* 175.

6. Karmason with Stacke, *Majolica,* 196.

7. ibid, 177-180.

8. Dawes, *Majolica,* 153.

9. Karmason with Stacke, *Majolica,* 186.

10. ibid, 180-182.

11. Dawes, *Majolica,* 153.

12. ibid, 153; Karmason with Stacke, *Majolica,* 195-196.

13. Karmason with Stacke, *Majolica,* 184-185.

14. Dawes, *Majolica,* 153.

15. ibid, 146; Mike Schneider, *Majolica* (West Chester, PA: Schiffer Publishing Ltd., 1990), 130.

16. Karmason with Stacke, *Majolica,* 195.

17. Dawes, *Majolica,* 152.

18. Karmason with Stacke, *Majolica,* 195.

19. Dawes, *Majolica,* 152; Karmason with Stacke, *Majolica,* 194.

Bibliography

Barber, Edwin Atlee, "Etruscan Majolica", *Bulletin of the Pennsylvania Museum,* Memorial Hall, Fairmount Park, Philadelphia, July 1907.

Barber, Edwin Atlee, *Marks of American Potters,* Patterson & White Co., Philadelphia, PA, 1904.

Bergensen, Victoria, *Majolica. British, Continental and American Wares 1851-1915,* Barrie & Jenkins, London, 1989.

Bockol, Leslie. *Victorian Majolica.* Atglen, Pennsylvania: Schiffer Publishing, Ltd., 1996.

Cable, Mary & the Editors of American Heritage, *American Manners & Morals,* American Heritage Publishing Co., Inc., NY, 1969.

Cecil, Victoria, *Minton 'Majolica.' An Historical Survey and Exhibition Catalogue,* Jeremy Cooper Ltd., London, 1982.

Clegg, Miriam (ed.), "The Phoenix Pottery" *Historical Society of the Phoenixville Area,* Volume 8, Number 2, December, 1984.

Cunningham, Helen. *Majolica Figures.* Atglen, Pennsylvania: Schiffer Publishing, Ltd., 1997.

Dawes, Nicholas M., *Majolica,* Crown Publishers, Inc., New York, 1990.

Hillier, Bevis, *The Style of the Century, 1900-1980,* The Herbert Press, London, 1983.

Hubbard, Scott, "Baking powder premiums now a collector's prize.", *The Morning News,* Wilmington, DE, Sept. 23, 1975.

Hughes, Bernard and Therle, *The Collector's Encyclopaedia of English Ceramics,* Abbey Library, London, 1968.

James, Arthur E., *The Potters and Potteries of Chester County, Pennsylvania,* Schiffer Publishing Ltd., Exton, PA, 1978.

Karmason, Marilyn G. with Joan B. Stacke, *Majolica. A Complete History and Illustrated Survey,* Harry N. Abrams, Inc., Publishers, New York, NY, 1989.

Karsnitz, Jim and Vivian. *Oyster Plates.* Atglen, Pennsylvania: Schiffer Publishing, Ltd., 1993.

Klein, Terry H., "Nineteenth-Century Ceramics and Models of Consumer Behavior," *Historical Archaeology* 25 (2), 1991, pp.77-91.

Kowalsky, Arnold A. and Dorothy E. *Encyclopedia of Marks on American, English, and European Earthenware, Iron-stone, and Stoneware.* Atglen, Pennsylvania: Schiffer Publishing, Ltd., 1999.

Larkin, Jack, *The Reshaping of Everyday Life 1790-1840,* Harper & Row, Publishers, New York, 1988.

Murray, D. Michael. *European Majolica.* Atglen, Pennsylvania: Schiffer Publishing, Ltd., 1997.

Newhouse, Elizabeth L. (ed.), *The Story of America,* National Geographic Society, Washington, D.C., 1992.

Nye, Russel Blaine, *Society and Culture in America, 1830-1860,* Harper Torchbooks, Harper & Row, Publishers, New York, 1974.

Pool, Daniel, *What Jane Austen Ate and Charles Dickens Knew. From Fox Hunting to Whist - the Facts of Daily Life in 19th - Century England,* Simon &n Schuster, New York, NY, 1993.

Quillman, Catherine. "Phoenixville firm known for majolica pottery." *Philadelphia Inquirer,* Chester County Home Page B2, August 28, 2000.

Quimby, Ian M.G. (ed.), *Material Culture and the Study of American Life, A Winterthur Book,* W.W. Norton & Company, New York & London, 1978.

Savage, George and Harold Newman, *An Illustrated Dictionary of Ceramics,* Thames and Hudson Ltd., London, 1974 - reprint 1989.

Schneider, Mike, *Majolica,* Schiffer Publishing Ltd., West Chester, PA, 1990.

Snyder, Jeffrey B. "American majolica dazzled fair goers in 1876." *Antique Week* 33(10), May 22, 2000.

Stern, Anne M.P., "Colorful Majolica", *Majolica Matters,* Summer 1992.

Wall, Diana Di Zerega, "Sacred Dinners and Secular Teas: Constructing Domesticity in Mid-19th-Century New York," *Historical Archaeology* 25(4), 1991, pp. 69-81.

Weidner, Ruth Irwin, "The Majolica Wares of Griffen, Smith, & Company (Part II: The Designs and Their Sources)," *Spinning Wheel,* March/April, 1980.

Yarnell, Druscilla Smith, Penned history of her father's (David Smith) association with a local pottery which produced majolica: Griffen, Smith & Hill, *Historical Society of the Phoenixville Area,* Phoenixville, PA, n.d.

Index